THE
FLOWER
RECIPE
BOOK

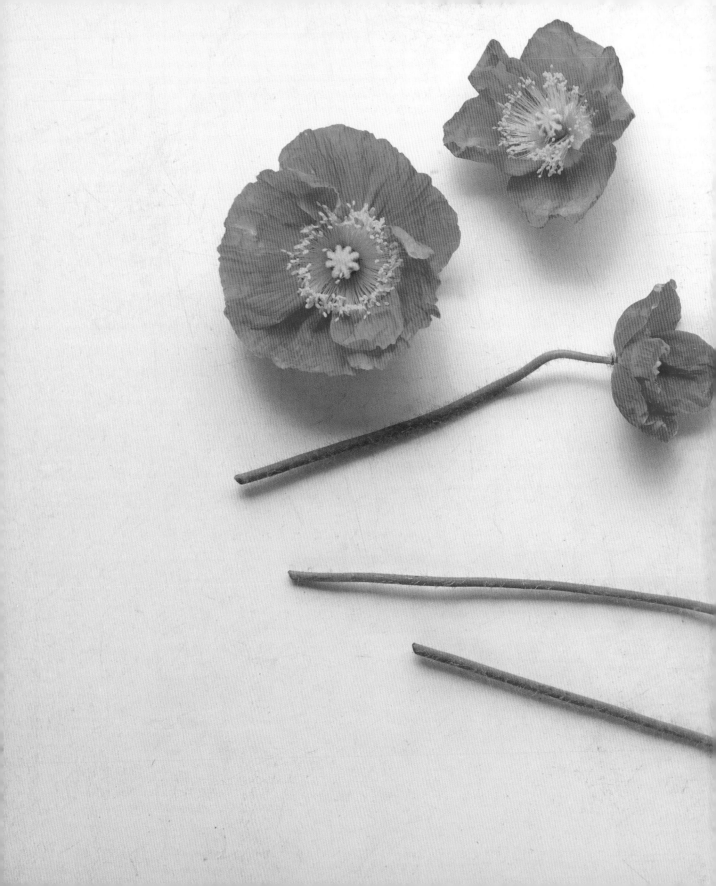

THE
FLOWER
RECIPE
BOOK

*Alethea Harampolis and Jill Rizzo
of Studio Choo*

Photographs by Paige Green

ARTISAN
NEW YORK

Published by Artisan
A division of Workman Publishing Company, Inc.
225 Varick Street
New York, NY 10014-4381
artisanbooks.com

Published simultaneously in Canada by Thomas Allen & Son, Limited

Library of Congress Cataloging-in-Publication Data
Harampolis, Alethea.
 The flower recipe book / Alethea Harampolis and Jill Rizzo of
Studio Choo.
 pages cm
 ISBN 978-1-57965-530-3
1. Flower arrangement. I. Rizzo, Jill. II. Title.
 SB449.H256 2013
 745.92—dc23
 2012046704

Design by Michelle Ishay-Cohen

Printed in China

10 9 8 7 6 5 4 3

To our nature-loving mothers

CONTENTS

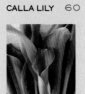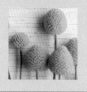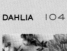

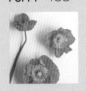

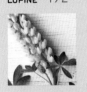
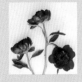

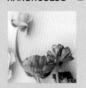

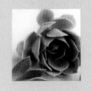

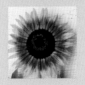

INTRODUCTION

A patch of unruly honeysuckle makes our hearts skip a beat. The gnarled and thorny stems of garden roses call to us despite the guaranteed hand scratches. We also have great respect for the clean lines of calla lilies and the simplicity of a single blooming succulent. We love flowers, and even though we work with cut (um, dying) flowers, we believe arrangements should have some life to them. The recipes in this book showcase forty-three different flowers, each arranged on its own as well as in combination with other ingredients.

Like most of you, we are not botanists. This book doesn't delve into specific varieties, plant families, or genera. We use common flower names for the plants we work with and provide a basic pronunciation guide to get you started, but that's about as far as it goes when it comes to our taxonomic prowess. We list commonly available flower colors, but they are by no means inclusive of all the varieties. We encourage you to further research your favorite blooms!

BASE, FOCAL, BITS

This is our basic recipe for creating mixed arrangements: Start with a strong supporting cast of flowers and greenery (base), add in a hero flower (focal), and then toss in a few pieces full of character (bits) to fill out the group. This recipe can be used time and time again with whatever flowers you have available to yield very different results. Amp up the number of ingredients for special-occasion pieces or pare it down for a more casual look.

DIFFERENT STROKES FOR DIFFERENT FOLKS

When it comes to color, the rule is don't follow the rules. Use what you like, try new things, and welcome the happy accident. We tend to favor hues that lie close to each other on the color wheel rather than opposite, so our arrangements usually end up with subtle, blended palettes rather than starkly contrasting ones. Color is a very personal choice, though, so keep an open mind when selecting your palette. Combine a few blooms in hand to see what they look like together before adding anything to the vase.

MOVE IT

Ideally, the composition of an arrangement will keep your eyes moving from one ingredient to the next, just like a painting. Varying the size and shape of blooms, clustering, and using directional elements like spires and vines can point the eye in different directions and also give it a place to rest. A simple twist of a flower head to face one way or another can change the entire attitude of an arrangement. Also, keep in mind that air and space in a composition can create as big an impact as a focal flower; arrangements don't always need to be packed full.

DON'T BE AFRAID TO FOLLOW YOUR GUT

As with cooking, use these recipes as a guide. As you feel more comfortable, start adding your own flair. Don't be dissuaded from following a recipe because you only have mums when the directions call for peonies—the information in this book can be used in lots of different ways.

Whether you want to replicate a recipe as closely as possible, re-create a color palette with entirely different blooms, or make a few similarly shaped substitutions, the basic arranging techniques shown will help you design with the flowers you have available. In cooking, a recipe may hinge on having sweet paprika or pearl onions, but with a flower recipe, there's plenty of room for experimentation without risk of spoiling the whole batch.

GOOD TO KNOW

SEASONALITY AND LOCALITY

You know how you wait and wait for peach season, and then one day every roadside fruit stand and greengrocer is packed with juicy, delicious peaches? Those peaches taste so much better than the unripe, flavorless fruits that are available year-round at the grocery store. It's like that with flowers, too. Make an effort to use what's local and in season and you'll usually end up with nice juicy flowers.

TOXICITY

Many flowers contain some level of toxicity. If you have small children or pets that like to munch on leaves, we advise that you keep all arrangements out of reach. Rule of thumb: Don't eat the arrangements, even if they look yummy.

SAP

Some flowers, like hyacinth and narcissus, ooze a clear or milky sap from the stems when cut. Use caution when handling them because the sap can irritate skin and may be poisonous to other flowers. If possible, trim the stems and place them in a bucket of water for a few hours before using them in arrangements. When you add them to the arrangement, do not retrim the stems.

WATER AND LONGEVITY

For the majority of our arrangements, we recommend filling each vase three-quarters of the way full with cool, clean water. Bacteria formed from dirty water will clog the flowers' stems and prevent them from drinking, so it's best to change the water every day, if possible.

If you happen to have a spray nozzle on your faucet, here's an easy way to refresh the water: Hold the vase over the sink and tilt it so that the dirty water pours out. At the same time, spray a stream of fresh water into the opposite side until the vase is filled with all new water.

Regularly changing the water and occasionally recutting stems is the best way to prolong the life and beauty of our arrangements—no need to use any additional preservatives.

Arrangements should also be kept in a cool place and out of direct sunlight; both heat and sunlight cause bacteria growth. As a general rule you should keep your flowers away from fruit, which gives off natural gases that can cause premature wilt. (We often disregard this rule, though, because we love using fruit in our arrangements.)

RULES TO LIVE BY

These are the only rules to keep in mind:

- Clean your vases and buckets after using them.
- Change the water in the vase at the very least every few days.
- Trim the stems of flowers right before you add them to the vase. The cut stem should be exposed to the air for as little time as possible.
- Keep your tools sharp. Dull tools can crush the stems as you are making cuts and prevent water from being absorbed properly.

Now go ahead, make arrangements!

STOCKING YOUR TOOLBOX

We recommend stocking a floral toolbox with all your supplies so that they are at the ready when you arrive home with your bounty. Most of these supplies can be purchased at your local craft store or floral shop. Some items, such as the frogs, are a little less readily available, but they are not difficult to find at flea markets or online (there are some amazing antique styles out there).

FLORAL ADHESIVE: A useful glue for affixing stems to one another or to a surface. Also secures fruits onto skewers.

CAGE FROG: A unique grid-shaped stem stabilizer.

PIN FROG: A must-have for stabilizing stems in a low vase or just a few blooms in a simple cup.

FLORAL TAPE: Essential for wrapping bouquets and boutonnieres, this tape becomes sticky when stretched, so make sure to pull it taut while wrapping.

FLORAL PUTTY: This waterproof adhesive putty secures floral frogs firmly in a vessel.

RUBBER BANDS: Keep assorted sizes on hand to easily bind bunches of stems so that they stay clustered in an arrangement.

CELLOPHANE TAPE: Use this tape to create an "invisible" grid on top of a vase to hold stems in place.

FLORAL SNIPS: These scissors are your primary tool for cutting flowers. Make sure your pair is very sharp in order to avoid crushing stems while making angled and sectional cuts. These can also be used for leaf and thorn removal.

PRUNERS: These shears make angled cuts on thick branches and woody stemmed flowers.

FLORAL KNIFE: Perfect for making long angled cuts and removing sharp thorns.

SKEWERS: Use these to create "stems" for succulents and fruit.

FLORAL WIRE: Available in different gauges and lengths, floral wire is used to skewer succulents and fruit and to attach flowers to displays.

WREATH FRAME: A plastic or wire form used as the foundation for a wreath; ingredients are attached to the frame with floral wire.

WATERPROOF TAPE: This tape is used to hold down a cage frog or chicken wire in a vessel. Like cellophane tape, it is also used to create a grid on top of a vase to hold stems in place. We wrap it around the bottom of amaryllis stems to prevent splitting.

PADDLE WIRE: A flat roll of wire, available in different gauges, used to continuously wrap ingredients onto a wreath form.

BIND WIRE: This paper-coated wire is perfect for securing garlands and heavy branches to displays.

Chicken wire (not pictured): A stem stabilizer made by forming bendable coated wire into a ball shape and placing it in an unusually shaped or large opaque vessel.

Water tube (not pictured): A small water vessel used to keep individual stems hydrated.

Lighter (not pictured): Use this to burn and seal poppy stems.

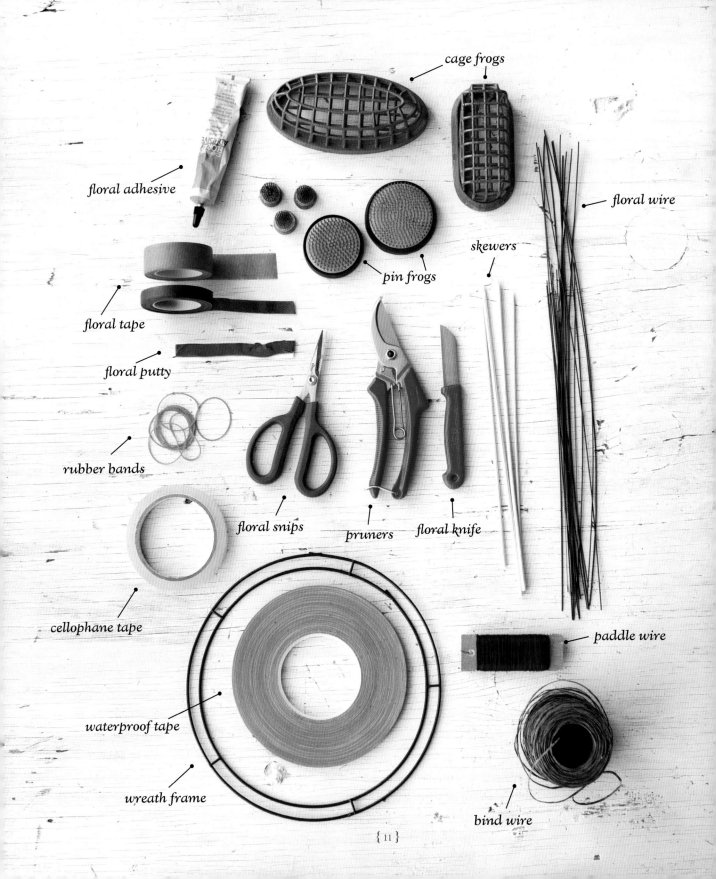

cage frogs

floral adhesive

floral wire

skewers

pin frogs

floral tape

floral putty

rubber bands

floral snips

pruners

floral knife

cellophane tape

paddle wire

waterproof tape

bind wire

wreath frame

CHOOSING THE RIGHT VESSEL

Before you begin arranging, take some time to select a vessel that accentuates what you love about your flowers. Tall, arcing tulip stems might look right at home in a simple, clear vase that will highlight their long, clean lines. A bunch of beautiful wide-open ranunculus with less than lovely foliage might be best showcased in your favorite teacup, with the blooms grouped in a short, tight mass.

Using your vessels to create arrangements can also be very impactful. A grouping made up of single stems in individual bottles is a super-fast and simple way to create a unique floral display. A common factor should unite the display to keep it from looking like a hodgepodge. For example, if you are using different types of flowers, one kind of bottle will look best. If the bottles are different, use the same flower type or color.

Flowers can be arranged in almost anything, so keep your eye out for interesting pieces to use as vessels. Line a cute cardboard strawberry container from the farmers' market with a squat jar, or fit a few flexible plastic cups inside a vintage cheese box, and you may have found your new favorite "vase."

And always, always make sure your vase is clean and filled with fresh, cold water.

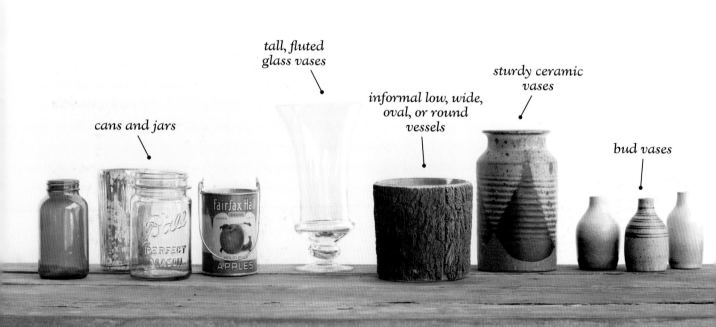

cans and jars

tall, fluted glass vases

informal low, wide, oval, or round vessels

sturdy ceramic vases

bud vases

Amassing a small collection of vessels will allow you to build a variety of arrangements. These are also the vessels we most often call upon for the recipes in this book:

CANS AND JARS: These are a standard size and easy to come by. They are perfect for small, casual arrangements. Collect a variety to suit your style and decor.

TALL, FLUTED GLASS VASES: Great for large, wide arrangements. They allow stems to splay out so that the blooms can open wide without being squished together.

INFORMAL LOW, WIDE, OVAL, OR ROUND VESSELS: These work well for low arrangements, such as centerpieces.

STURDY CERAMIC VASES: Ideal for heavier elements that may cause a lighter vase to topple over.

BUD VASES: A must for those delicate single stems.

PERSONALITY PIECES: These are the pieces that may not have started out as a vase, but that are well suited to the job. Pitchers, creamers, urns, trophies, and wooden boxes can all be used for flowers as long as they are watertight or lined with a vessel that is.

LOW TRAYS: Great for centerpieces or coffee-table arrangements. The addition of floral frogs or chicken wire makes filling them to the brim with flowers a piece of cake.

TALL NARROW BOTTLES: Ideal for a large single bloom or a tall arrangement with just a few airy stems.

NARROW CLEAR VASES: These provide a stage to showcase interesting stems.

FANCY PEDESTAL BOWLS: These give centerpieces a more sophisticated look when the occasion calls for it.

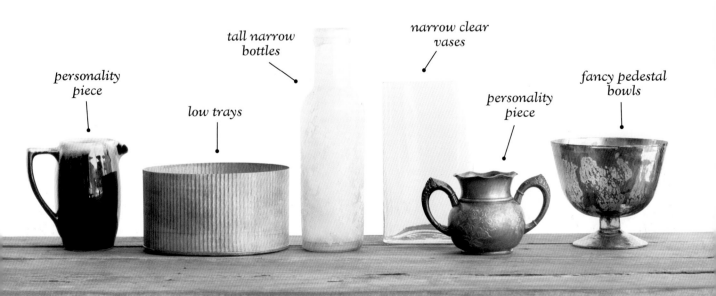

personality piece

low trays

tall narrow bottles

narrow clear vases

personality piece

fancy pedestal bowls

TECHNIQUES

Unless noted otherwise, here are some general rules to keep in mind when following the recipes in this book.

CUTTING TECHNIQUES

MEASURING STEMS TO CUT

Before making any cuts, it's important to understand how your stems will sit in the vase. Place the vase on the edge of the work surface and hold your stem in front of it so that you can see where the foliage and blooms will fall. Once you determine the length you need, remove the lower leaves and trim using one of the cuts described below.

Cut long to start; you can always go back and make a stem shorter as needed. No matter the cut, make sure to minimize the amount of time a cut stem is exposed to the air. If you cut a stem and then have to put it down on the counter to answer the telephone, cut it again before you place it in water.

ANGLED CUT

Cutting stems at a sharp angle creates more surface area on the stem, which increases water absorption. We use the angled cut on everything unless a tight grouping makes an angled cut too difficult. Also, the stems in bouquets usually get a flat cut because it looks cleaner.

WOODY STEM CUT

This cut is used for thick, hard stems that have a difficult time absorbing water. Use your pruners to make an angled cut first, then cut the stem upward, vertically, about an inch.

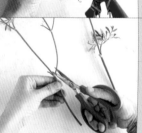

SECTIONAL CUTTING

Sectional cutting works with sprays and long stems that have multiple forks and angles. This technique will give you multiple pieces from a single stem. It's perfect for maximizing flower and foliage usage from tall stems in short arrangements. If you're using sectional cutting on a woody stem, be sure to conceal any visible cut ends in your arrangement with the surrounding ingredients.

STEM CARE

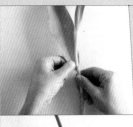

LEAF REMOVAL
Clean your stems of extra leaves (after you've measured for stem length) in order to keep the water clear of any material that will degrade when submerged. Removing the lower leaves also allows you to use the stem's remaining leaves as support when they rest on the vase. Depending on the leaves, they can be removed by gently tearing them off with your hands or with floral snips.

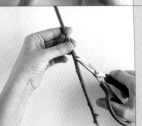

THORN REMOVAL
Thorns can add an interesting textural element to an arrangement but are not very practical for bouquets or groupings that are handled often. Avoid thorn strippers, which tend to strip a few layers of the stem's flesh along with the thorns. Instead, use floral snips or a knife to gently snip off thorns, and do your best to damage the stem as little as possible (and try to not hurt yourself!). Use gardening gloves if you are working with especially beastly specimens.

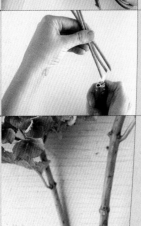

STEM BURNING
Cauterizing a stem with a lighter seals off the stem and keeps important nutrients from seeping out and dirtying the water. We've found that burning the stems of poppies allows them to open and stay intact for quite a while. The technique is simple: just hold the newly cut end of a poppy's stem in the flame of a lighter for a few seconds.

ALUM POWDER DIP
To help prevent hydrangeas from wilting, dip the stems in alum powder, commonly used for pickling and usually found in the spice section at the grocery store. Place the alum in a small shallow dish, then make an angled cut on a stem of hydrangea. Immediately dip the bottom of the stem into the alum to coat the cut, and place the stem in the vase. Because the alum will cloud the water, you may want to arrange in an opaque vessel.

WIRING AND SKEWERING

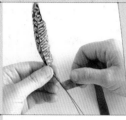

WIRING

Wiring the end of a feather gives it a longer "stem" so that it can be added to bouquets and arrangements. Place the feather at the halfway point of a piece of wire. Wrap the wire around the end of the feather several times until it's secure. Fold the ends of the wire down, and twist the wire ends around each other to form a stem. Finish by wrapping the wire with floral tape.

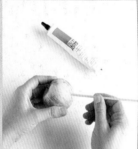

SUCCULENT SKEWERING AND WIRING

Wooden cooking skewers can be used to give heavy-headed succulents longer stems. The simplest method is to cut a succulent from its roots, leaving as long a stem nub as possible, and simply push a skewer into the bottom of the succulent through the nub. Take care to not push the skewer out through the top! For a cleaner and more durable "stem," push floral wire halfway through the stem just below where the leaves start. Wrap the ends of the wire around the stem, and down the length of the skewer. Wrap with floral tape to finish. If you are using smaller succulents that don't require as much support, replace the skewer with the appropriate length of heavy-gauge wire, and follow the same instructions above.

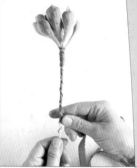

SKEWERING FRUIT

Wooden skewers are perfect for holding heavier items, such as fruit, in arrangements. Consider where and at what angle you want the fruit to be placed in your arrangement, and squeeze a dab of floral glue at the point you want your "stem" to come out at. The glue will create a seal between the skewer and the fruit, and prevent the fruit from sliding around. While the glue is still wet, slide your skewer through the dab of glue, piercing it deep enough so that the skewer can support the weight of the fruit. The glue will dry in a few minutes and the fruit will be ready to use.

WIRING FLOWERS

We often wire durable blooms onto wreaths and headpieces because thick, heavy stems are not practical in these types of designs. Snip a bloom from its stem and carefully poke floral wire through the very bottom of the bloom. Push the wire halfway through, and pull the ends of the wire down around the stem. Trim the wire to the required length and wrap with floral tape to finish. In some cases you will just want to push the wire through and use it to affix the flower to your design without taping. An alternative for delicate, hollow-stemmed flowers is to carefully feed a heavy-gauge wire all the way up through the stem and into the bloom for extra support.

A NOTE ABOUT FLORAL FOAM

Floral foam has been used by florists for years to address issues of support, hydration, and flower placement in arrangements. We have made the conscious decision not to use floral foam because of the chemicals it gives off, whether in the air in the form of toxic dust or in landfills, where it will never decompose or degrade.

TAPE GRID

Using a tape grid is an easy way to create stability and help you to create simple, sculptural arrangements. You can place stems through the grid at various points to create a low, full display, or use only a few stems at different angles to create a simple, striking piece.

Use cellophane tape for clear vases and waterproof floral tape for grids that will be hidden. Divide the top of your vase in half with tape from right to left, and then again from top to bottom, creating an X over the top of your vase. Continue to tape left to right and top to bottom across the vase, as needed, to create a grid. Place one long piece of tape around the entire rim to secure all the ends in place.

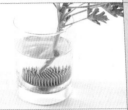

PIN FROGS

Pin frogs provide traction at the bottom of a vase and help keep pieces from moving. Secure a piece of floral putty to the bottom of your frog, and place the frog in the bottom of an empty vase. Push to secure so that the frog doesn't slip, and push the stems into the pins where desired. Branches and heavier items may cause your vase to tip over, so be sure to balance both sides.

CHICKEN WIRE

Chicken wire can provide support in large vases, and is flexible enough to fit a variety of oddly shaped vessels. You don't need to use much—a piece just a few inches long will provide enough of a supportive base. Wedge a ball of wire into the vase until it's secure, and insert your stems between the wires.

Plastic-coated wire is a good option, as metal chicken wire will quickly rust, discoloring your water and damaging your flowers.

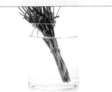

BAND BUNCH

Rubber banding stems together helps to create dense clusters that won't drift apart. Create a grouping in your hand and wrap a rubber band around the stems several times. Move the rubber band up or down the stems to create a looser or denser collection. This technique works best in an opaque vase.

BASE GREENERY

A few stems of bushy greenery or foliage provide a natural "shelf" for other elements to rest on, and gives support to surrounding stems.

TAPING A BOUQUET

Floral tape has an adhesive that is activated when it's stretched, adhering to itself tightly without clinging to the other elements. Once you've assembled a bouquet in hand, place the floral tape just under the bottom leaves, and begin to wrap the tape around the stems, stretching the tape as you go. Finish by cutting the tape and stretching the cut end to adhere it to the rest of the wrap.

THE INGREDIENT CHART

Our arrangements feature a number of different types of flowers, and this chart illustrates the main categories, as well as a few additional elements to spice things up.

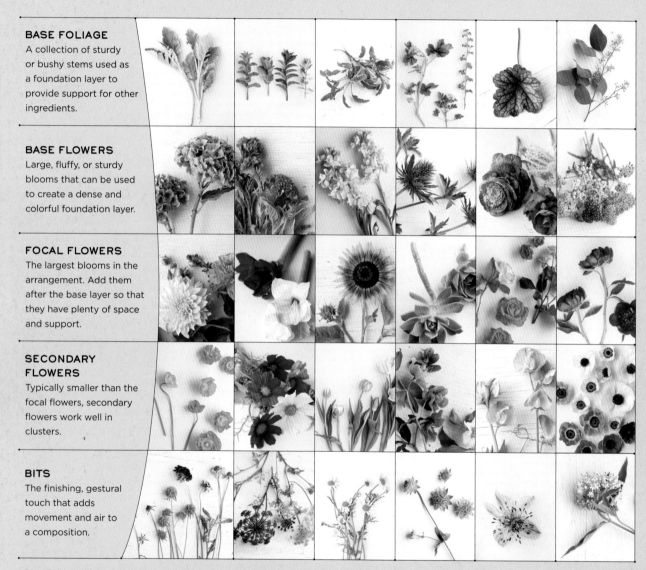

BASE FOLIAGE
A collection of sturdy or bushy stems used as a foundation layer to provide support for other ingredients.

BASE FLOWERS
Large, fluffy, or sturdy blooms that can be used to create a dense and colorful foundation layer.

FOCAL FLOWERS
The largest blooms in the arrangement. Add them after the base layer so that they have plenty of space and support.

SECONDARY FLOWERS
Typically smaller than the focal flowers, secondary flowers work well in clusters.

BITS
The finishing, gestural touch that adds movement and air to a composition.

Base Foliage, left to right: dusty miller, mint, sage, geranium, heuchera, seeded eucalyptus; Base Flowers, left to right: hydrangea, celosia, stock, thistle, kale, yarrow; Focal Flowers, left to right: dahlia, amaryllis, sunflower, succulent, rose, peony; Secondary Flowers, left to right: poppy, cosmos, tulip, hellebore, sweet pea, anemone; Bits, left to right: scabiosa, Queen Anne's lace, chamomile, astrantia, nigella, asclepias.

ADDITIONAL TEXTURAL INGREDIENTS

Add in or substitute from the ingredient categories below for more variation
in height, direction, and texture in your arrangements.

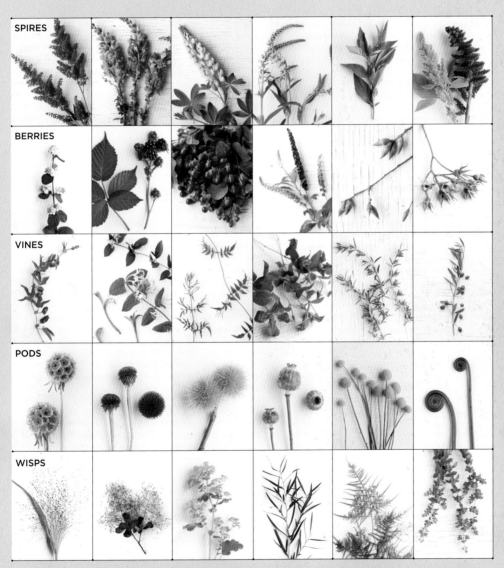

Spires, left to right: astilbe, snapdragon, lupine, veronica, lysimachia, amaranthus; Berries, left to right: snowberry,
blackberry, hypericum berry, pokeberry, acorn, rose hip; Vines, left to right: passion vine, honeysuckle, jasmine,
clematis, rosemary, olive; Pods, left to right: scabiosa pod, echinacea pod, chestnut, poppy pod, craspedia, fern curl;
Wisps, left to right: explosion grass, smoke bush, lady's mantle, agonis, plumosa fern, oregano.

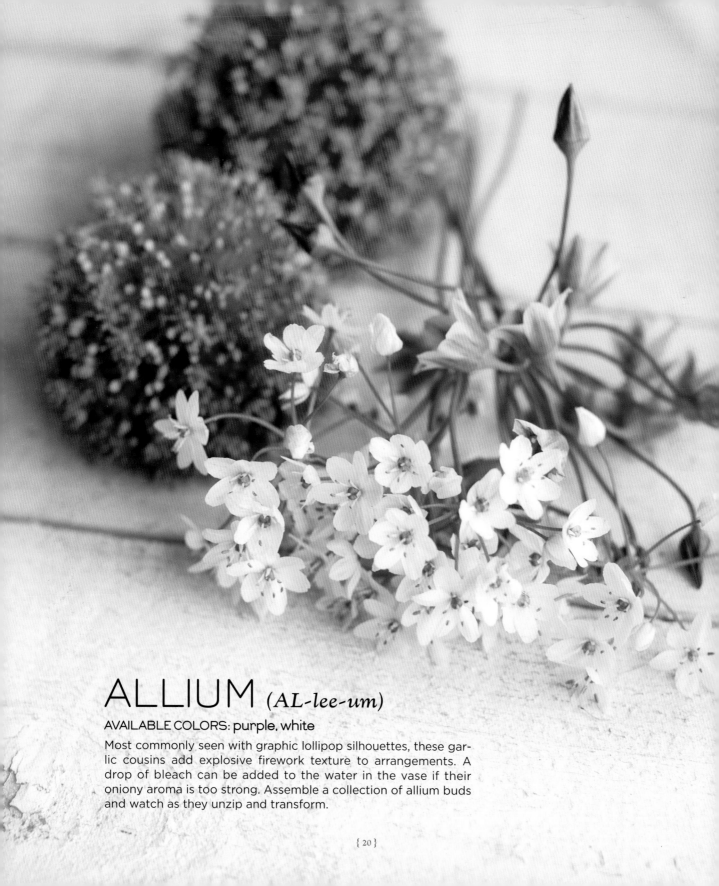

ALLIUM (AL-lee-um)

AVAILABLE COLORS: purple, white

Most commonly seen with graphic lollipop silhouettes, these garlic cousins add explosive firework texture to arrangements. A drop of bleach can be added to the water in the vase if their oniony aroma is too strong. Assemble a collection of allium buds and watch as they unzip and transform.

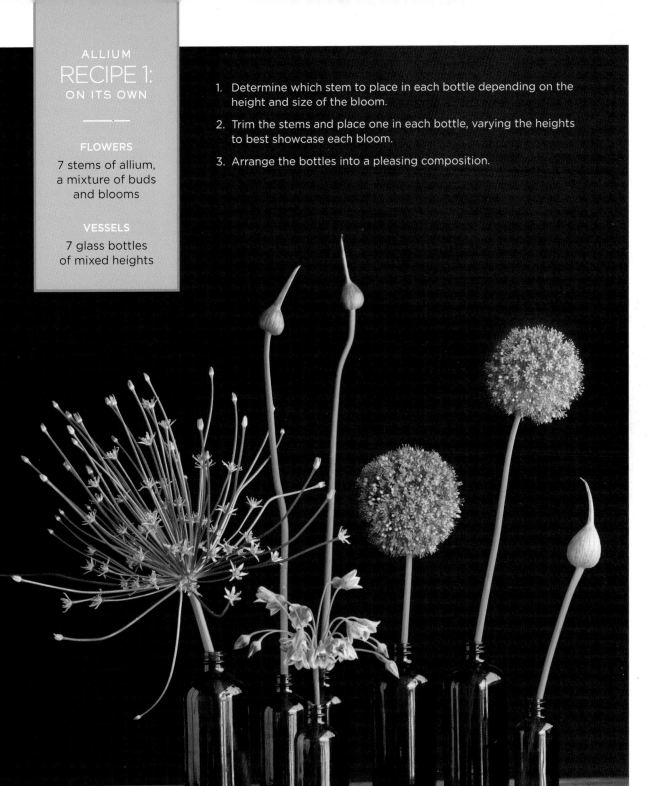

ALLIUM
RECIPE 1:
ON ITS OWN

—————

FLOWERS

7 stems of allium,
a mixture of buds
and blooms

VESSELS

7 glass bottles
of mixed heights

1. Determine which stem to place in each bottle depending on the
 height and size of the bloom.

2. Trim the stems and place one in each bottle, varying the heights
 to best showcase each bloom.

3. Arrange the bottles into a pleasing composition.

———

FLOWERS

3 stems of allium in
a puffball shape

6 stems of
lady's mantle

5 stems of allium

VESSEL
Vintage pitcher

Choose a pitcher with an
architectural silhouette
that contrasts with the
softness of the puffs.

2 Trim the stems of the puffball allium
and place them in the pitcher so that
the blooms rest an inch above the
rim on all sides.

3 Trim and add the stems of lady's
mantle, filling the spaces between
the allium puffballs.

4 Finish by trimming and adding the
stems of the other variety of allium,
allowing them to arc out of the
pitcher at the front, back, and
right sides.

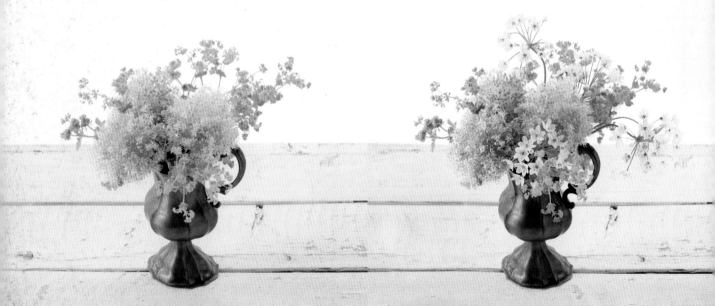

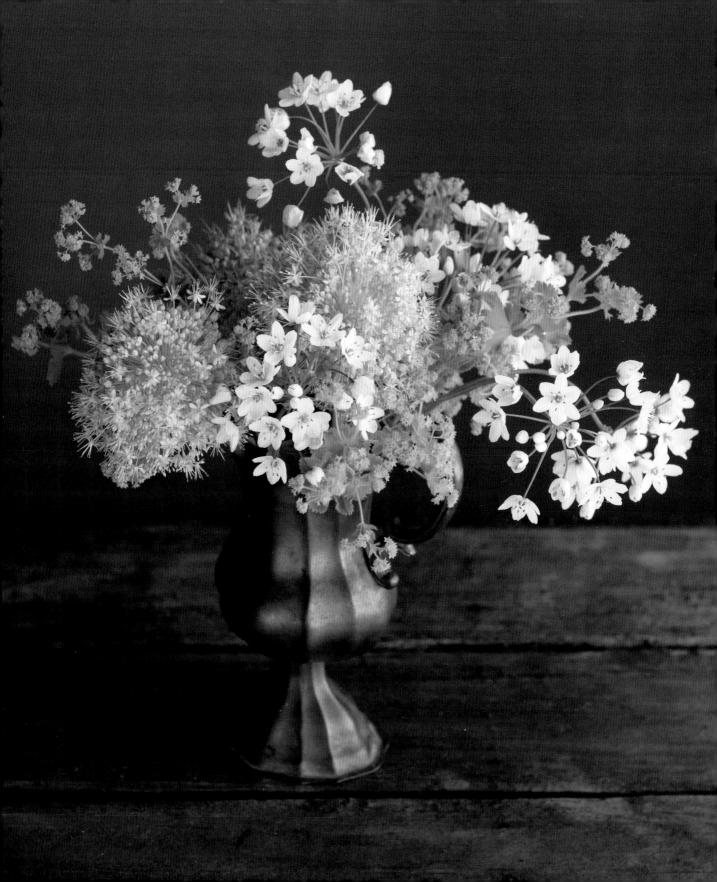

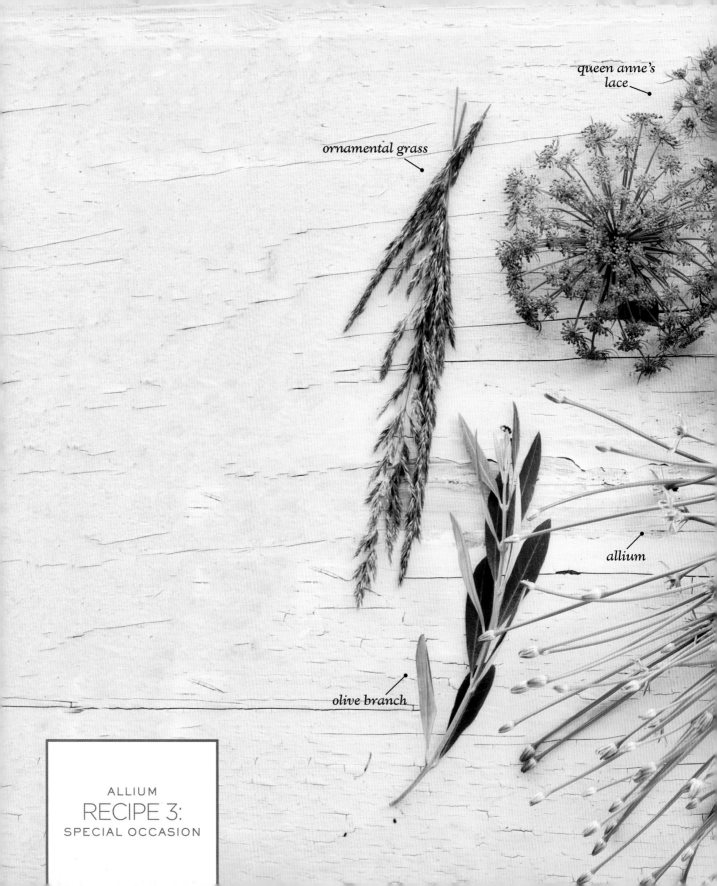

queen anne's
lace

ornamental grass

allium

olive branch

ALLIUM
RECIPE 3:
SPECIAL OCCASION

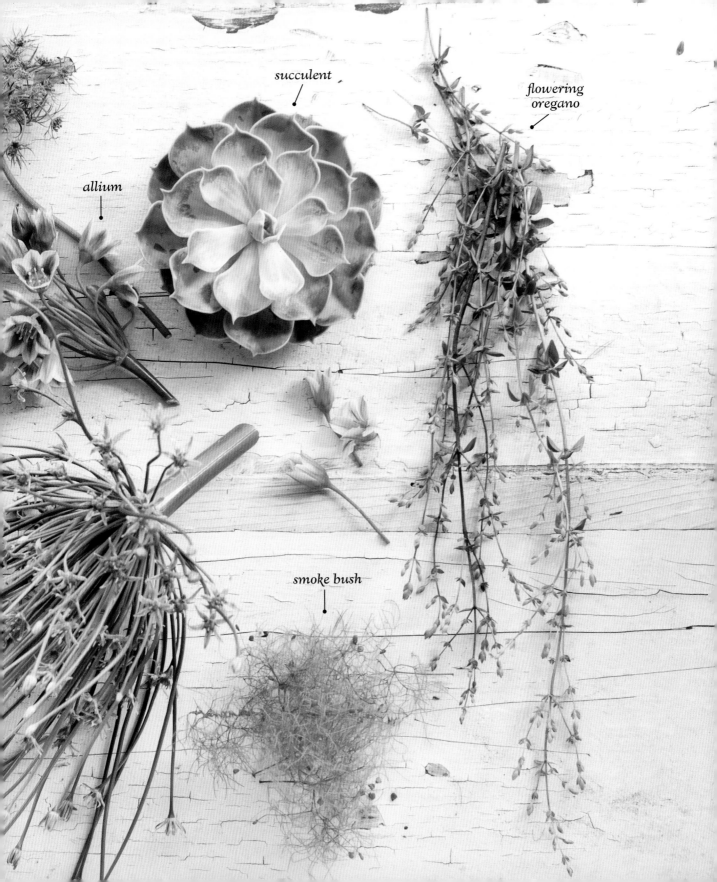

allium

succulent

flowering
oregano

smoke bush

ALLIUM

RECIPE 3:

SPECIAL OCCASION

FLOWERS

3 skewered succulents

3 stems of assorted allium

1 spray of smoke bush

3 stems of Queen Anne's lace

4 olive branches

10 stems of ornamental grass

5 stems of flowering oregano

VESSEL

Footed urn

1 Use floral putty to affix a large flower frog to the bottom of the urn.

2 Place the skewered succulents in a cluster at the front rim of the urn.

3 Trim and place the largest allium so that its lowest blooms start a few inches above the rim of the urn, just above the succulents.

4 Add the smoke bush and one stem of Queen Anne's lace to fill in the remaining space around the rim.

5 Trim and add one of the remaining allium stems, clustered low with the succulents. Trim and add the other stem, allowing it to arc out to the side opposite the largest allium.

6 Trim and place the remaining stems of Queen Anne's lace at the back of the composition, one just above the succulents and the other at the highest point on the left side.

7 Finish the arrangement with the wispy olive branches, ornamental grass stems, and flowering oregano stems to contrast the dense grouping at the rim of the urn with a looser, airier texture.

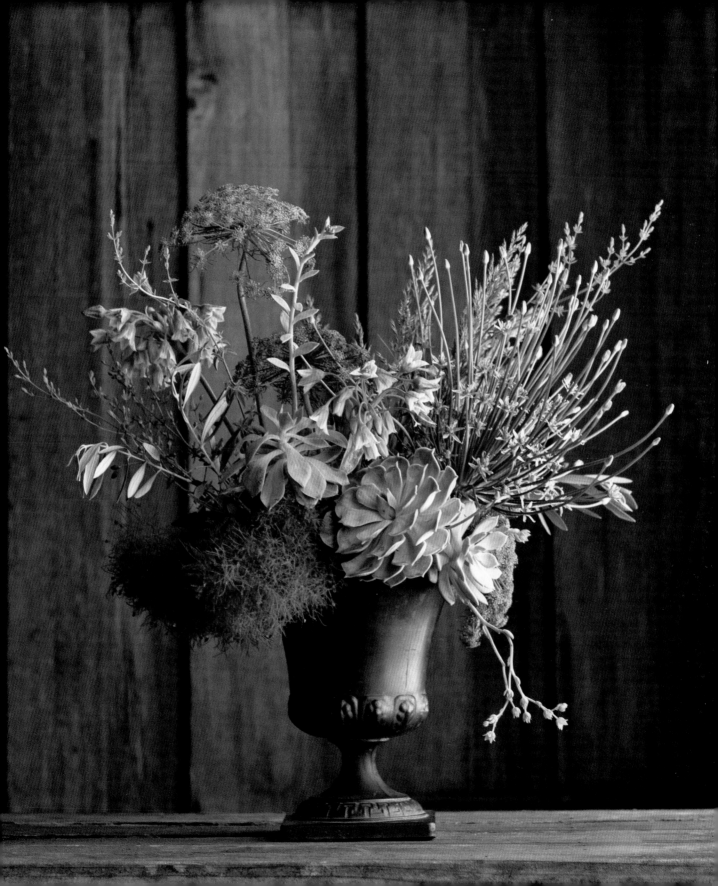

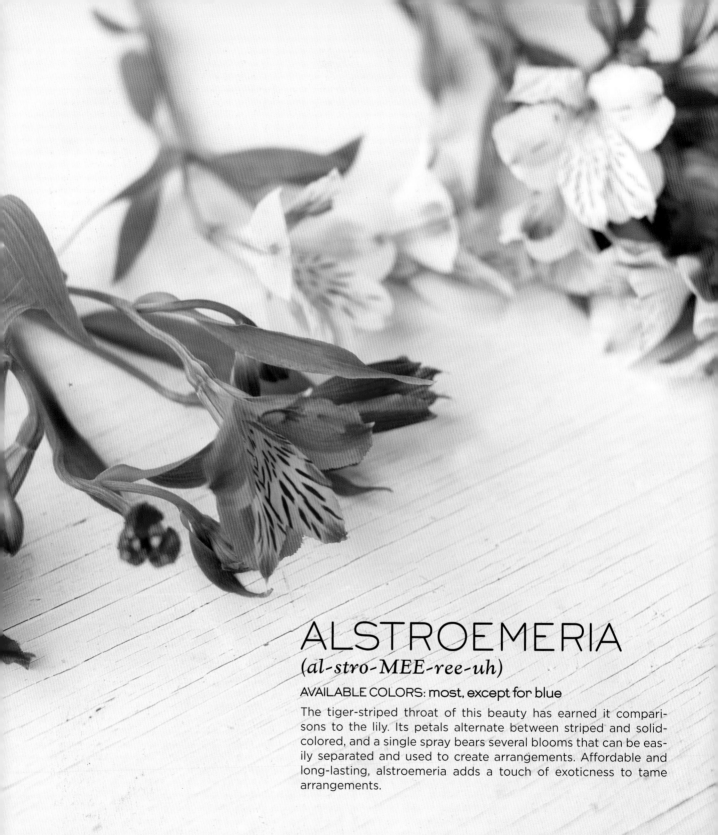

ALSTROEMERIA
(al-stro-MEE-ree-uh)

AVAILABLE COLORS: most, except for blue

The tiger-striped throat of this beauty has earned it comparisons to the lily. Its petals alternate between striped and solid-colored, and a single spray bears several blooms that can be easily separated and used to create arrangements. Affordable and long-lasting, alstroemeria adds a touch of exoticness to tame arrangements.

FLOWERS

2 sprays of
alstroemeria
(6 blooms total)

VESSEL

Vintage egg cup

1. Place a small flower frog in the cup and secure with floral putty.

2. Snip off the alstroemeria blooms from the main stems; the blooms themselves will have very short stems.

3. Trim and place one bloom facing forward so that the base of the bloom sits just inside the rim of the cup. Trim and place the next four blooms in a clockwise pattern around the rim.

4. Trim and place the last bloom in the center so that it sits slightly higher than the others.

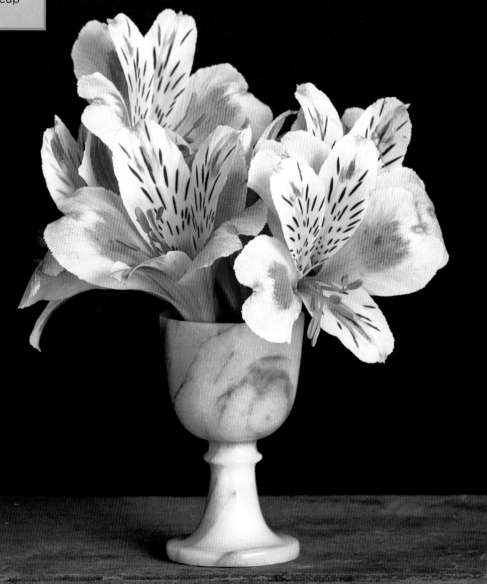

FLOWERS

3 branches of maple

3 stems of sedum

3 sprays of
alstroemeria

1 stem of
kangaroo paw

VESSEL

Handmade
ceramic vase

1 | Choose a vase with colors that match or highlight the alstroemeria's intense color.

 Trim the maple branches to approximately two times the height of the vase and then place inside.

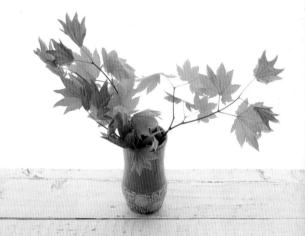

 Trim and add two of the sedum stems at the front of the vase so that their heads sit 2 inches out from the rim. Add the third sedum stem to the center so that it sits a few inches higher than the others.

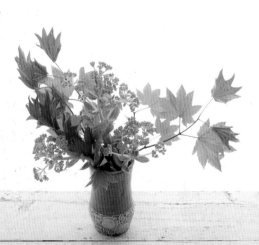

4 Trim the alstroemeria stems and nestle two sprays so that they face out between the sedum at the front and right side of the composition. Add the remaining spray of alstroemeria on the back left side so that the tops of the blooms rest a few inches above the tallest sedum. Finish by trimming the stem of kangaroo paw and adding it to the right side, mirroring the height of the alstroemeria on the left.

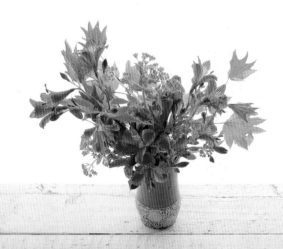

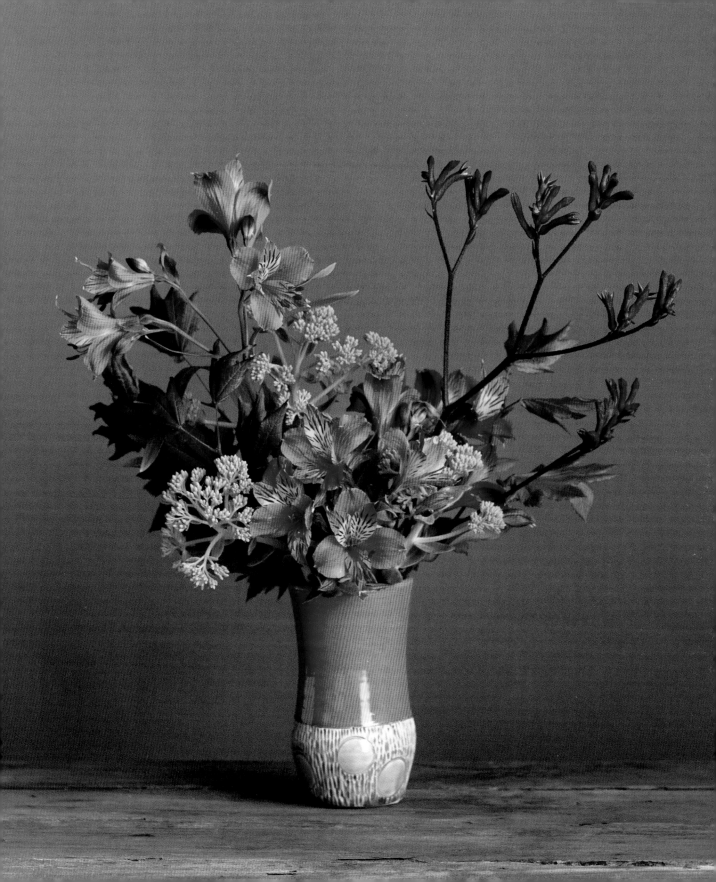

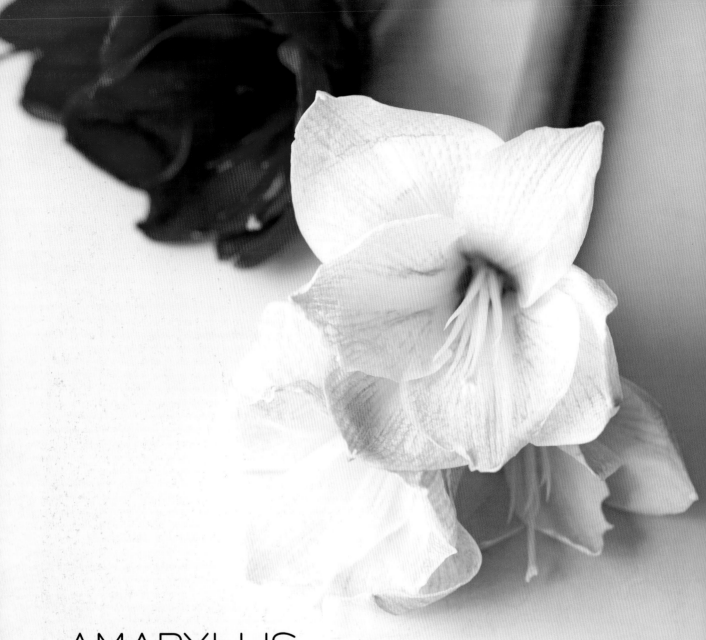

AMARYLLIS
(am-uh-RIL-is)

AVAILABLE COLORS: most, except for blue

This focal flower is characterized by star-shaped blooms that flare out in a cluster atop a long, smooth stem. Reds are extremely popular around the winter holidays, but the striped, bicolored, and mottled varieties also make big splashes in autumn arrangements. Amaryllis have delicate, hollow stems, so be mindful to not crush them when placing them in an arrangement.

RECIPE 1:
ON ITS OWN

———

FLOWERS
2 stems of amaryllis
with 5 blooms

VESSEL
Vintage
wooden box

1. Trim the amaryllis blooms from their stems and place each bloom
 in a water tube.

2. Add the blooms to the box so that the shortest bloom faces
 upward at the far right, one is in the center, and the remaining
 blooms are clustered at the left side.

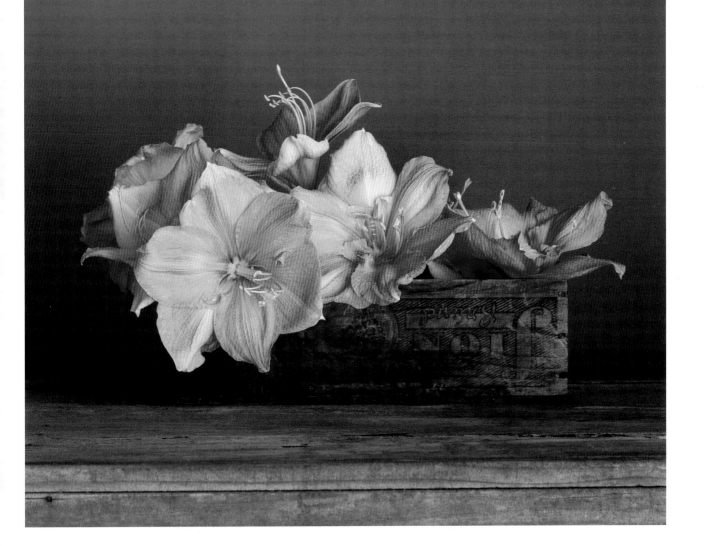

AMARYLLIS
RECIPE 2:
WITH COMPANY

FLOWERS

5 branches of cedar

5 branches of
snowberry

1 stem of kale

1 stem of amaryllis
with multiple
blooms

1 orchid

VESSEL

Vintage can
with liner

Select a can with
festive colors for
a casual, cheerful
holiday arrangement.

2 Trim and add the branches of cedar
to create a base, placing the two
longest branches so that they arc out
on the left side of the vase. Trim and
place the three longest branches of
snowberry in the can so that they arc
out on the left side; then place the
remaining two branches in the center
at the front and back.

3 Trim and add the stem of kale to the
right side so that the bottom of the
bloom rests on the rim of the can.

4 Trim the stem of amaryllis and place
it in the center of the arrangement so
that the blooms are facing out. Finish
by trimming and adding the orchid
to the center of the arrangement
between the amaryllis and the kale,
so that the tops of the blooms sit
above the rest of the elements.

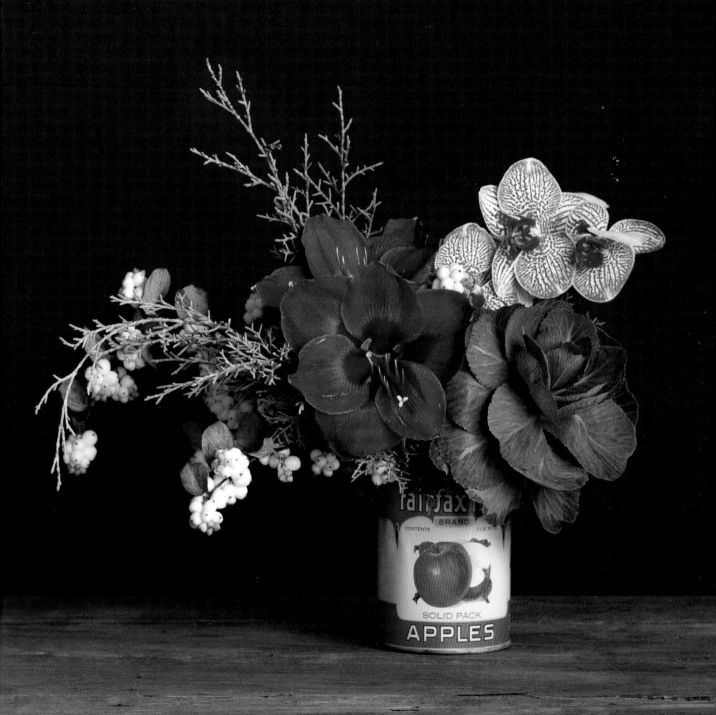

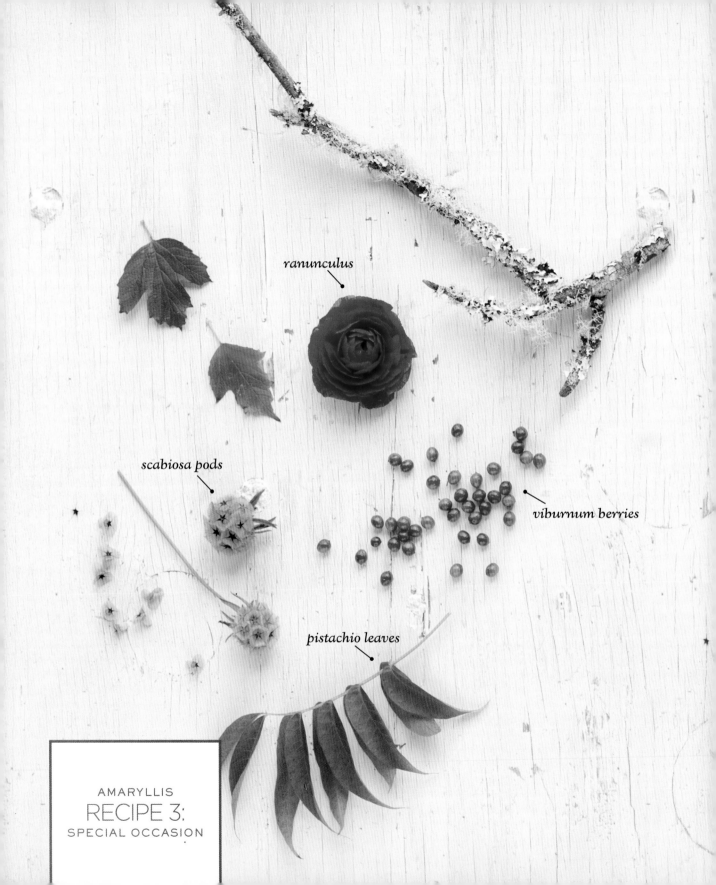

ranunculus

scabiosa pods

viburnum berries

pistachio leaves

AMARYLLIS
RECIPE 3:
SPECIAL OCCASION

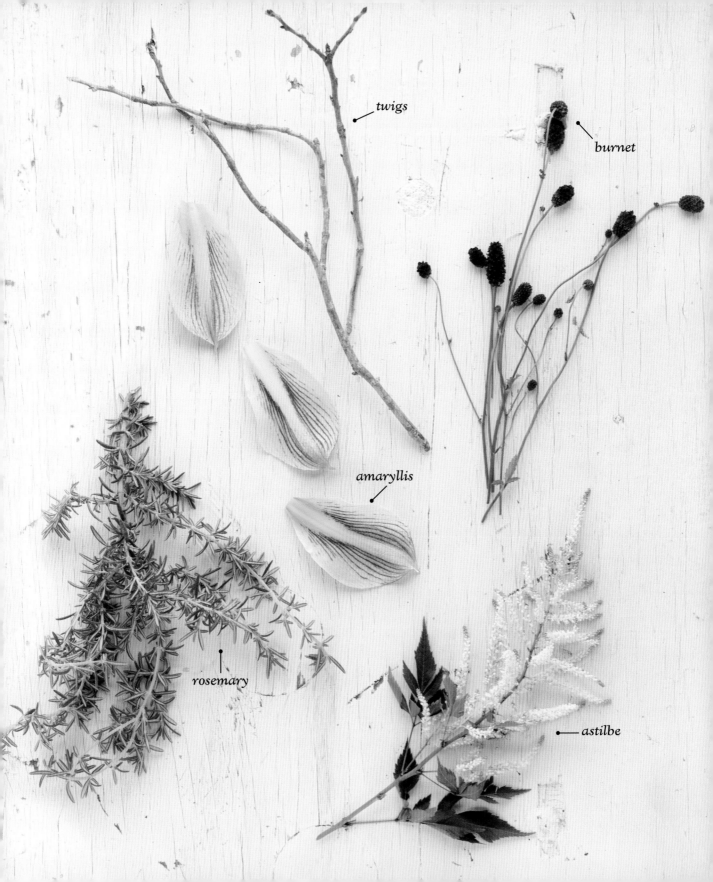

twigs

burnet

amaryllis

rosemary

astilbe

AMARYLLIS
RECIPE 3:
SPECIAL OCCASION

FLOWERS

3 stems of pistachio leaves

6 stems of rosemary

2 branches of viburnum berries

3 twigs

2 stems of amaryllis

5 stems of ranunculus

5 stems of astilbe

7 stems of scabiosa pods

2 sprays of burnet

VESSEL

Vintage flour tin

1 Trim and add the pistachio leaves and stems of rosemary so that they cascade over the rim of the tin on opposite sides.

2 Place one trimmed branch of viburnum berries to the front center, and the other to the left behind the rosemary so that the berries rest a few inches above the rim.

3 Trim the stems of amaryllis, clustering the blooms on the right side of the tin.

4 Trim the stems of ranunculus and add them in a cluster to the left side of the arrangement next to the amaryllis blooms.

5 Trim two stems of astilbe and place them next to the ranunculus. Add the remaining stems of astilbe on the right side, trimming the stems so that the tips of the blooms sit at the highest place in the composition.

6 Trim two stems of scabiosa pods to a similar height and add next to the amaryllis on the right side of the arrangement. Trim the remaining stems so that the blooms sit at different heights on the left side, with the longest stem mirroring the tallest astilbe.

7 Add two of the twigs so that they arc out on the left side above the other ingredients, and the remaining twig on the right side under the astilbe.

8 Finish by adding the trimmed sprays of burnet to the upper right side of the arrangement.

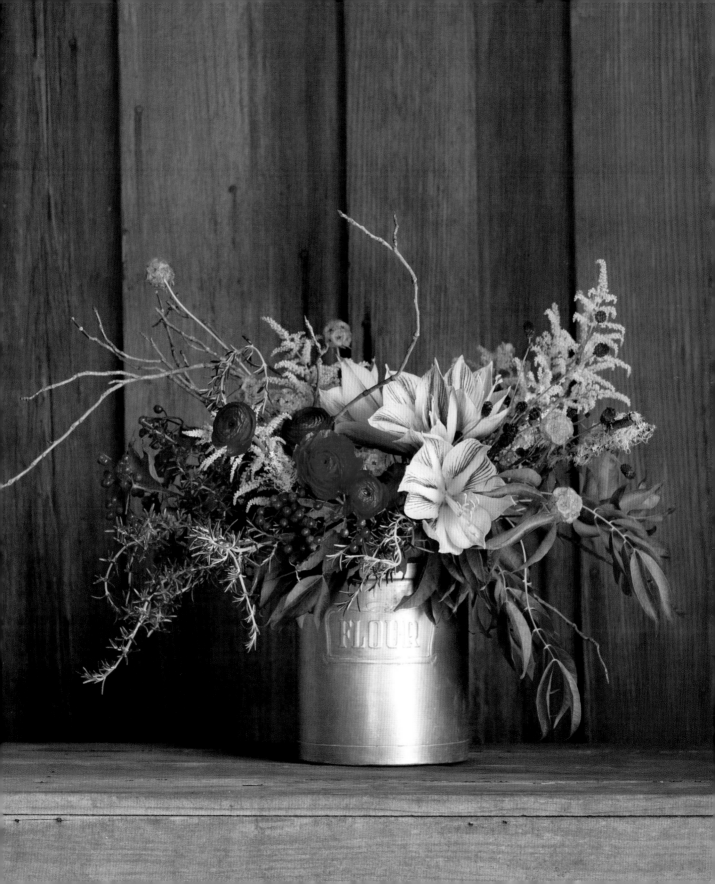

ANEMONE *(ah-NEM-oh-nee)*

AVAILABLE COLORS: blue, pink, purple, red, white

Anemones sport cute black (sometimes green) button centers and frilly petal collars. They can be challenging to use in arrangements when they have really bendy stems, but the right display accentuates their curves. Their delicate, hollow stems will rot quickly in deep water, so make sure to add only a few inches to the vessel you'll be using.

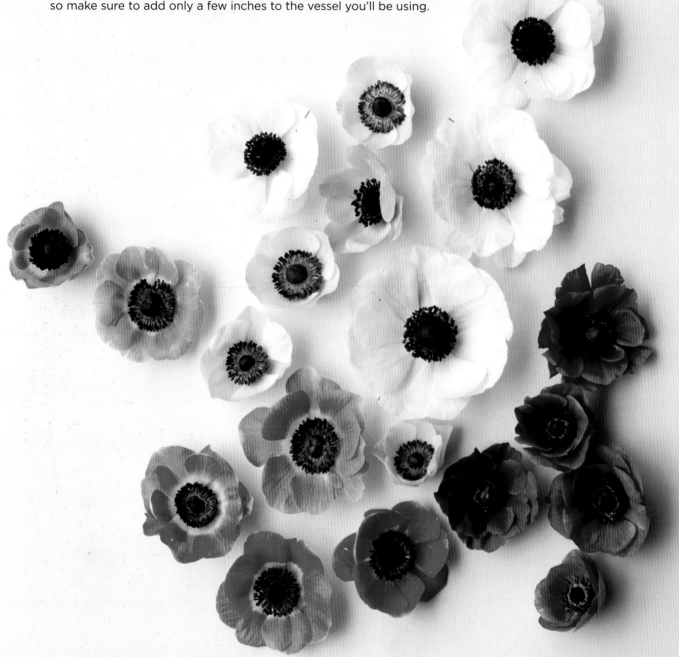

ANEMONE
RECIPE 1:
WITH COMPANY

———

FLOWERS
3 stems of geranium

4 stems of agonis

7 stems of anemone

3 jasmine vines

VESSEL
Vintage sugar bowl

1. Trim and place the geranium stems and agonis so that the lowest leaves rest at the rim of the bowl.

2. Trim and add five stems of anemone to rest on the geranium leaves in the center of the bowl and the remaining two stems so that they're a few inches higher on the left and right.

3. Trim and tuck in the vines of jasmine so that two drape over the edges of the bowl and one reaches out to the top of the arrangement.

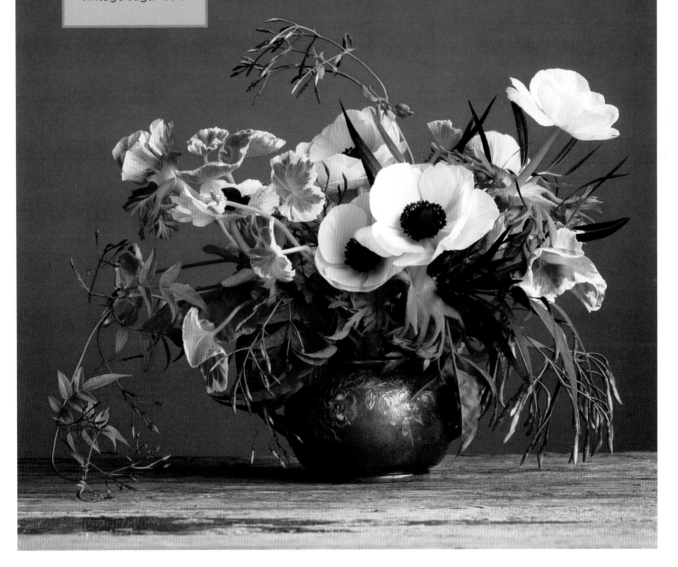

ANEMONE
RECIPE 2:
ON ITS OWN

———

FLOWERS

20 stems of red anemone

5 stems of white anemone

VESSEL

Footed, clear glass cylinder

1 | Choose a clear glass cylinder that will showcase the architecture of the stems. Create a tape grid (see page 17) across the top of the cylinder, with holes that are the same size as the anemone stems. Add a small amount of water to the vase.

2 | Trim and add the curviest red anemone stems first, angling them through the outer holes of the grid to cascade over the front and sides of the cylinder.

3 | Next, trim and add the tallest, straightest red stems through the center holes of the grid.

4 | Finish by trimming and adding the white blooms to fill in any spaces.

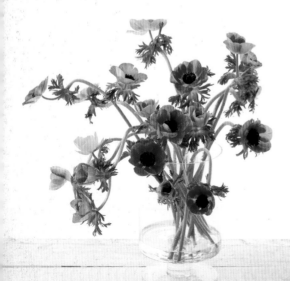
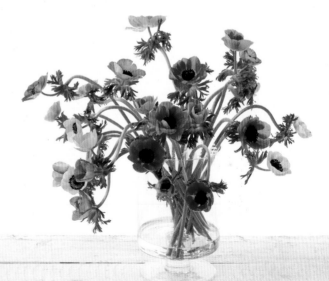

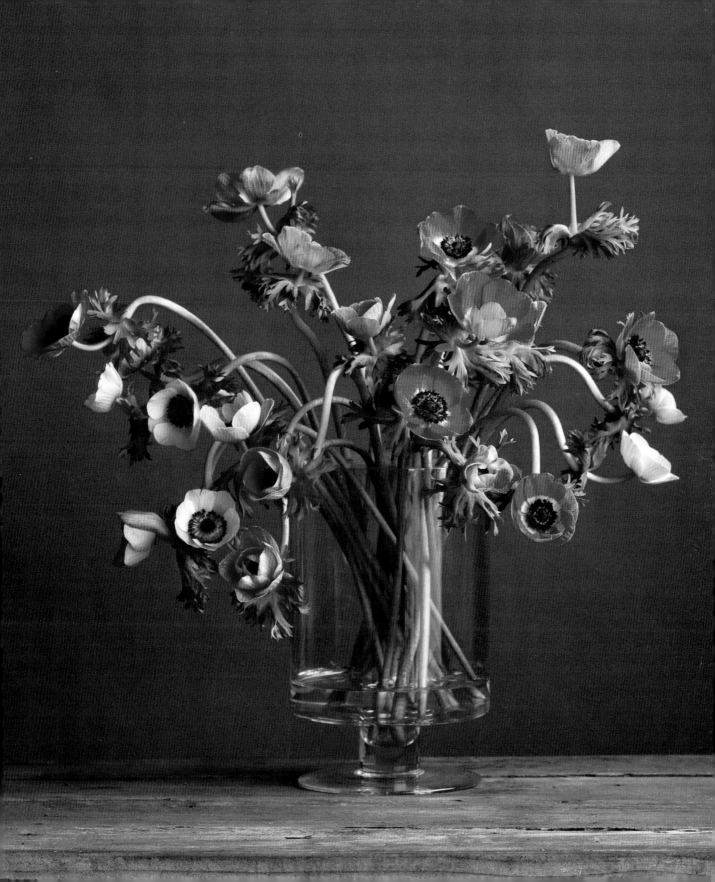

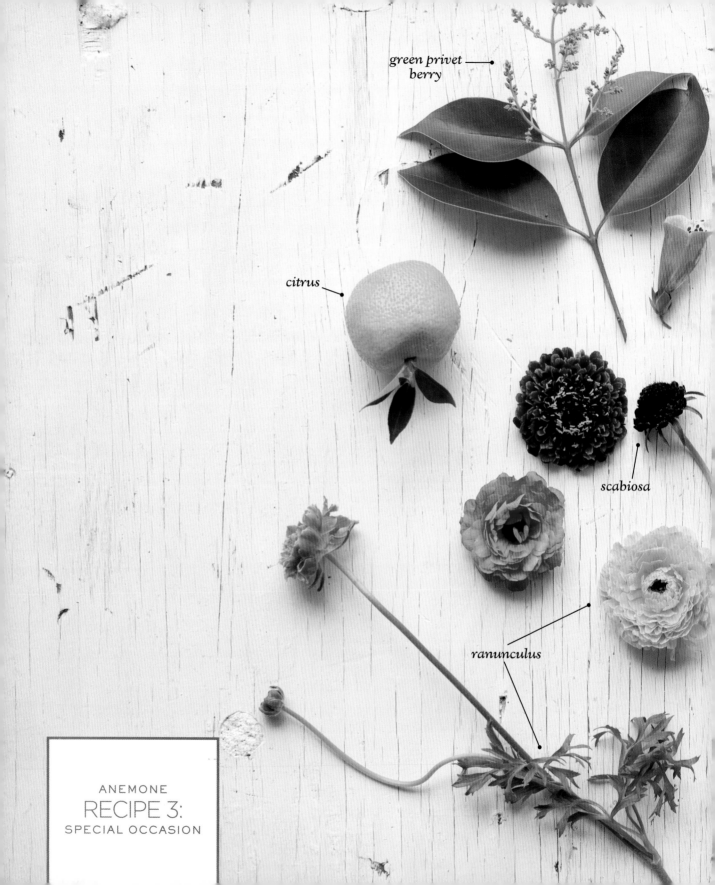

green privet
berry

citrus

scabiosa

ranunculus

ANEMONE
RECIPE 3:
SPECIAL OCCASION

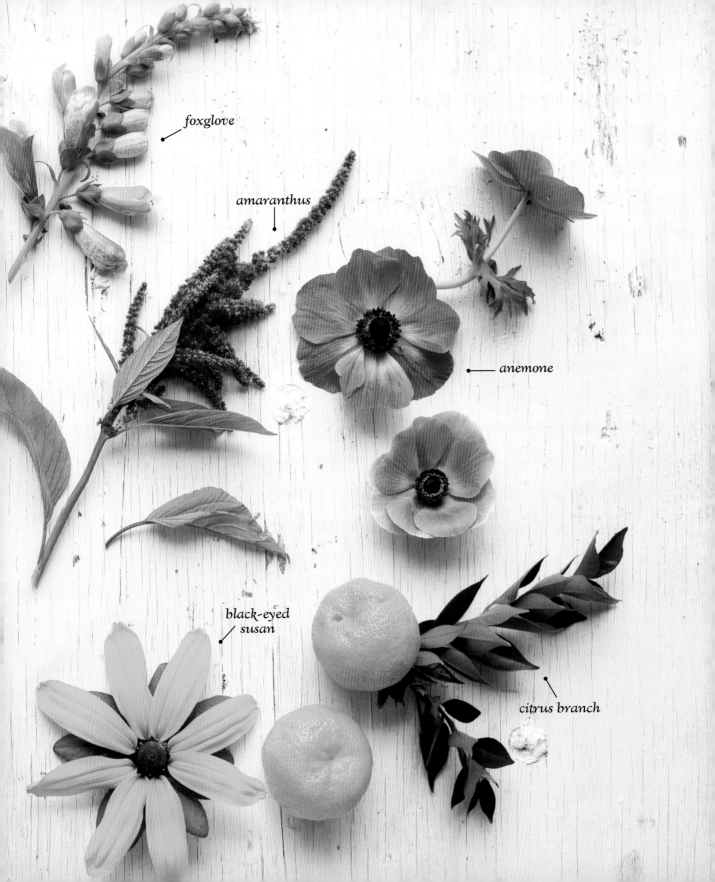

foxglove

amaranthus

anemone

black-eyed
susan

citrus branch

RECIPE 3:

SPECIAL OCCASION

FLOWERS

3 citrus branches

3 stems of amaranthus

5 stems of green privet berry

2 stems of black-eyed Susan

3 stems of foxglove

8 stems of anemone

5 stems of ranunculus

5 stems of scabiosa

VESSEL

Mercury glass footed bowl

1 Use floral putty to affix a large flower frog to the bottom of the bowl.

2 Start by trimming and placing the citrus branches in the bowl, letting the fruit rest at the rim. Remove and reserve a few citrus fruits to add later.

3 Trim and add the hanging amaranthus so that it drapes down over the rim between the citrus branches.

4 Trim and place the stems of privet in the bowl so that the lowest leaves sit at the rim, slightly behind the citrus and amaranthus. The tips of the berries will be at different heights.

5 Skewer and place the additional pieces of citrus in the center of the composition, a few inches above rim level.

6 Trim and nestle the black-eyed Susan stems between the citrus fruit at the center and on the right side.

7 Trim the foxglove stems so that the tips arc above the rest of the flowers, and add them to the right side of the arrangement.

8 Trim and place the stems of anemone and ranunculus next, filling the space between the foxgloves and the rest of the flowers. Taller stems of anemone should somewhat balance the foxgloves on the opposite side of the bowl. Turn the stems so that the faces of the blooms angle up and out.

9 Finish with the stems of scabiosa, trimmed, filling in empty spaces with this dark element to echo the centers of the anemone.

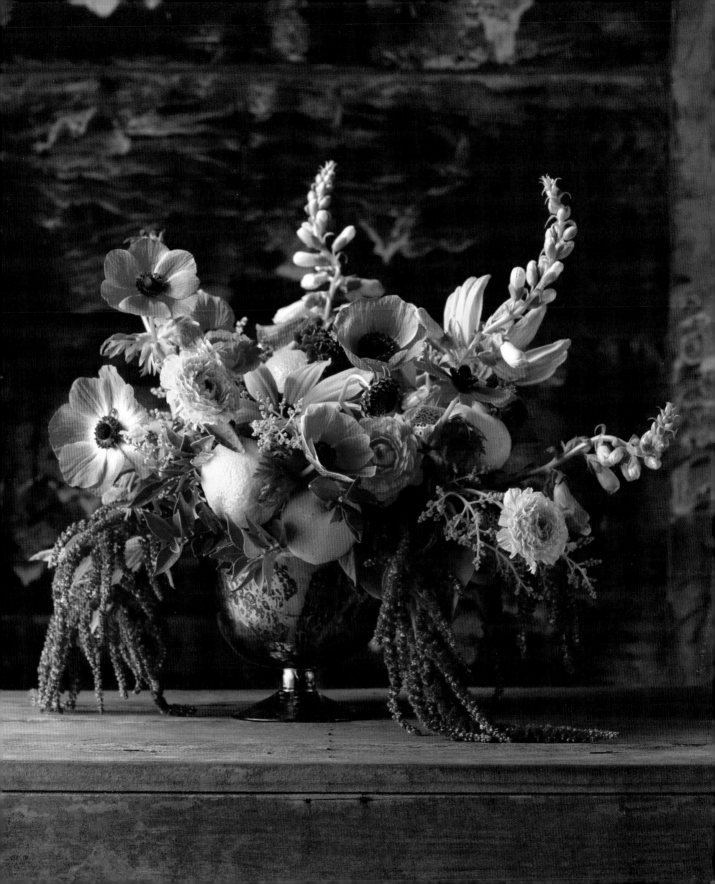

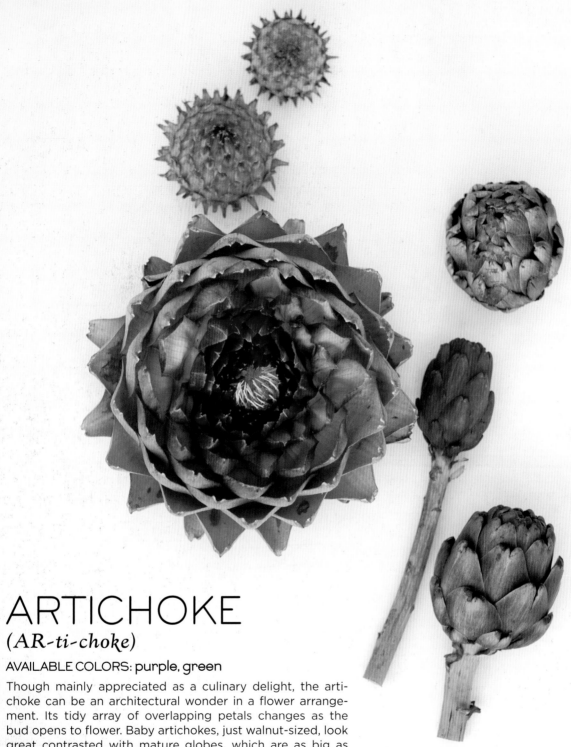

ARTICHOKE
(AR-ti-choke)

AVAILABLE COLORS: purple, green

Though mainly appreciated as a culinary delight, the artichoke can be an architectural wonder in a flower arrangement. Its tidy array of overlapping petals changes as the bud opens to flower. Baby artichokes, just walnut-sized, look great contrasted with mature globes, which are as big as melons. If you can't find artichokes with stems, skewer the heads for the same effect.

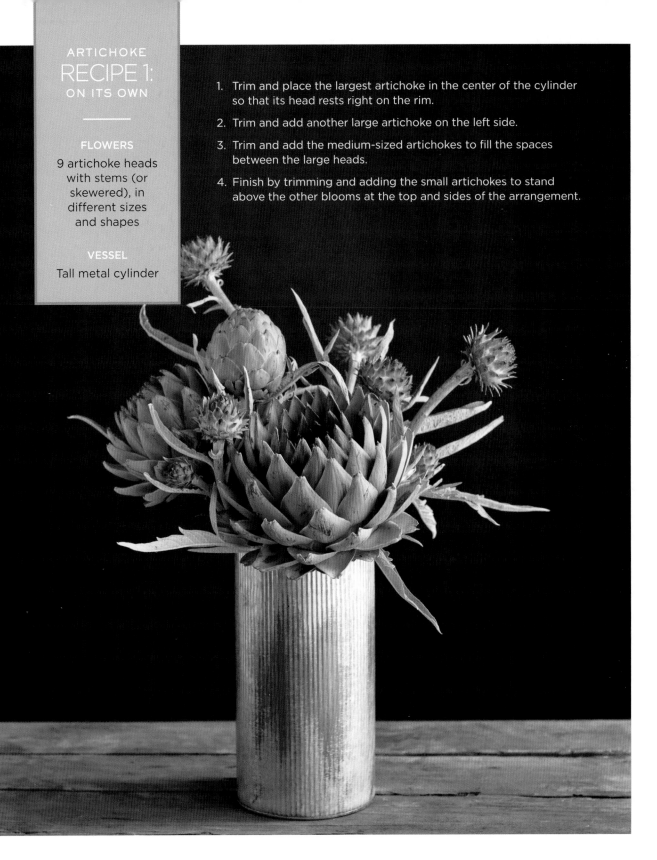

ARTICHOKE
RECIPE 1:
ON ITS OWN

FLOWERS
9 artichoke heads with stems (or skewered), in different sizes and shapes

VESSEL
Tall metal cylinder

1. Trim and place the largest artichoke in the center of the cylinder so that its head rests right on the rim.

2. Trim and add another large artichoke on the left side.

3. Trim and add the medium-sized artichokes to fill the spaces between the large heads.

4. Finish by trimming and adding the small artichokes to stand above the other blooms at the top and sides of the arrangement.

Choose a vessel with a narrow base to contain the top-heavy artichokes.

2 Trim and place the large artichokes in a low cluster in the vessel. Then trim the small artichokes so that they are a few inches taller and add them to the back.

3 Trim the borage stems and add them to the vessel, filling the spaces between the artichokes. Allow the branches to cascade over the rim and extend up on the sides.

4 Finish the arrangement by trimming and adding a cluster of roses to the right side.

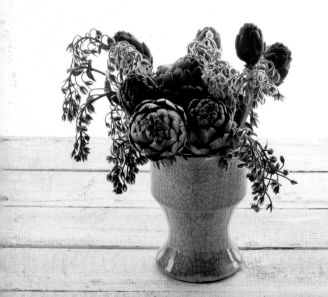

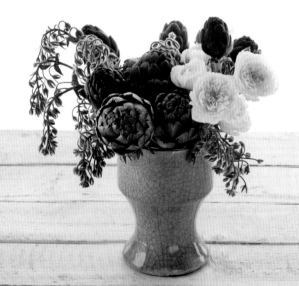

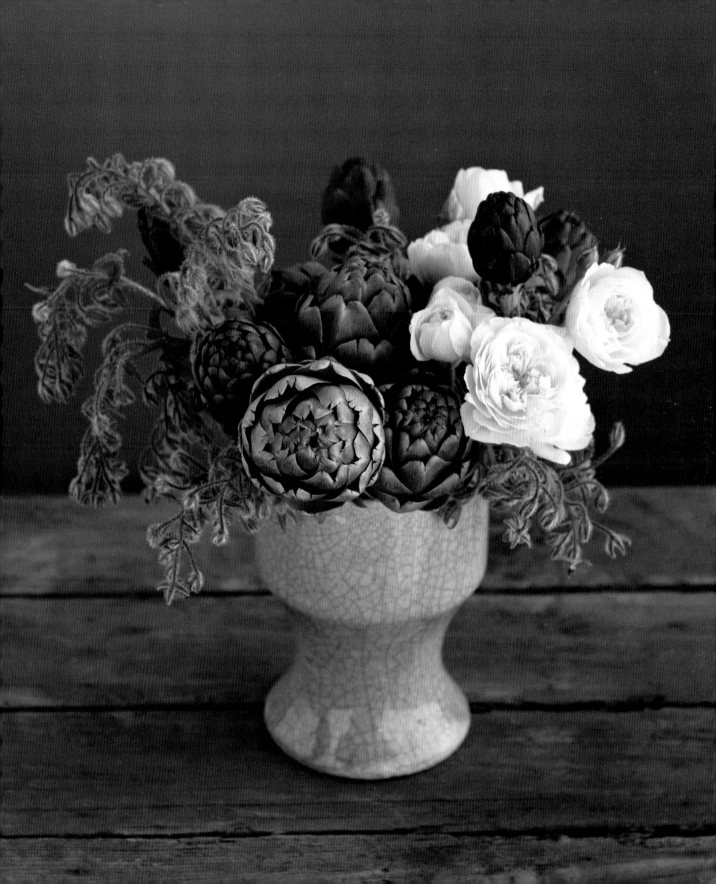

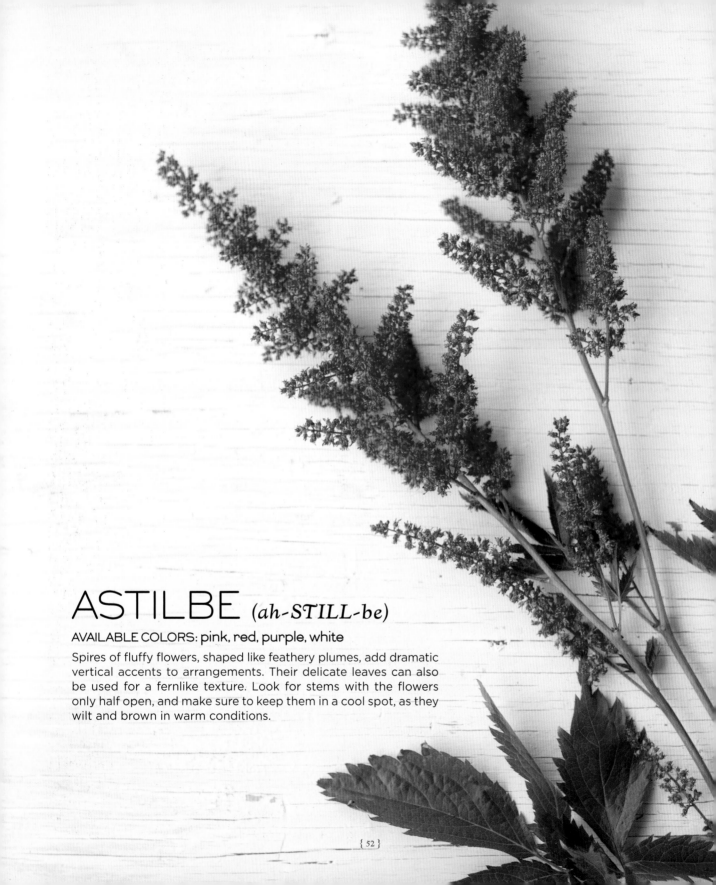

ASTILBE *(ah-STILL-be)*

AVAILABLE COLORS: pink, red, purple, white

Spires of fluffy flowers, shaped like feathery plumes, add dramatic vertical accents to arrangements. Their delicate leaves can also be used for a fernlike texture. Look for stems with the flowers only half open, and make sure to keep them in a cool spot, as they wilt and brown in warm conditions.

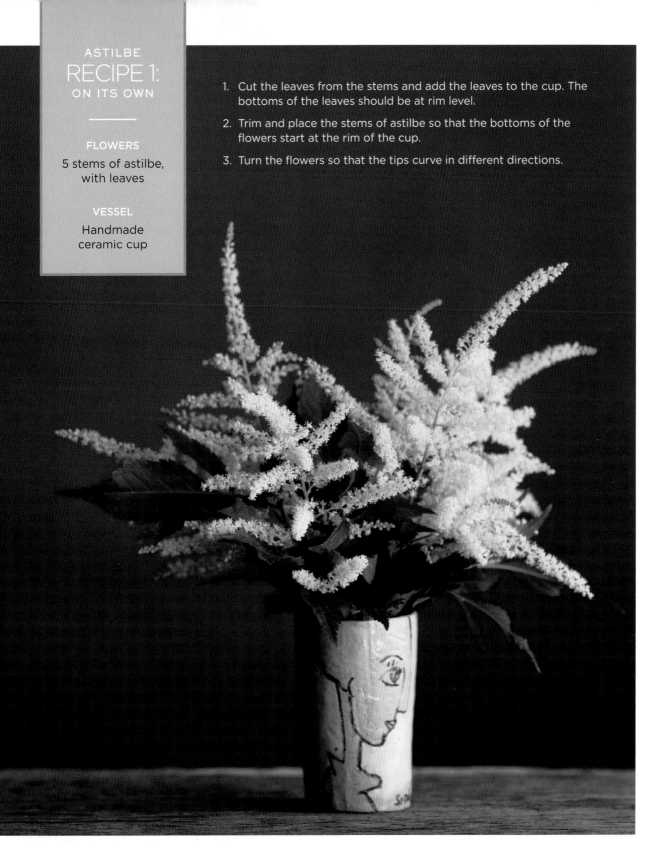

RECIPE 1:
ON ITS OWN

FLOWERS
5 stems of astilbe,
with leaves

VESSEL
Handmade
ceramic cup

1. Cut the leaves from the stems and add the leaves to the cup. The bottoms of the leaves should be at rim level.

2. Trim and place the stems of astilbe so that the bottoms of the flowers start at the rim of the cup.

3. Turn the flowers so that the tips curve in different directions.

ASTILBE
RECIPE 2:
WITH COMPANY

FLOWERS

5 stems of astilbe,
with leaves

4 stems of
pokeberry

1 stem of
cymbidium orchid

4 stems of Queen
Anne's lace

VESSEL
Metallic glass

I | Choose a glass that has the same muted palette as the flowers.

2 | Trim and add four astilbe stems so that the bases of the flowers sit at the rim of the glass. Allow the last stem to arc several inches out to the left side.

 Trim and add the stems of pokeberry as a cluster on the same side of the arrangement as the tall, arcing astilbe.

4 | Trim the orchid so that the bottom bloom will rest on the rim, and tuck it into the front of the glass. Trim one stem of the Queen Anne's lace to the same height as the tallest astilbe and add to the right side. Trim and add the remaining two stems to fill any empty spaces.

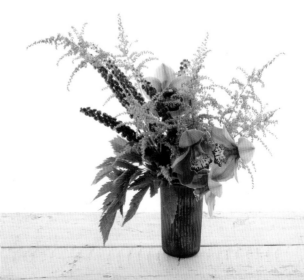

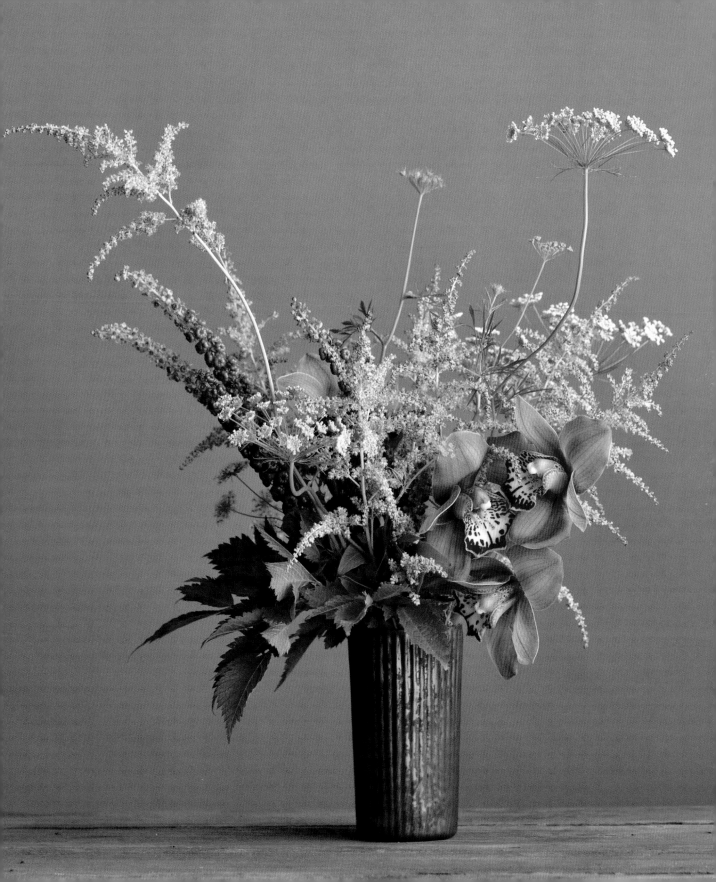

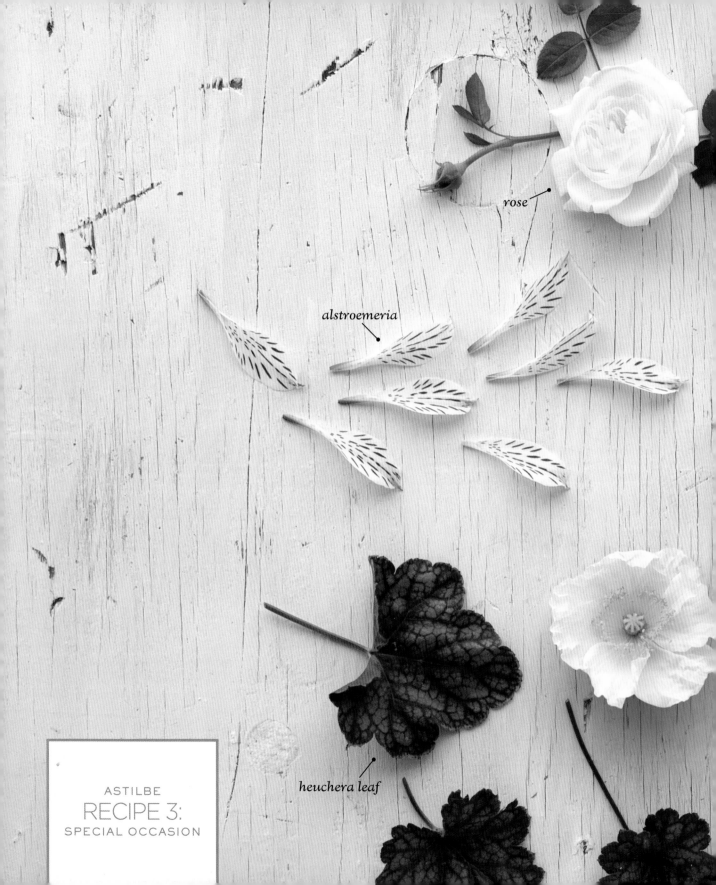

rose

alstroemeria

heuchera leaf

ASTILBE
RECIPE 3:
SPECIAL OCCASION

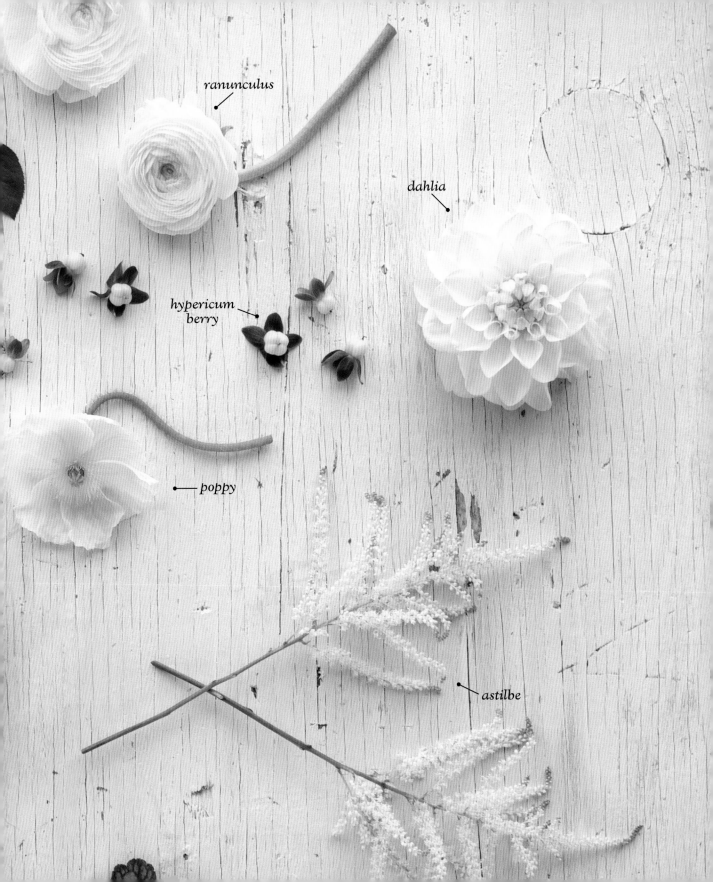

ranunculus

dahlia

*hypericum
berry*

poppy

astilbe

ASTILBE
RECIPE 3:
SPECIAL OCCASION

FLOWERS

3 sprays of alstroemeria

10 heuchera leaves

2 stems of hypericum berries

2 dahlias

3 stems of ranunculus

4 roses

5 poppies

2 stems of astilbe

VESSEL

Bark vase with liner

1 Use floral putty to affix a large flower frog to the liner of the vase.

2 Trim the sprays of alstroemeria so that the bottoms of the blooms rest at the rim of the vase, and add them to the center. Fill in around the alstroemeria blooms with the heuchera leaves and the stems of hypericum berries.

3 Trim and add the dahlias to the back of the arrangement so that the blooms rest on the rim of the vase.

4 Trim the stems of ranunculus and the roses and add a cluster of four mixed blooms in the front center and a cluster of three mixed blooms so that they hang over the rim on the right side, creating a low, mounded look.

5 Trim and burn the poppy stems (see page 15), and cluster three blooms in the center of the composition so that the bottoms of the blooms rest on the flowers below. Add the remaining two poppies to the left side so that the blooms arc out and upward several inches above the mounded flowers.

6 Add one stem of astilbe to the center, trimming it so that the tip arcs out to the right and balances the long poppies on the left. Finish by placing the remaining stem of astilbe next to the first, trimming it to the same height but facing to the left.

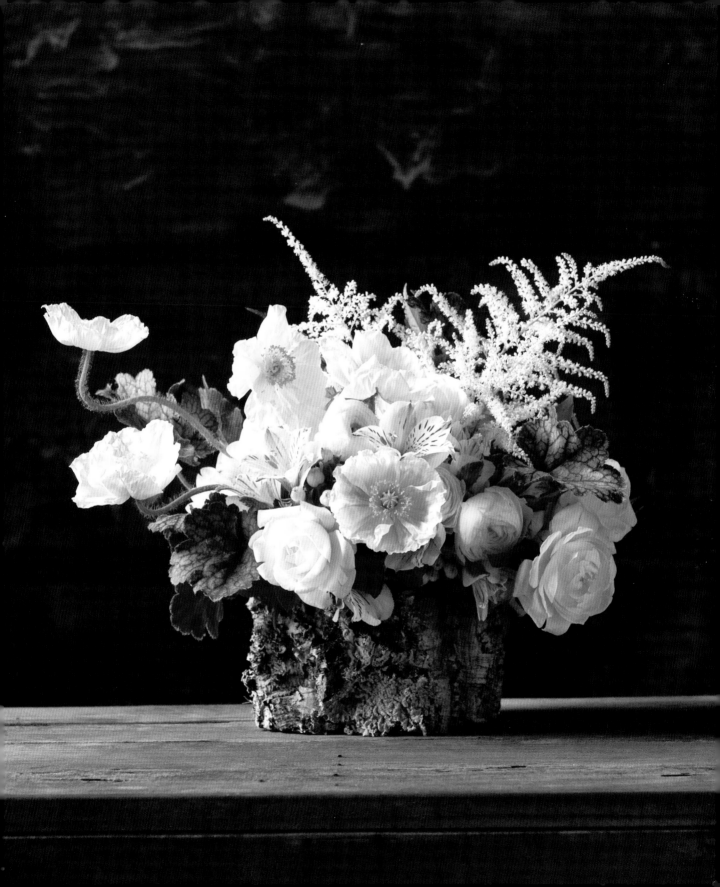

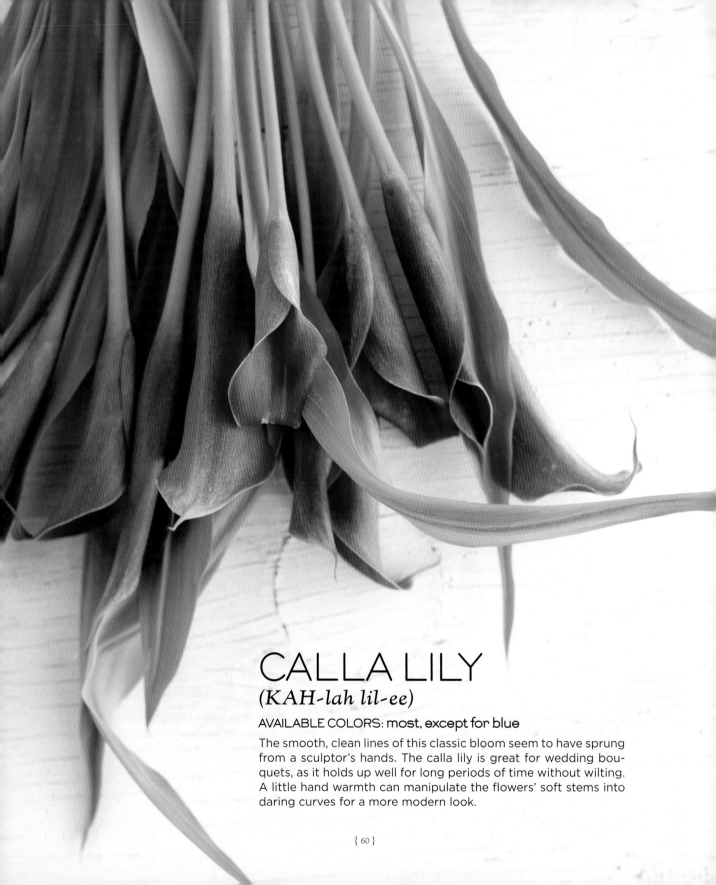

CALLA LILY
(KAH-lah lil-ee)

AVAILABLE COLORS: most, except for blue

The smooth, clean lines of this classic bloom seem to have sprung from a sculptor's hands. The calla lily is great for wedding bouquets, as it holds up well for long periods of time without wilting. A little hand warmth can manipulate the flowers' soft stems into daring curves for a more modern look.

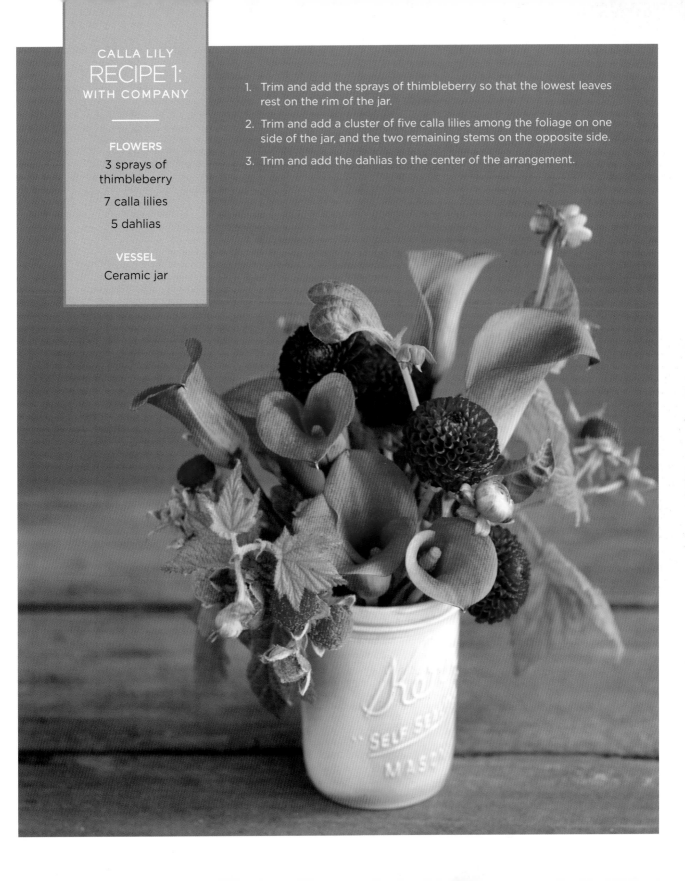

CALLA LILY
RECIPE 1:
WITH COMPANY

———

FLOWERS

3 sprays of
thimbleberry

7 calla lilies

5 dahlias

VESSEL

Ceramic jar

1. Trim and add the sprays of thimbleberry so that the lowest leaves rest on the rim of the jar.

2. Trim and add a cluster of five calla lilies among the foliage on one side of the jar, and the two remaining stems on the opposite side.

3. Trim and add the dahlias to the center of the arrangement.

RECIPE 2:
ON ITS OWN

FLOWERS
20 to 30 calla lilies

VESSEL
Cylindrical vase

1 Choose a cylindrical vase to use as a hidden structure onto which you will affix the stems. Calculate the number of stems you'll need to totally surround the outside of the vase by dividing the circumference of the vase by the average stem width. It is helpful to have extra stems on hand in case of miscalculation.

2 Thoroughly dry each stem. Apply glue to the outside of the vase in a 1-inch vertical strip. Let the glue become tacky, then line up the first few flower stems over the strip of glue. Hold in place until the stems are secure.

3 Continue applying strips of glue and stems, keeping the base of the flowers at the same level (the stems can hang over the bottom). Make sure the stems lie straight and are right next to one another without any gaps. Repeat until you have surrounded the entire vase.

4 Trim the bottom of the stems to line up with the bottom of the vase, allowing the tower to stand on its own. The flowers can stay out of water for several hours but can also be placed on a low tray with a small amount of water to last much longer.

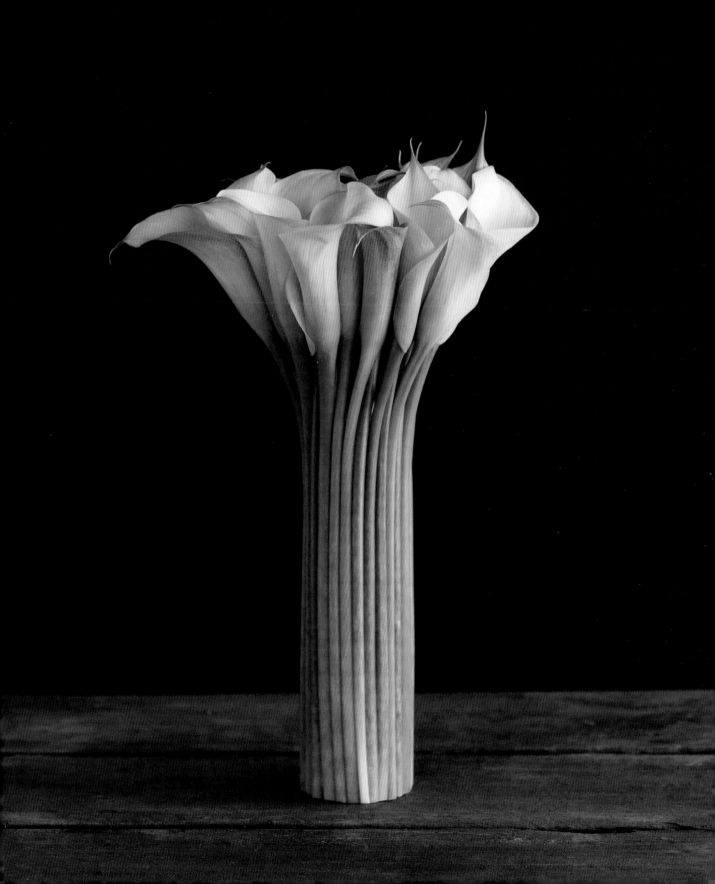

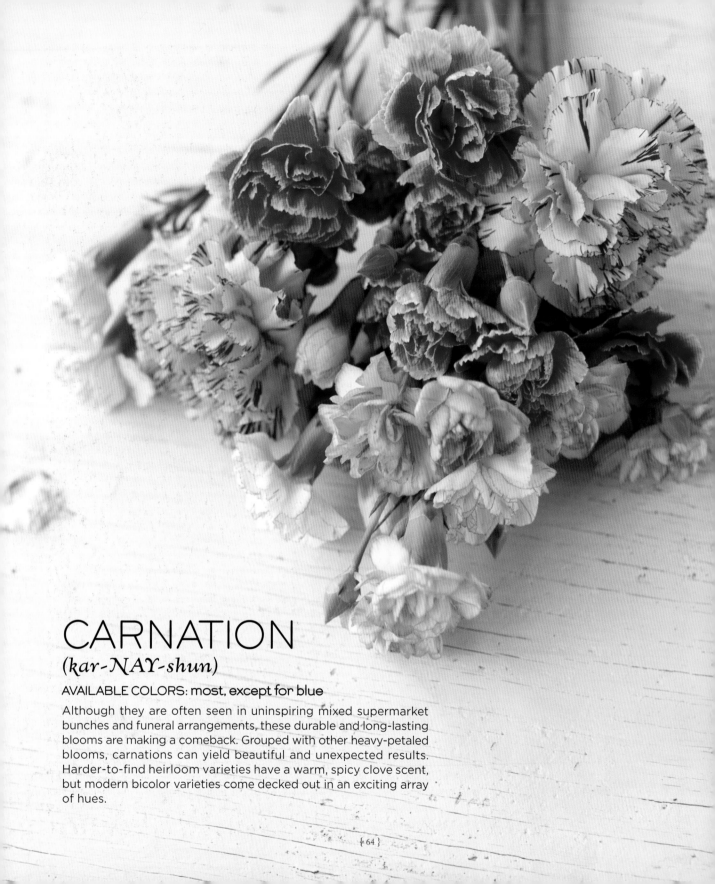

CARNATION
(kar-NAY-shun)

AVAILABLE COLORS: most, except for blue

Although they are often seen in uninspiring mixed supermarket bunches and funeral arrangements, these durable and long-lasting blooms are making a comeback. Grouped with other heavy-petaled blooms, carnations can yield beautiful and unexpected results. Harder-to-find heirloom varieties have a warm, spicy clove scent, but modern bicolor varieties come decked out in an exciting array of hues.

CARNATION
RECIPE 1:
WITH COMPANY

FLOWERS
12 carnations

3 dahlias

4 sprays of
minicarnations

3 stems of rose hip

7 stems of gaillardia

VESSELS
2 canning jars,
1 large and 1 small

1. Trim and add eight carnations and the dahlias to the large jar so that the blooms rest at rim level to create a mound effect.

2. Trim and add three minicarnation sprays between the dahlias so that the lowest bloom starts at the rim of the jar. Nestle in two of the rose hip stems to fill any empty spaces.

3. Trim and add four stems of gaillardia so that the blooms float a few inches above the other flowers.

4. Repeat using the remaining ingredients and the small jar.

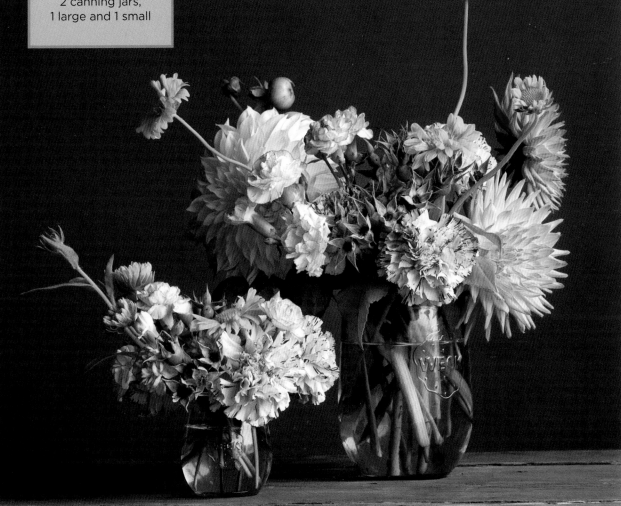

CARNATION
RECIPE 2:
ON ITS OWN

FLOWERS
50 to 75
minicarnations,
in assorted colors

MATERIALS
Embroidery or lei-
making needle

Monofilament or
waxed thread

1 | Snip the blooms from their stems, keeping the green base of each flower intact. Thread the needle with the desired length of thread.

2 | Insert the needle into the first bloom through the center of the petal side, so that it comes out in the middle of the green base. Add the next few blooms, varying the colors.

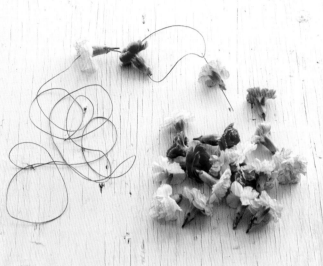

3 | Pull the blooms all the way down the thread, leaving enough thread on the end to hang the completed garland.

4 | Continue the process until all the blooms have been strung and the garland reaches the desired length.

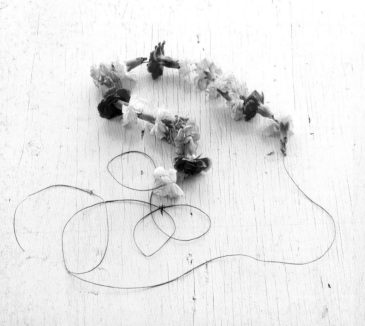
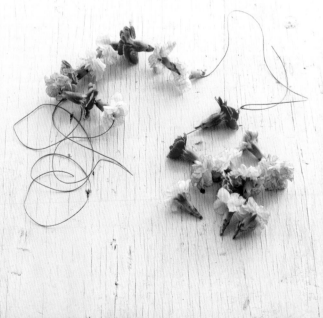

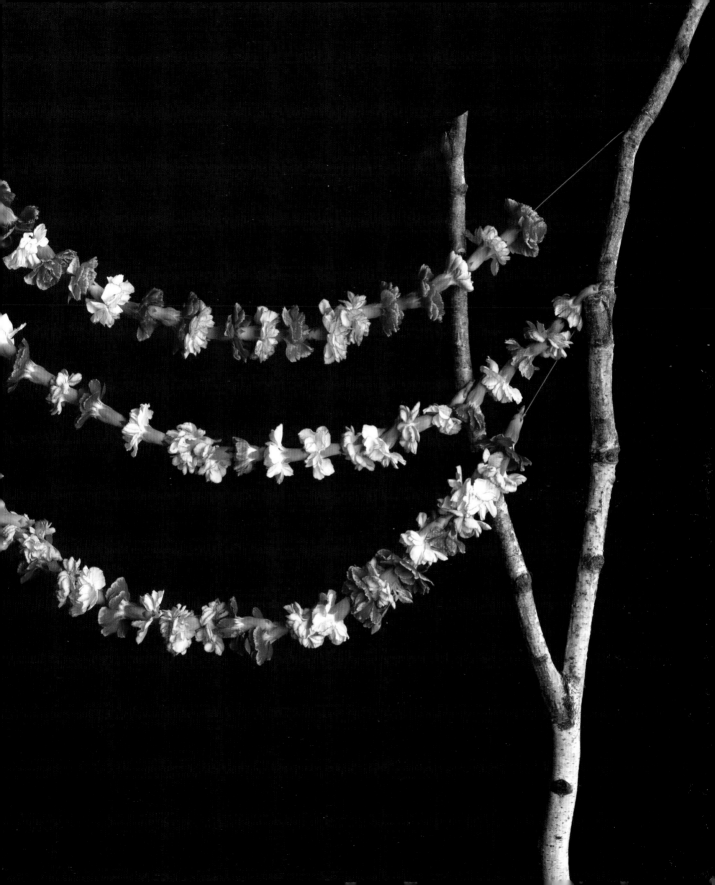

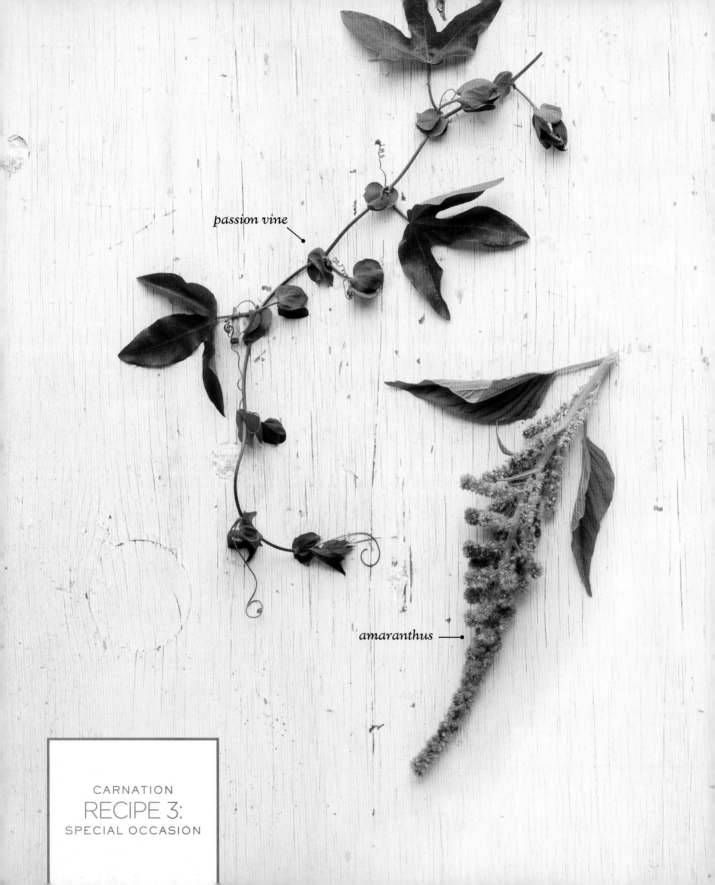

passion vine

amaranthus

CARNATION
RECIPE 3:
SPECIAL OCCASION

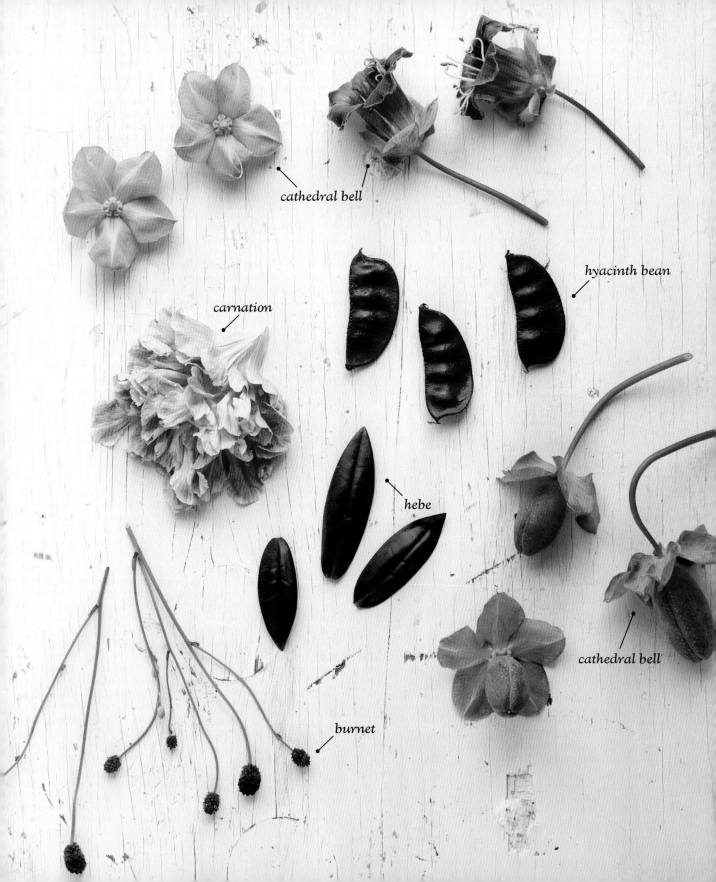

cathedral bell

hyacinth bean

carnation

hebe

cathedral bell

burnet

RECIPE 3:
SPECIAL OCCASION

FLOWERS

3 stems of passion vine

8 vines of cathedral bells with fruits and flowers

2 stems of amaranthus

2 stems of hebe

3 stems of burnet

2 carnations

3 stems of hyacinth beans

VESSEL

Silver trophy urn

1 Trim and add the stems of passion vine in a cluster so that they cascade down the right side of the urn and onto the table surface.

2 Group the vines of cathedral bells with fruits in your hand, lining up the lowest level of leaves. Twist a rubber band around the stems, trim, and add the bunch to the left side of the urn so that the fruits hang low over the rim. Repeat with the cathedral bell vines that have flowers and add them to the urn above the first bunch.

3 Trim and add the two amaranthus stems to the back, arcing one stem up to the left and the other stem down to the right. Trim and add the stems of hebe to fill the back center of the arrangement.

4 Group the stems of burnet in your hand, trim, and add as a cluster high on the right side of the composition.

5 Trim and add the carnations, clustering them above the cathedral bell blooms. Finish by trimming and adding the stems of hyacinth beans, placing one to arc out on the left side next to the carnations, and the remaining stems so that they rest on the lower right rim of the urn next to the passion vine.

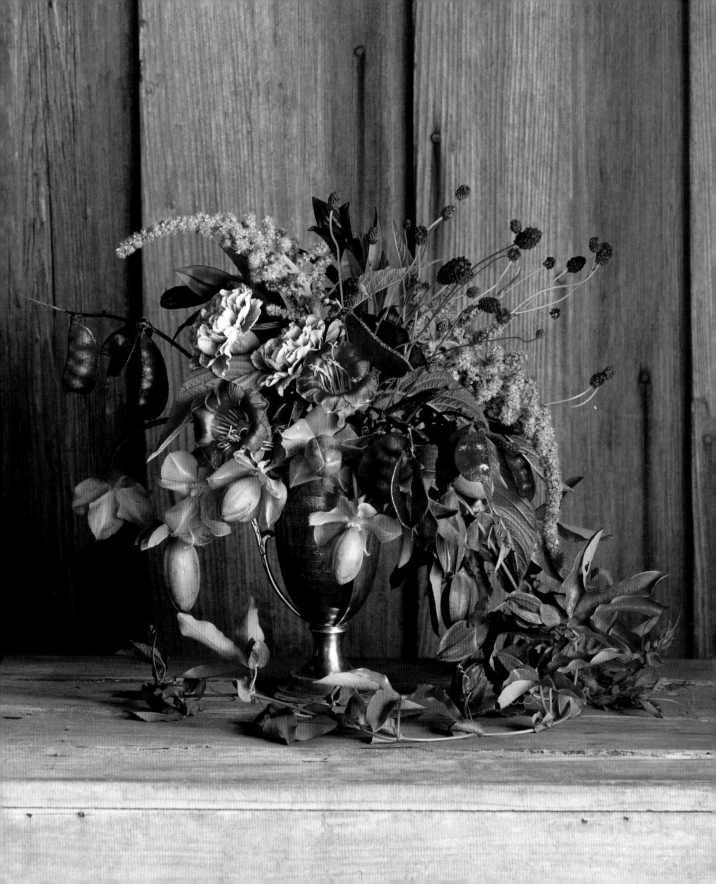

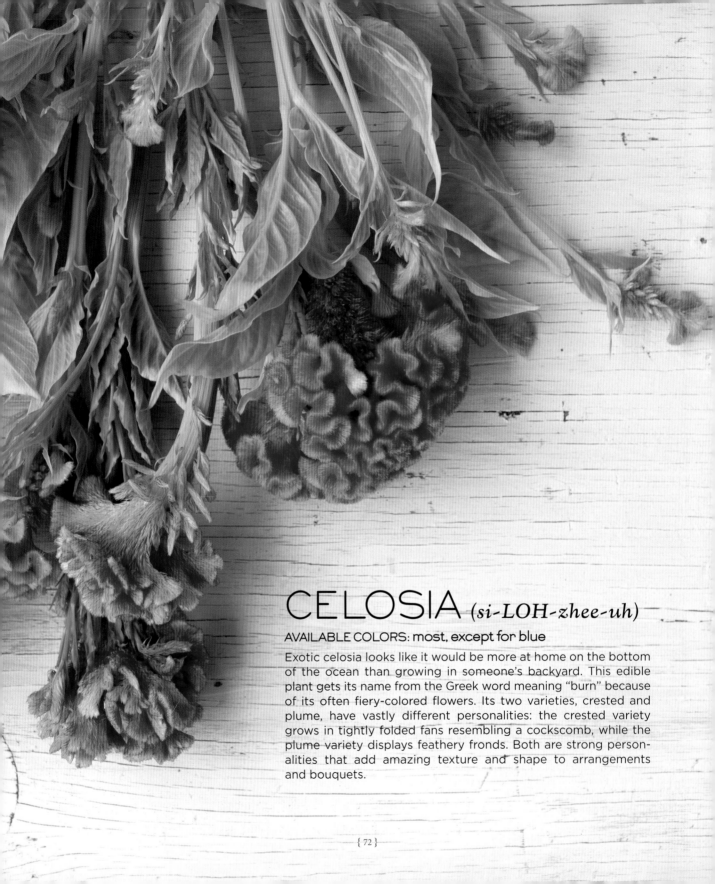

CELOSIA *(si-LOH-zhee-uh)*

AVAILABLE COLORS: most, except for blue

Exotic celosia looks like it would be more at home on the bottom of the ocean than growing in someone's backyard. This edible plant gets its name from the Greek word meaning "burn" because of its often fiery-colored flowers. Its two varieties, crested and plume, have vastly different personalities: the crested variety grows in tightly folded fans resembling a cockscomb, while the plume variety displays feathery fronds. Both are strong personalities that add amazing texture and shape to arrangements and bouquets.

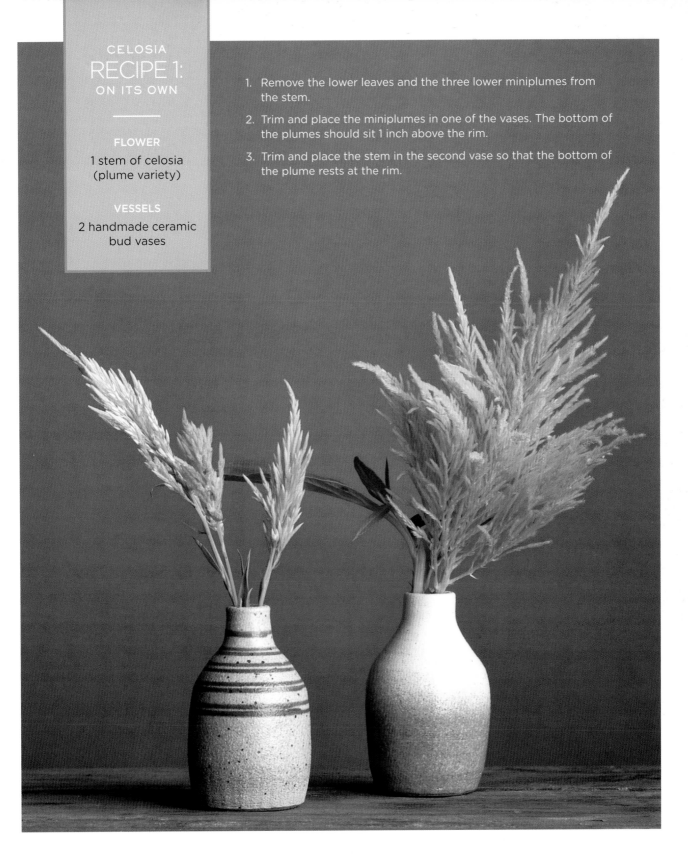

CELOSIA
RECIPE 1:
ON ITS OWN

———

FLOWER
1 stem of celosia
(plume variety)

VESSELS
2 handmade ceramic
bud vases

1. Remove the lower leaves and the three lower miniplumes from the stem.

2. Trim and place the miniplumes in one of the vases. The bottom of the plumes should sit 1 inch above the rim.

3. Trim and place the stem in the second vase so that the bottom of the plume rests at the rim.

FLOWERS

3 dahlias

5 stems of celosia
(crested variety)

2 stems of
hydrangea

2 sprays of
candy cap

VESSEL

Handmade
ceramic cup

1 | Select a low, squat cup to create a full, rounded arrangement.

2 Trim the dahlias so that the blooms sit about 3 inches above the rim of the cup. Add to the cup, angling one out to the right and two out to the left.

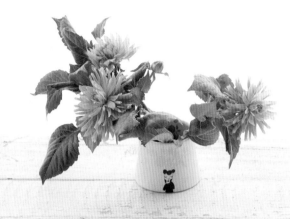

3 Trim the stems of celosia so that they stand at approximately the same height as the dahlias, and add them between the dahlias in the center of the arrangement.

4 Trim the stems of hydrangea so that they are approximately the same height as the dahlias, dip the stems in alum (see page 15), and add them to the right side of the cup. Finish by trimming and adding the stems of the candy cap so that the blooms sit about an inch above the other flowers.

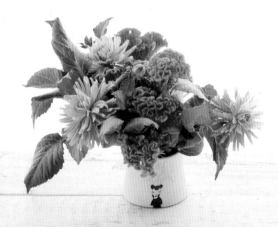

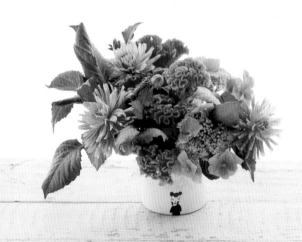

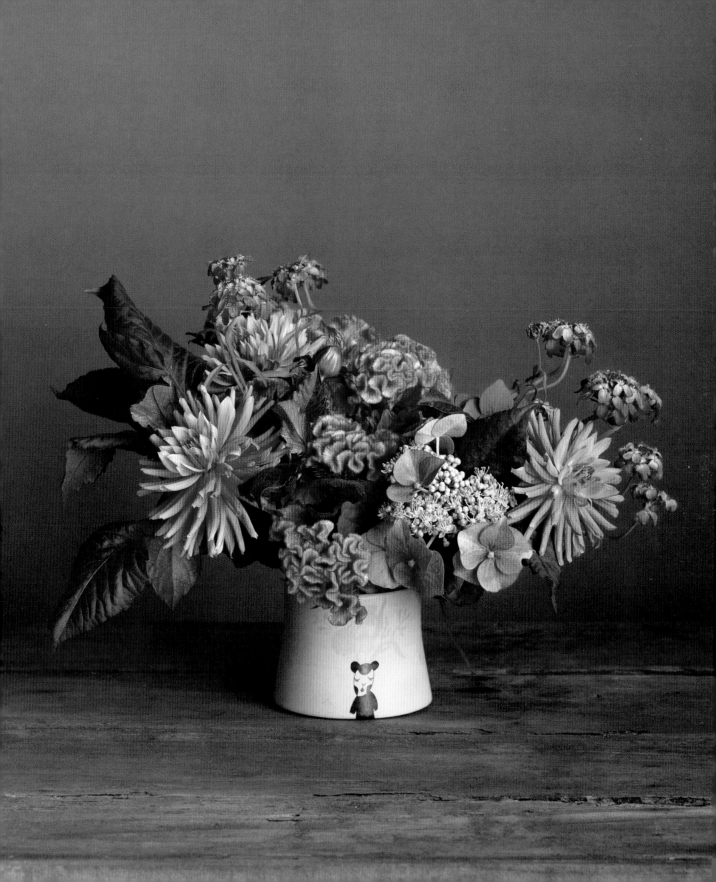

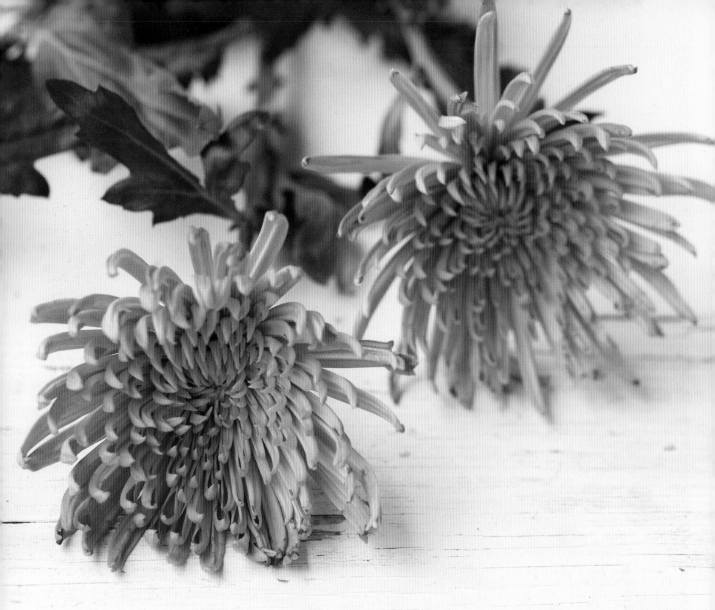

CHRYSANTHEMUM
(kri-SAN-thuh-muhm)

AVAILABLE COLORS: most, except for blue

Pompon, quill, spider, and spoon are just a few of the fascinating forms of the chrysanthemum flower. A symbol of longevity and happiness, this regal cousin of the dahlia was the emblem of imperial Japan for hundreds of years. The flowers' petal-packed heads come in various sizes and shapes, and their sturdy stems allow the sometimes heavy-headed mums to stand tall on their own.

FLOWERS
12 chrysanthemums

VESSEL
Low glass cylinder
with a large
flower frog

1. Remove most of the leaves from the chrysanthemum stems, leaving only a few high at the neck of the flowers.

2. Trim the first chrysanthemum and place it in the outer edge of the frog so that the stem stands straight up.

3. Trim the rest of the stems to the same height as the first and place them throughout the flower frog evenly so that all the blooms are close together but not touching. Leave extra room between blooms if they are not yet fully open.

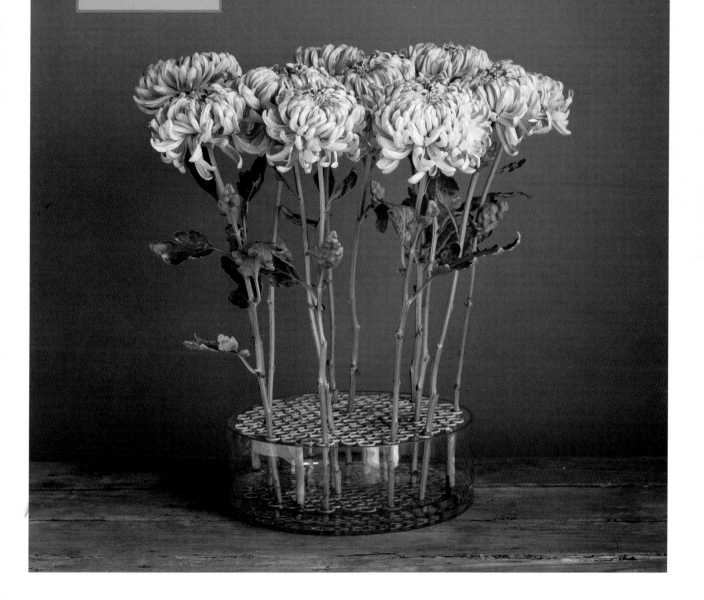

1 Choose a glass in the same color palette as the sprays of chrysanthemum that is also tall enough to support the height of the snowberry branches.

2 Trim the branches of snowberry so that the berries are at various heights. Add the branches to the glass so that the lowest leaves sit at the rim, placing the longer branches on the left.

3 Trim and add one stem of stock to the center of the glass, and one stem of viburnum berries low in front.

4 Trim the sprays of chrysanthemum and add them to the front of the arrangement, clustering the blooms together. Trim and add the remaining stock stems and the scabiosa stems on the right side, trimming the scabiosa to balance the longest snowberry branch on the left. Finish by trimming the remaining stems of viburnum berries and placing them on opposite sides of the arrangement.

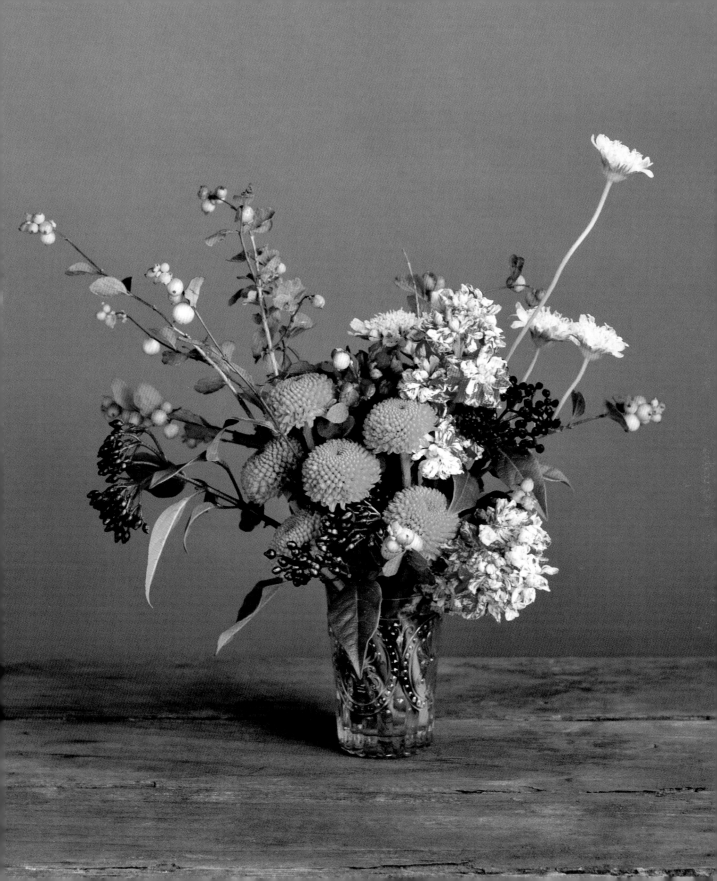

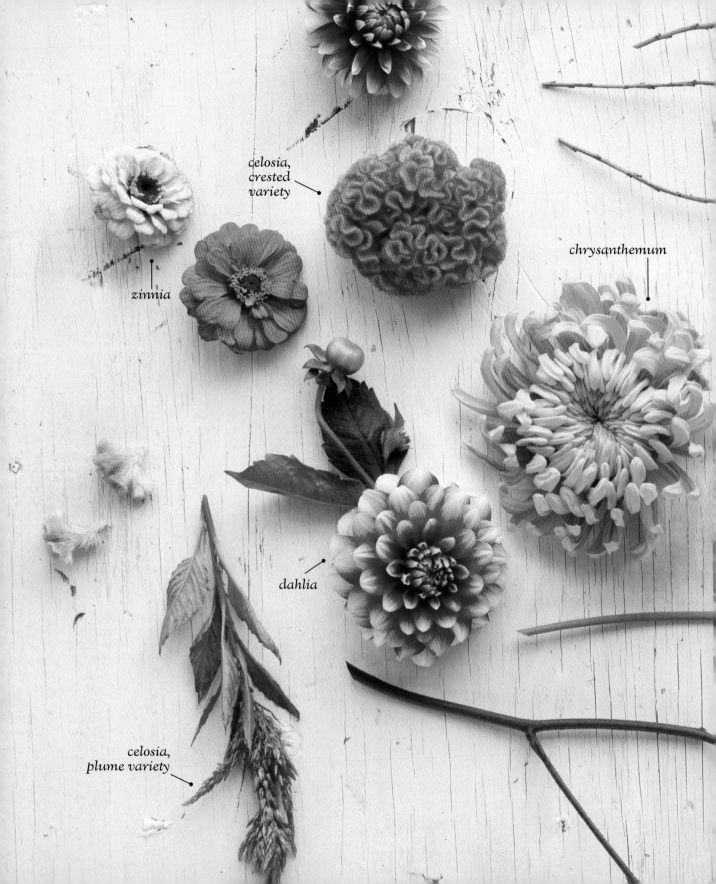

celosia,
crested
variety

chrysanthemum

zinnia

dahlia

celosia,
plume variety

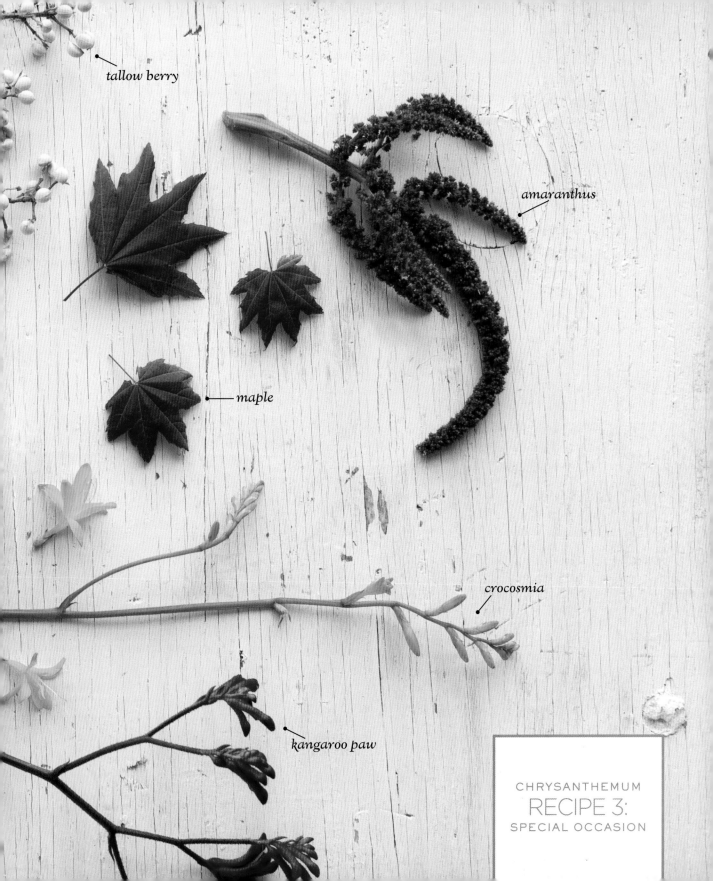

tallow berry

amaranthus

maple

crocosmia

kangaroo paw

CHRYSANTHEMUM

RECIPE 3:

SPECIAL OCCASION

FLOWERS

1 branch of maple

2 stems of kangaroo paw

3 chrysanthemums

3 stems of celosia, crested variety

2 stems of celosia, plume variety

2 dahlias

1 zinnia

2 stems of amaranthus

3 branches of tallow berry

3 stems of crocosmia

VESSEL

Enamel pitcher

1 Begin by trimming and adding the maple branch to the right side of the pitcher so that its leaves hang over the rim.

2 Trim and add one stem of kangaroo paw to the right side of the pitcher so that the blooms sit a few inches higher than the tip of the maple. Add the remaining stem of kangaroo paw to the back center of the pitcher.

3 Trim and add one chrysanthemum to the left side so that the bloom rests at the pitcher's spout, and add the other two chrysanthemums on the right so that their blooms rest right above the maple.

4 Trim and nestle in two stems of celosia, one of each variety, to the center of the composition.

5 Trim and add the dahlias and the zinnia clustered above the chrysanthemum on the left side. Trim and add the remaining stems of celosia behind the dahlias on the left side.

6 Trim and add the stems of amaranthus at the back of the pitcher on the left side; arrange them so that the tip of one bloom arcs over the celosia cluster and the other points down below it.

7 Trim and add one branch of tallow berry to the center so that it reaches out to the left, and the other two branches so that they extend to the lower right side. To finish, trim and add two stems of crocosmia to the center so that they stand upright in the arrangement, and trim and add the remaining stem to the right side.

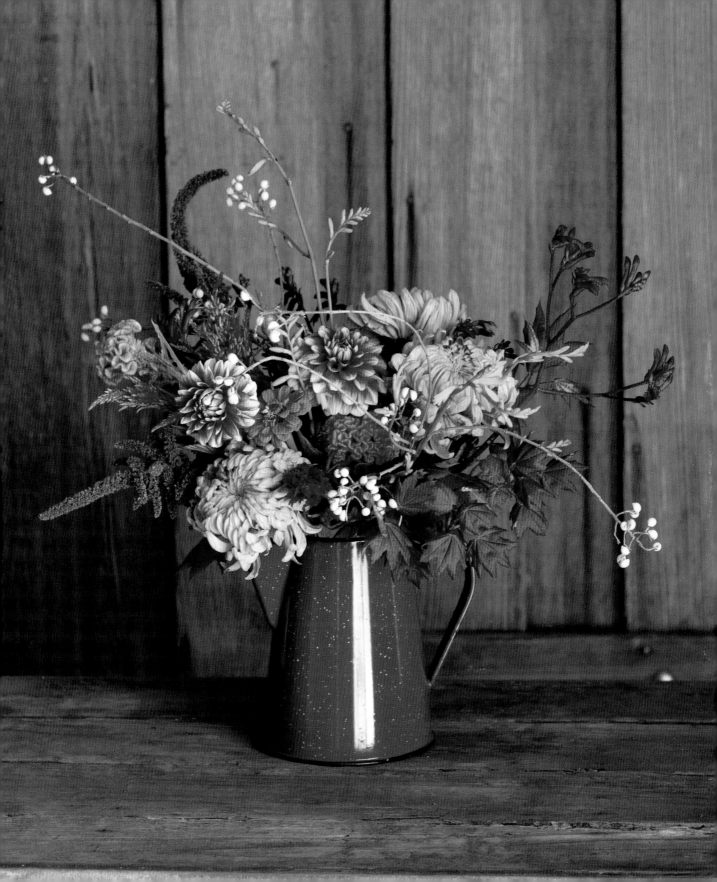

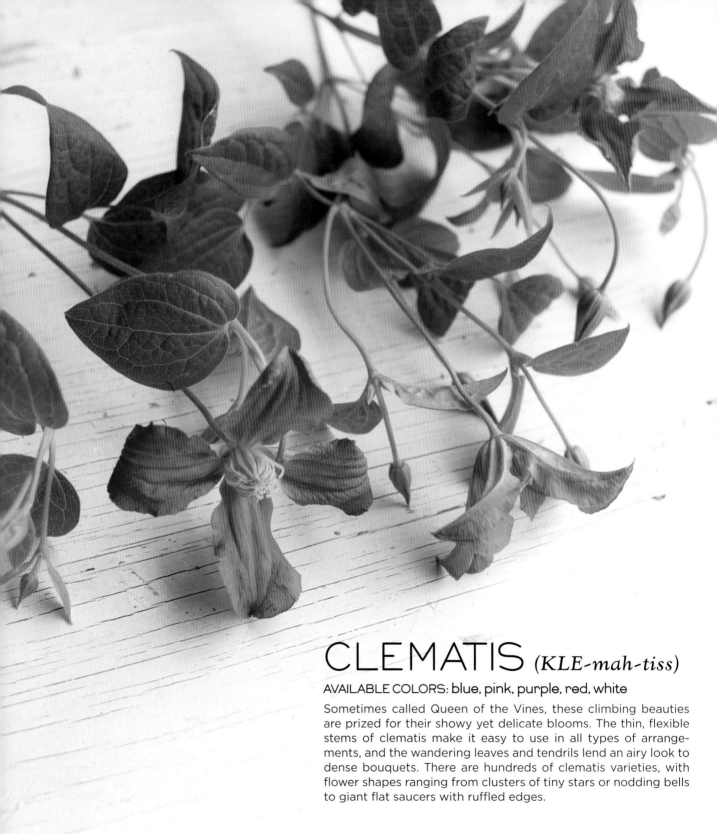

CLEMATIS *(KLE-mah-tiss)*

AVAILABLE COLORS: blue, pink, purple, red, white

Sometimes called Queen of the Vines, these climbing beauties are prized for their showy yet delicate blooms. The thin, flexible stems of clematis make it easy to use in all types of arrangements, and the wandering leaves and tendrils lend an airy look to dense bouquets. There are hundreds of clematis varieties, with flower shapes ranging from clusters of tiny stars or nodding bells to giant flat saucers with ruffled edges.

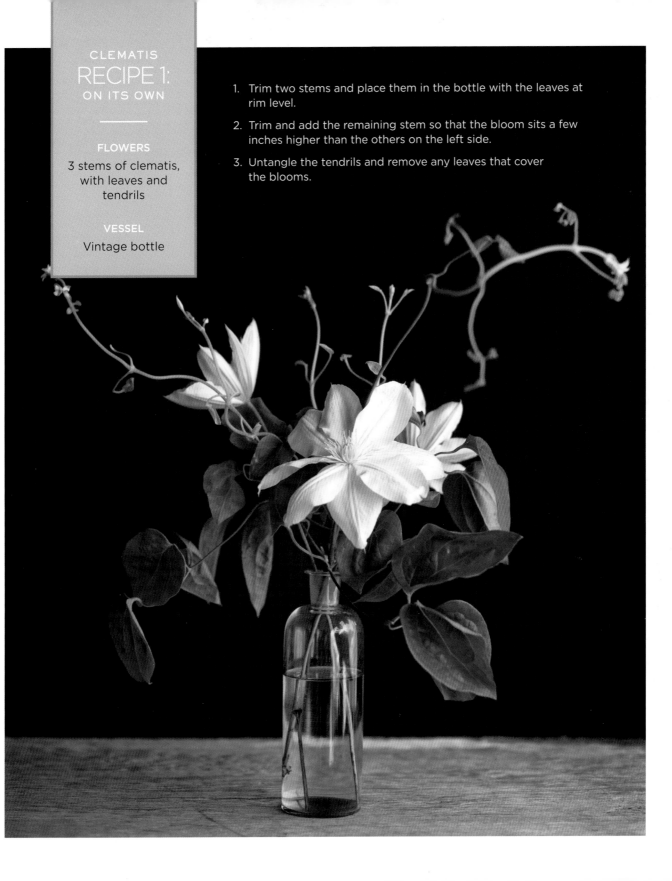

CLEMATIS
RECIPE 1:
ON ITS OWN

———

FLOWERS

3 stems of clematis,
with leaves and
tendrils

VESSEL

Vintage bottle

1. Trim two stems and place them in the bottle with the leaves at rim level.

2. Trim and add the remaining stem so that the bloom sits a few inches higher than the others on the left side.

3. Untangle the tendrils and remove any leaves that cover the blooms.

CLEMATIS
RECIPE 2:
WITH COMPANY

FLOWERS

4 stems of
dusty miller

2 viburnum berry
branches

3 stems of clematis

5 scabiosa stems

VESSEL

Antique teapot

1 Choose a tall teapot with a small opening and a wider bottom, which will allow the flowers to drape out at an angle.

2 Trim the dusty miller and add it to the teapot so that the bottom leaves sit just inside the rim. Arrange one long stem to mimic the flow of the spout.

3 Trim and add the viburnum berry branches next; they will provide a shelf for the clematis to rest on.

4 Trim and feed in the clematis stems so that the blooms are at different heights. Trim the foliage so that the interesting parts of the teapot and base layer, especially the viburnum, are still visible. Trim and insert the scabiosa stems at varying heights.

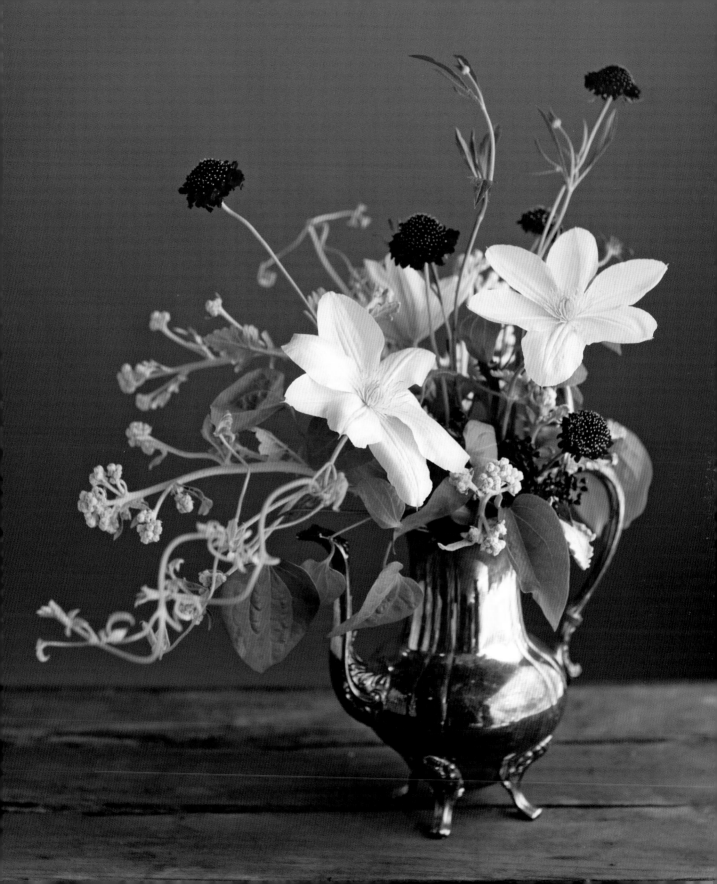

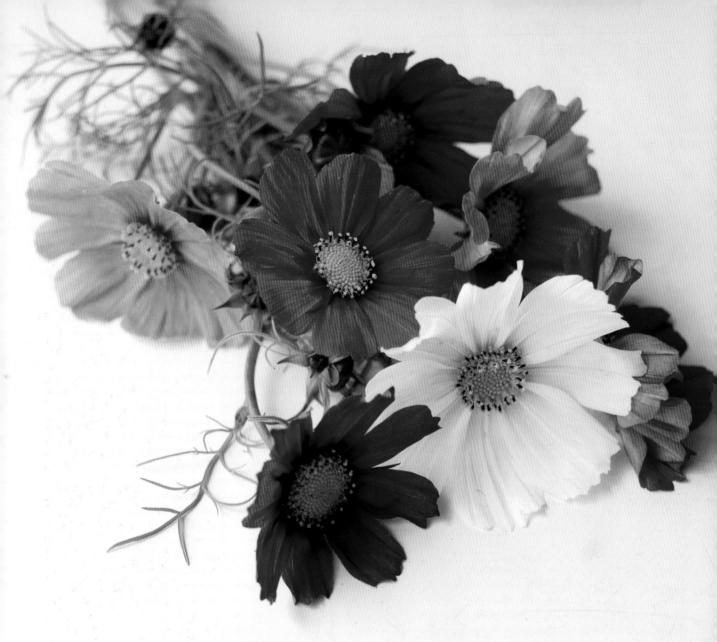

COSMOS
(KOZ-mose)

AVAILABLE COLORS: most, except for blue

Spell "summer" another way and you get cosmos, the cheerful
flower with soft, feathery foliage. Chocolate cosmos, a special
dark variety, has a deep, burgundy-brown color and a sweet,
chocolaty fragrance—ideal for when you need to add a pop of
dark contrast.

FLOWERS

9 stems of
chocolate cosmos

VESSEL

Flat-sided
glass vase

1. Add only a small amount of water to the vase in order to prevent the foliage from being submerged.

2. Leave the foliage and buds on the stems. Trim and add the cosmos to the vase one at a time, letting the stems intersect at the waterline.

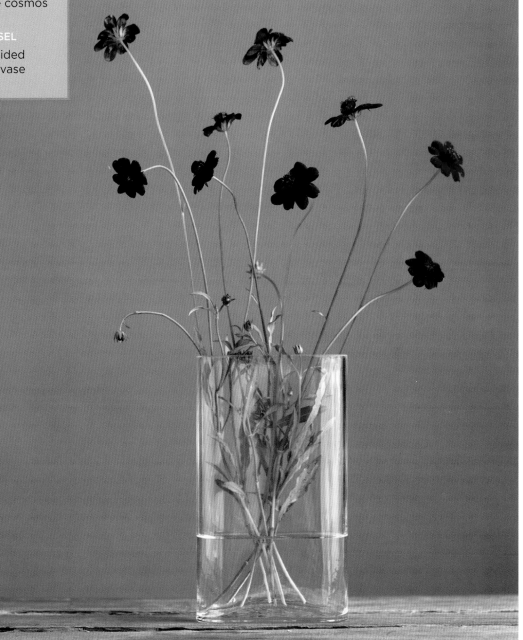

Choose a vase that complements this summery palette.

2 Gather the stems of cosmos into a bunch, loosely lining up the bottom leaves, then trim and place them in the vase. The blooms will be at different heights.

3 Trim and add the yarrow stems to the center of the arrangement, filling in spaces between the cosmos.

4 Trim and add the tweedia stems to fill the remaining spaces. Finish with the long stems of scabiosa, trimming and grouping two in one area and three on the opposite side.

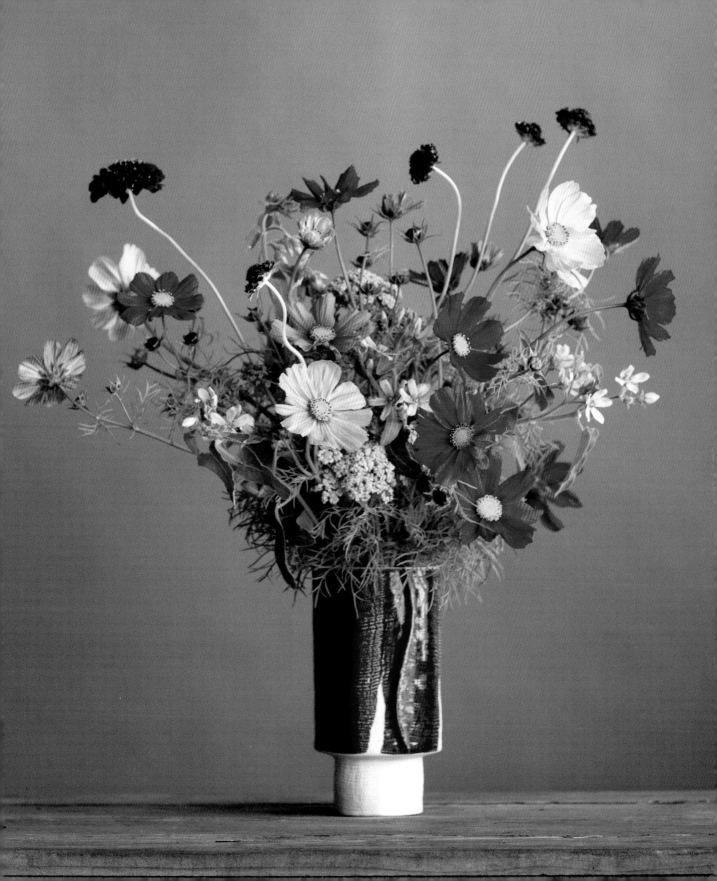

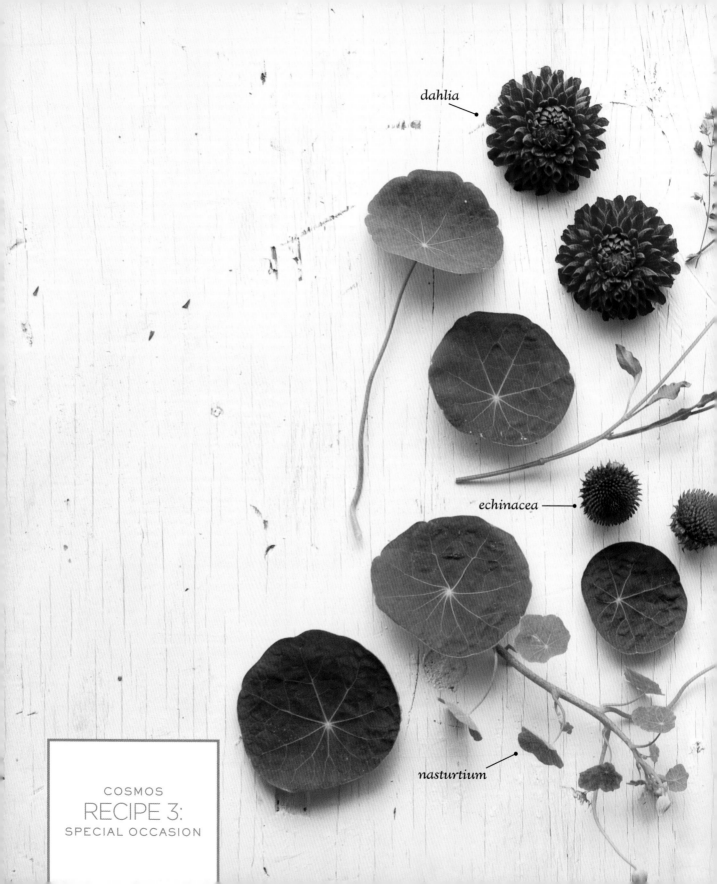

dahlia

echinacea

nasturtium

flowering oregano

chocolate
cosmos

foxglove

iris

scabiosa

yarrow

astrantia

RECIPE 3:
SPECIAL OCCASION

FLOWERS

4 nasturtium vines

3 stems of foxglove

5 irises

3 dahlias

4 stems of yarrow

3 echinacea pods

3 stems of scabiosa

8 stems of chocolate cosmos

3 stems of astrantia

3 stems of flowering oregano

VESSEL

Rustic twig basket

1 Place a watertight liner in the basket so that it is not visible above the rim.

2 Start by trimming and adding a long nasturtium vine, training it up one side of the handle. Attach the vine with thin wire or twine at the top and bottom of the handle. Trim and add the remaining vines to drape out over the rim.

3 Trim and add one foxglove so that it reaches up vertically next to the handle on one side. Trim and add the remaining stems to the opposite side so that they lean outward with the tips turned down.

4 Trim and place the irises next, so that the bases of the blooms start just above the rim. Create a cluster in the center at the front and another around the handle at one side of the basket.

5 Trim and place the dahlias, yarrow stems, echinacea pods, and stems of scabiosa to fill the spaces around the irises. Cluster the flowers and keep them low in order to highlight the shape of the basket.

6 Trim and place the stems of chocolate cosmos and astrantia next, trimming them so that the blossoms float several inches above the other flowers in the composition.

7 Finish with the wispy stems of flowering oregano, trimming and adding them so that they reach out on the right.

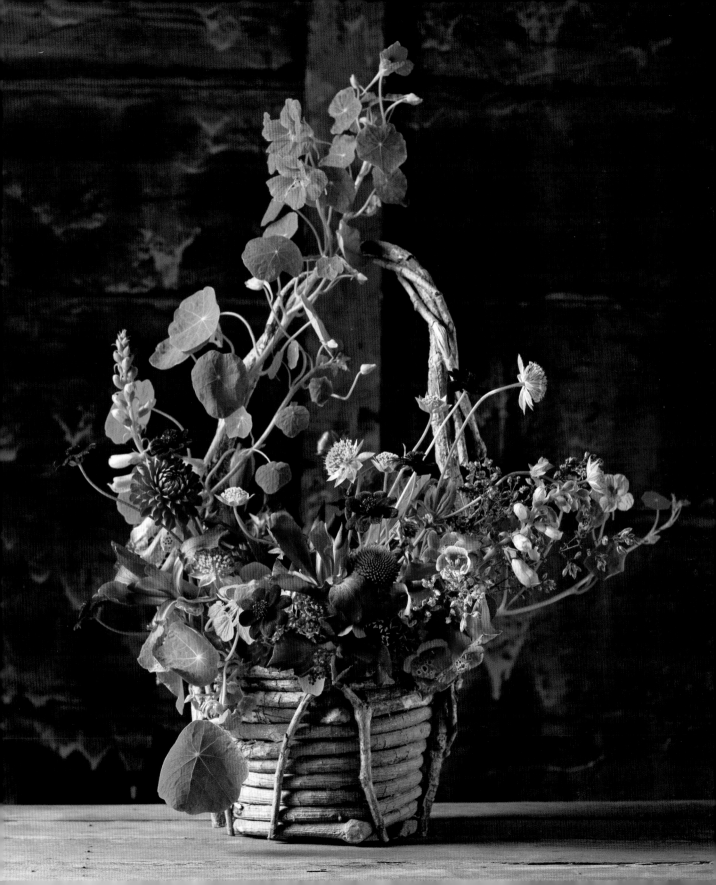

CRASPEDIA

(kras-PEH-dee-uh)

AVAILABLE COLOR: yellow

At once sculptural and whimsical, craspedia is something of a botanical lollipop. More commonly referred to as billy balls or billy buttons, stems of craspedia can punctuate arrangements with pops of yellow, or be displayed solo to truly showcase their graceful simplicity. Craspedia can often be found as dried flowers, which work just as well in arrangements; alternatively, you can dry them yourself by hanging them upside down for several days.

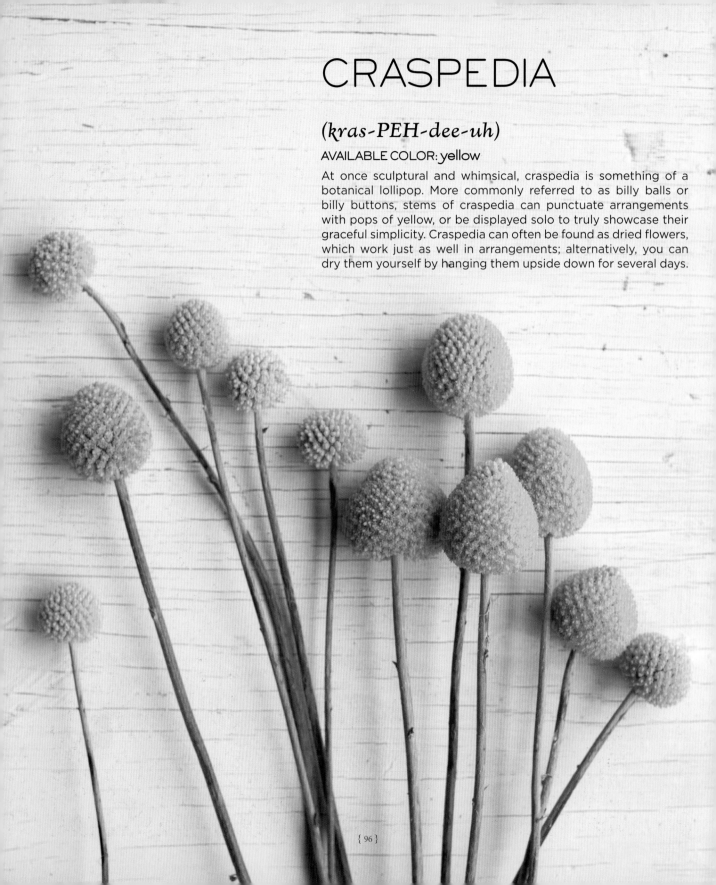

CRASPEDIA
RECIPE 1:
ON ITS OWN

FLOWERS
7 stems of craspedia

VESSELS
5 cut log slices

1. Drill a total of seven small holes slightly larger than a craspedia stem into five log slices. Make sure not to drill completely through the wood but deep enough so that the stems can stand upright. Choose different drilling locations on each piece of wood so that the stems stand scattered in the arrangement.

2. Trim the stems to varying heights.

3. Place a small bead of floral glue in the first drilled hole and add a stem of craspedia. Continue gluing and adding stems to the remaining holes.

4. Arrange the log slices into a pleasing composition.

5. Don't worry about watering this arrangement; the stems should last several weeks. You can also use dried stems for an even longer-lasting, lower-maintenance arrangement.

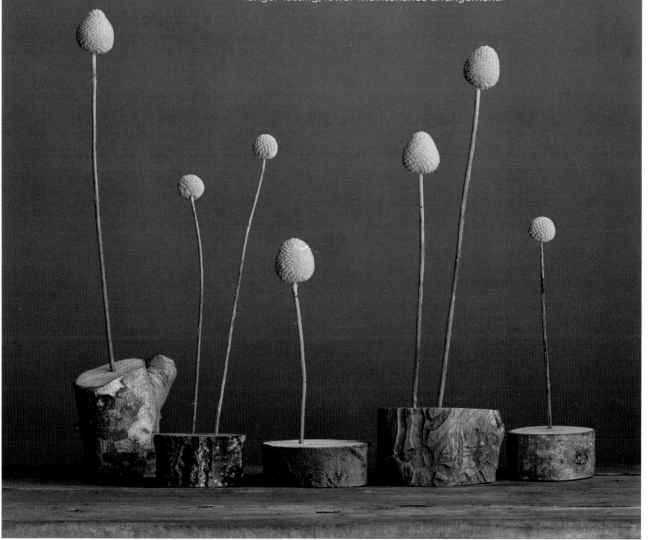

CRASPEDIA
RECIPE 2:
WITH COMPANY

————

FLOWERS

2 stems of craspedia

1 stalk of
ornamental grass

1 stem of yarrow

1 small succulent,
wrapped and wired
(see page 16)

1 feather, wrapped
and wired
(see page 16)

MATERIALS

8-inch length of
½-inch ribbon

6-inch length of
¼-inch waterproof
tape

Prepare the ingredients to assemble a boutonniere, trimming all the stems to several inches in length.

2 Loosely gather the ingredients, positioning the feather and the grass at the back of the collection.

3 Place the heads of the craspedia to the left in front of the feather and grass. Add the succulent to the right of the craspedia, and place the yarrow at the front so that its bloom will obscure the taped stems. Tightly wrap the waterproof tape around the arrangement just under the yarrow to secure all of the ingredients together.

4 Wrap the ribbon around the neck of the boutonniere, completely covering any visible floral tape. Finish with a simple bow, and trim the stems to 1 inch long.

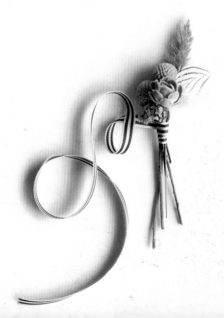

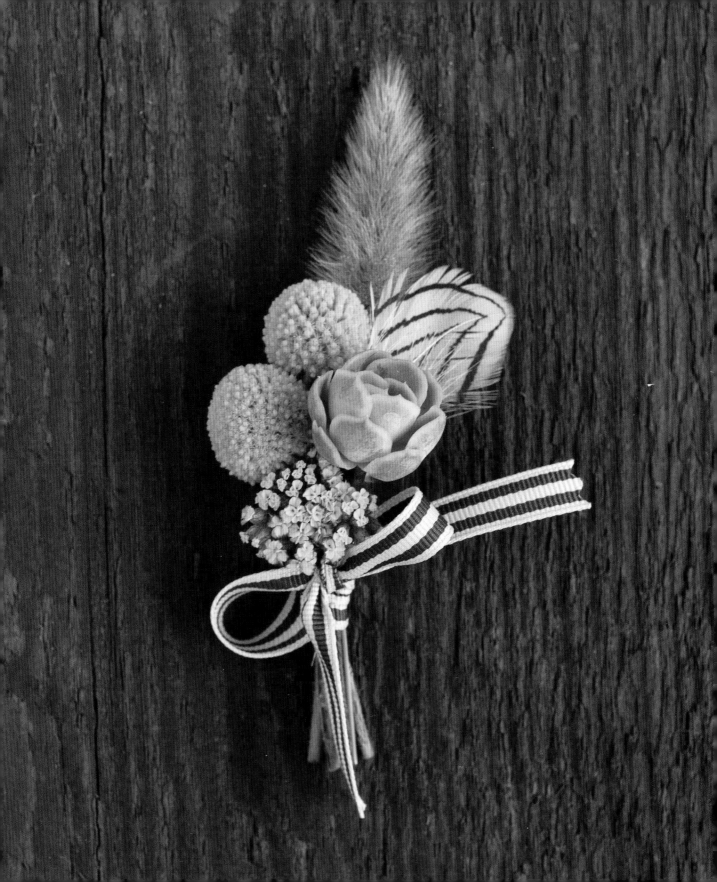

CYCLAMEN
(SY-kla-men)

AVAILABLE COLORS: red, pink, purple, white

You're more likely to find cyclamen tightly packed in a planter box than in an arrangement, but flexible, arcing stems and a delicate, papery bloom make this flower worth seeking out. Cyclamen is commonly thought of as a holiday flower because of its winter bloom time. Despite their delicate appearance, these little flowers can withstand very cold and even snowy conditions, often pushing up through the frost to reveal their interesting curves and festive blooms.

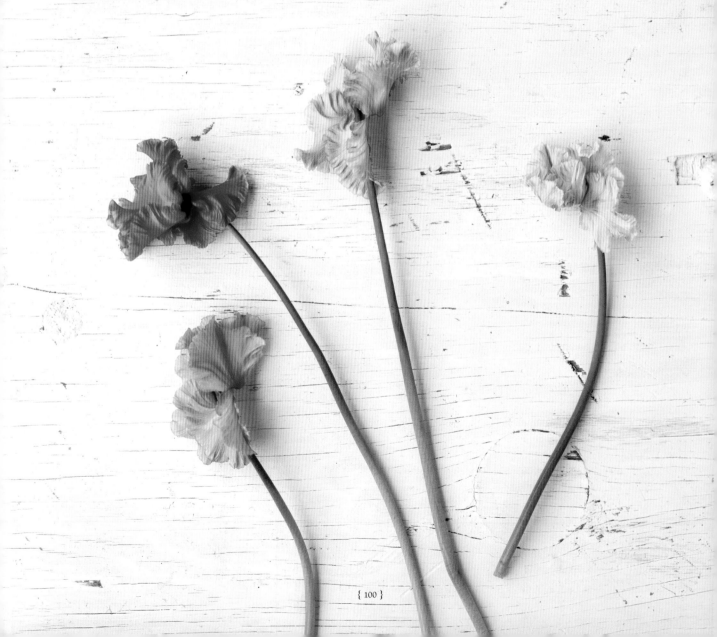

CYCLAMEN
RECIPE 1:
ON ITS OWN

FLOWERS
8 stems of cyclamen

VESSEL
Cage-type flower frog on top of a shallow dish

1. If you cannot fit a dish under the flower frog you are using, you can place the entire frog in a low glass vase. Trim and add each stem of cyclamen to the frog, running stems through the center and down through the bottom level of the grid at different angles.

2. To showcase cyclamen's sculptural quality, turn each stem to a different angle, ensuring that each has its own space in the composition.

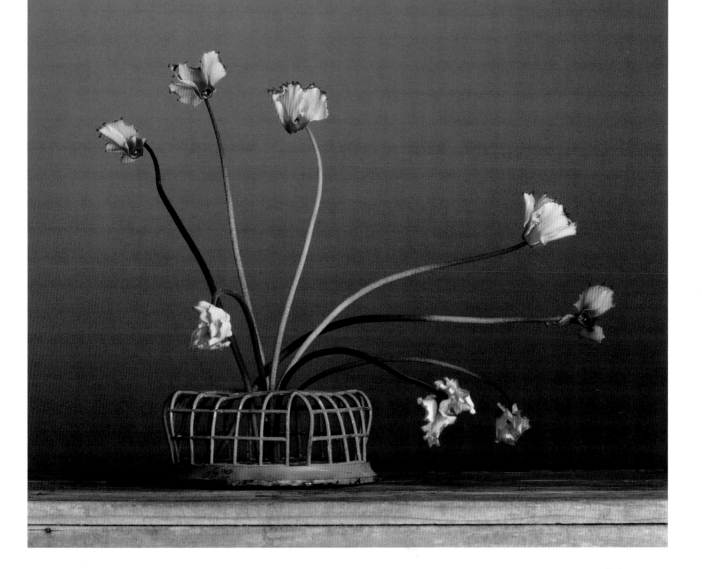

FLOWERS

3 stems of hebe

5 branches of
snowberries

2 air plants,
skewered

6 stems of cyclamen

VESSEL

Glass beaker

| A laboratory beaker showcases the unusual combination of elements.

2 Trim the stems of hebe and place two stems so that they lean over the left side of the beaker. Place the remaining stem so that it leans over the right side.

3 Trim the branches of snowberries and group them on the left so that the clusters of berries cascade over the rim of the beaker.

4 Add one skewered air plant to the front, and one to the back of the arrangement at slightly different heights. Trim the stems of cyclamen to different heights and add them throughout the arrangement so that each stem naturally arcs out at a different angle.

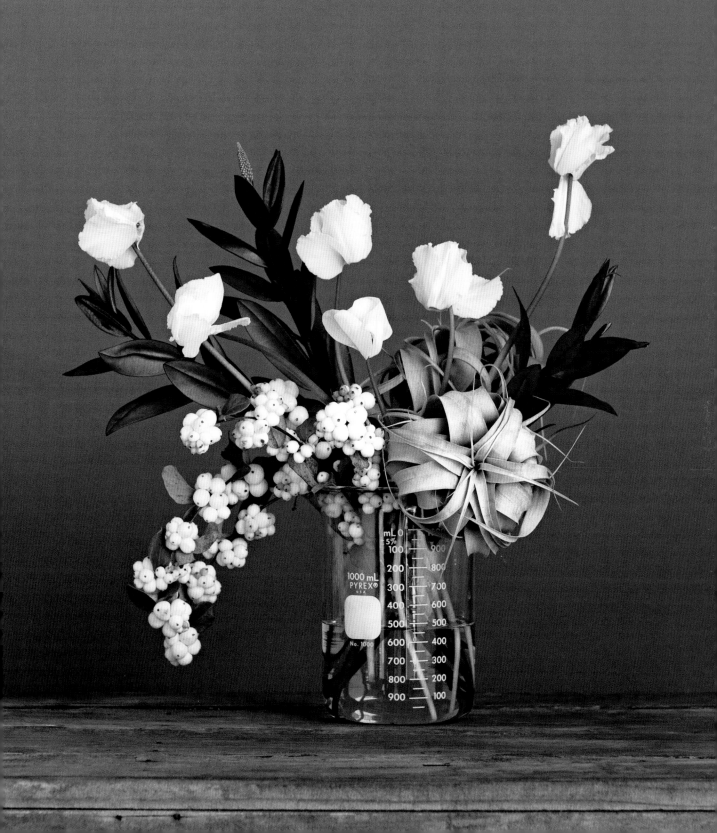

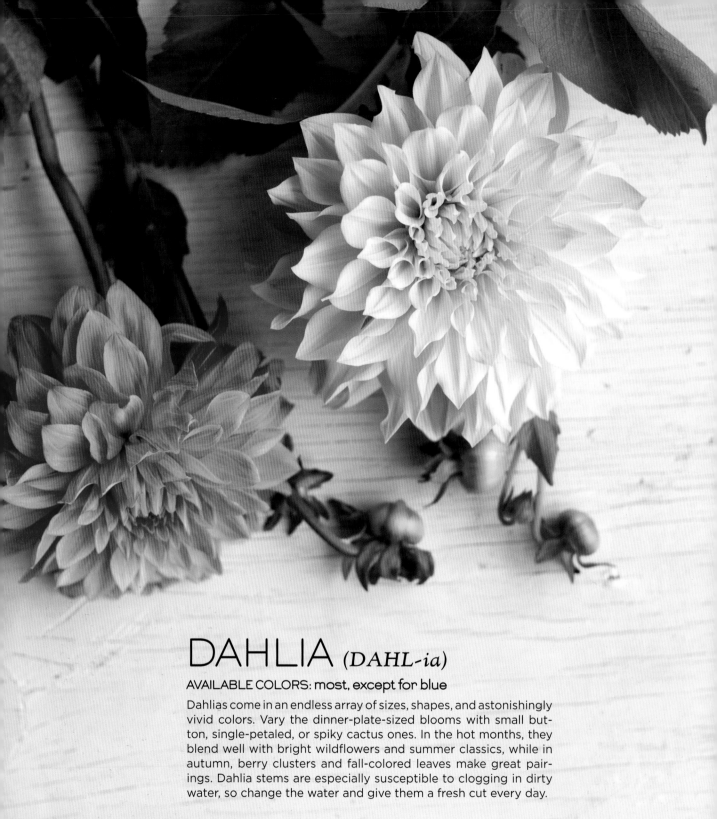

DAHLIA (*DAHL-ia*)

AVAILABLE COLORS: most, except for blue

Dahlias come in an endless array of sizes, shapes, and astonishingly vivid colors. Vary the dinner-plate-sized blooms with small button, single-petaled, or spiky cactus ones. In the hot months, they blend well with bright wildflowers and summer classics, while in autumn, berry clusters and fall-colored leaves make great pairings. Dahlia stems are especially susceptible to clogging in dirty water, so change the water and give them a fresh cut every day.

DAHLIA
RECIPE 1:
ON ITS OWN

FLOWERS

10 dahlias, various
colors and sizes

VESSELS

6 assorted
vintage bottles

1. Determine which stem to place in each bottle depending on height, size of bloom, and quantity.

2. Trim and place the three tallest dahlias in the largest bottle.

3. Trim and place the three smallest dahlias in the bottle with the second largest opening.

4. Place one stem in each of the remaining bottles at varied heights.

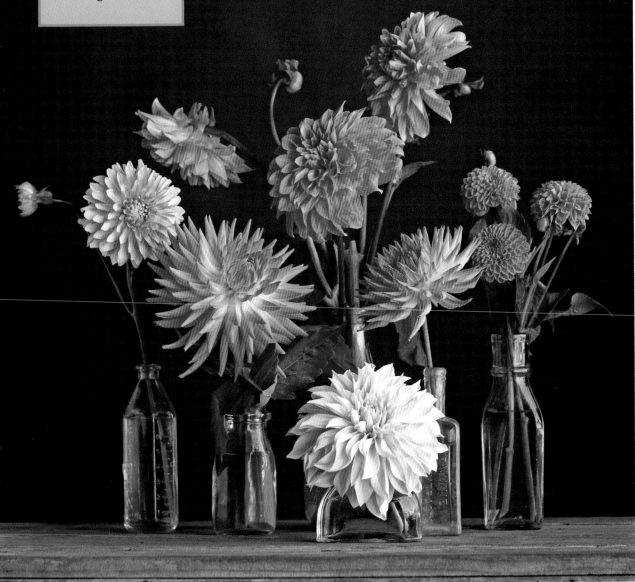

DAHLIA
RECIPE 2:
WITH COMPANY

FLOWERS

5 stems of
hydrangea

3 stems of
blue thistle

7 dahlias

5 stems of cosmos

VESSEL

Metal cylinder

1 | Choose a simple cylinder to create a dense, clustered design.

2 Trim the hydrangea stems so that the bottoms of the flowers will rest at the rim of the cylinder, then dip the stems in alum (see page 15) and add the hydrangea to the cylinder.

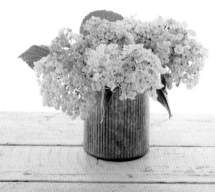

3 Trim and feed the thistle stems through the hydrangea so that the bottoms of the lowest blooms rest on top of the hydrangea base. (Since they grow in sections with multiple heads, there will be a few heads that stick out above the rest.)

4 Trim and feed the dahlia stems through the hydrangea so that the bottoms of the blooms rest on top of the hydrangea base. Nestle the blooms among the thistle, creating a round shape. Finish by trimming and adding the stems of cosmos so that the blooms float a few inches above the rest of the ingredients.

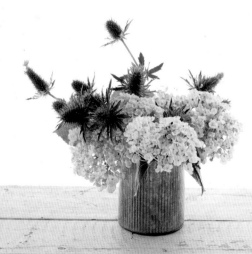

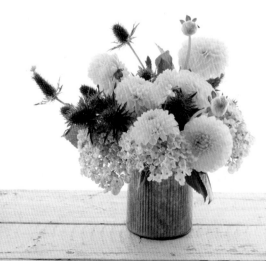

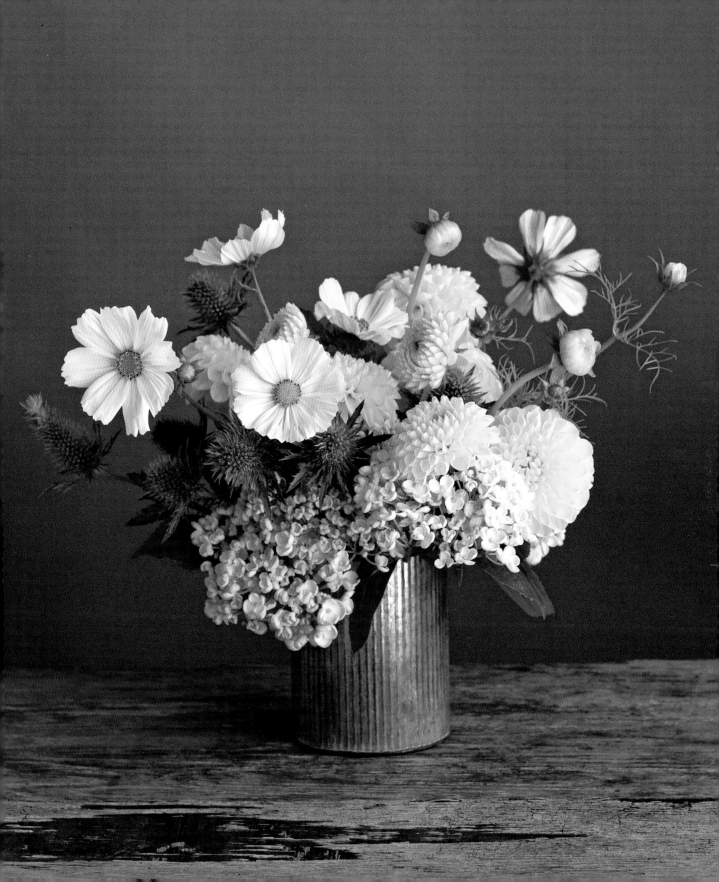

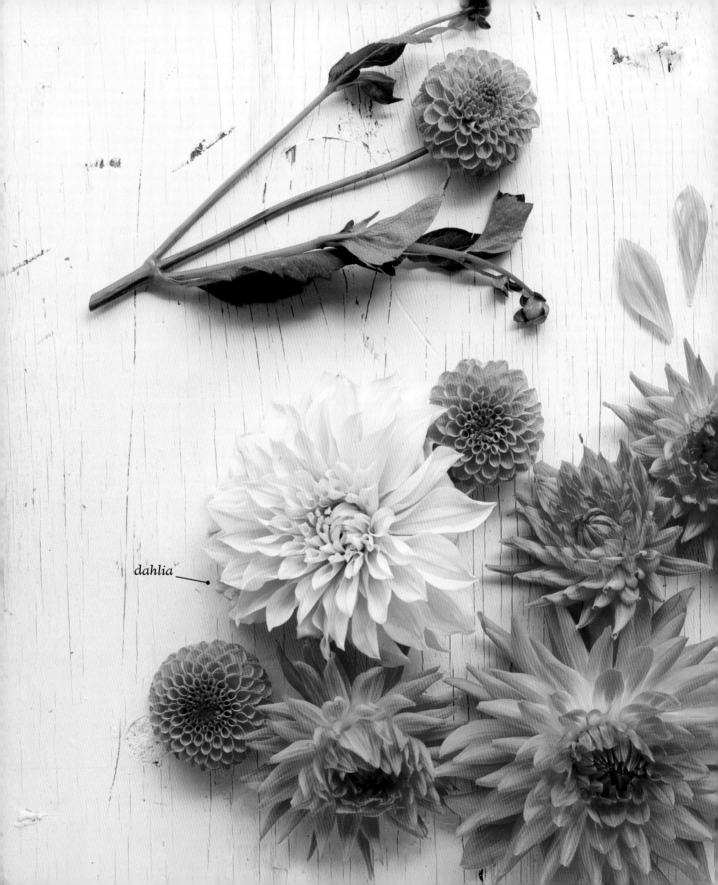

dahlia

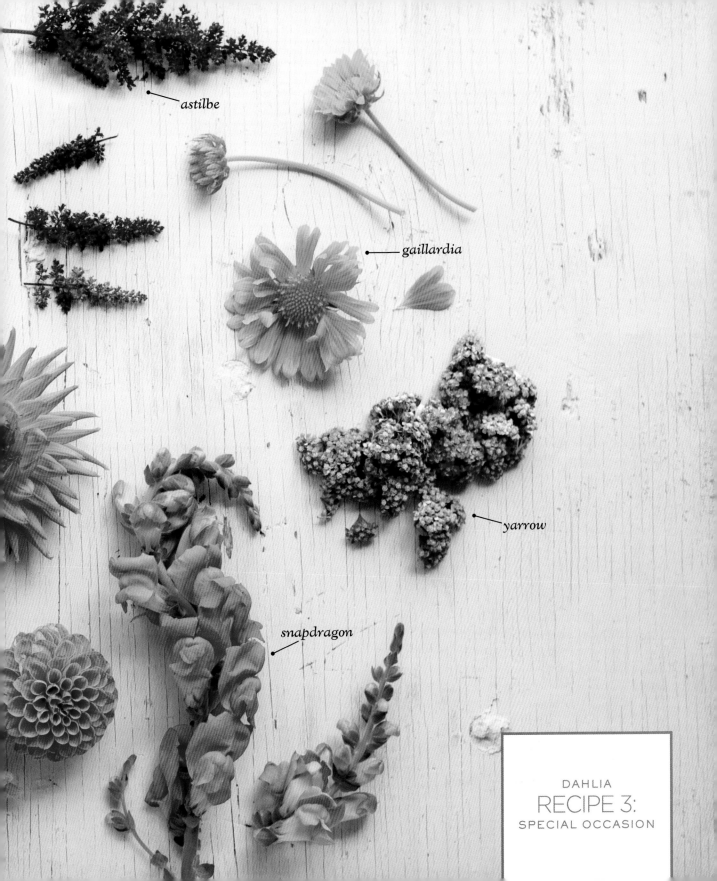

astilbe

gaillardia

yarrow

snapdragon

RECIPE 3:
SPECIAL OCCASION

FLOWERS

12 assorted dahlias

5 snapdragons

5 stems of astilbe

6 stems of yarrow

6 stems of gaillardia

VESSEL

Ceramic pitcher

1 Start by trimming and placing three large dahlias in the pitcher so that their blooms rest an inch above the rim and lean out in different directions.

2 Trim and add another five dahlias so that the blooms lean out a few inches higher than the blooms on the first level.

3 Trim and place the remaining dahlias at the highest level in the center of the arrangement. Twist the dahlia stems on both levels so that their blooms face in different directions.

4 Trim and add all of the snapdragons and stems of astilbe toward the top of the arrangement so that their tips reach out a few inches above the dahlias.

5 Finish by tucking in the stems of yarrow and gaillardia to fill the gaps between the other flowers.

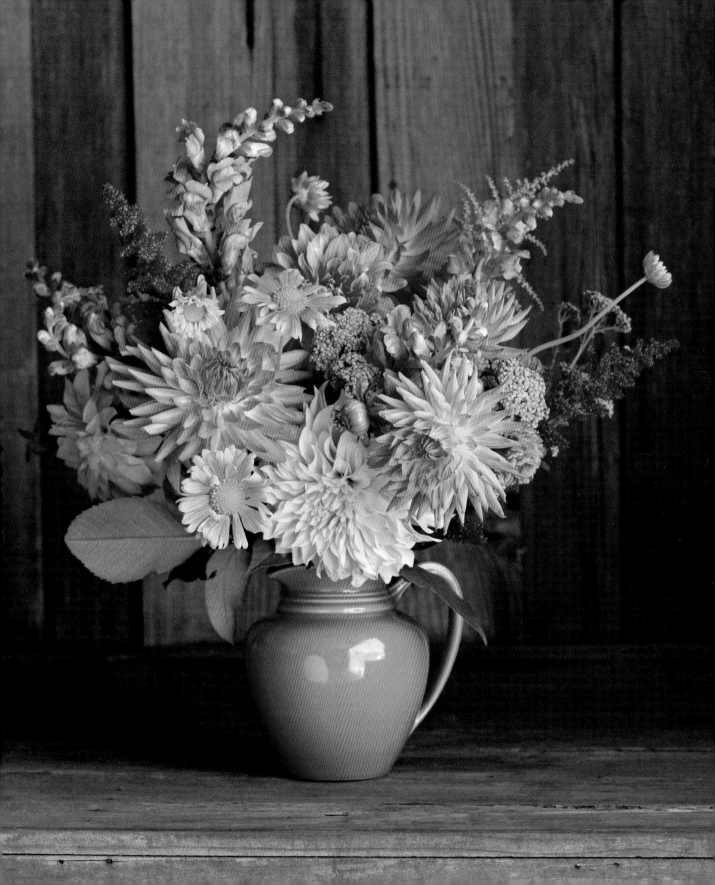

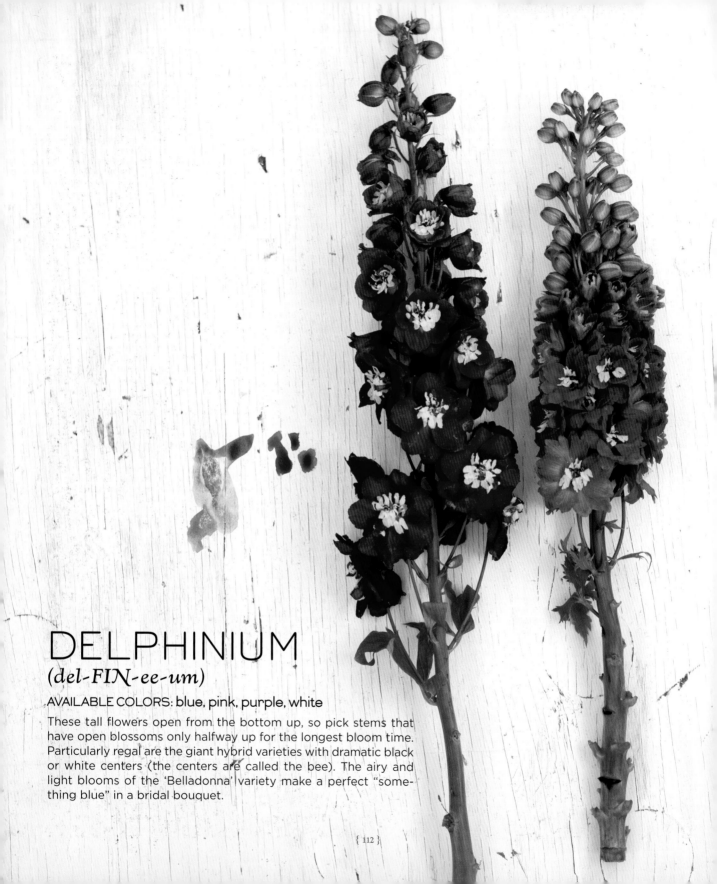

DELPHINIUM
(del-FIN-ee-um)

AVAILABLE COLORS: blue, pink, purple, white

These tall flowers open from the bottom up, so pick stems that
have open blossoms only halfway up for the longest bloom time.
Particularly regal are the giant hybrid varieties with dramatic black
or white centers (the centers are called the bee). The airy and
light blooms of the 'Belladonna' variety make a perfect "some-
thing blue" in a bridal bouquet.

{ 112 }

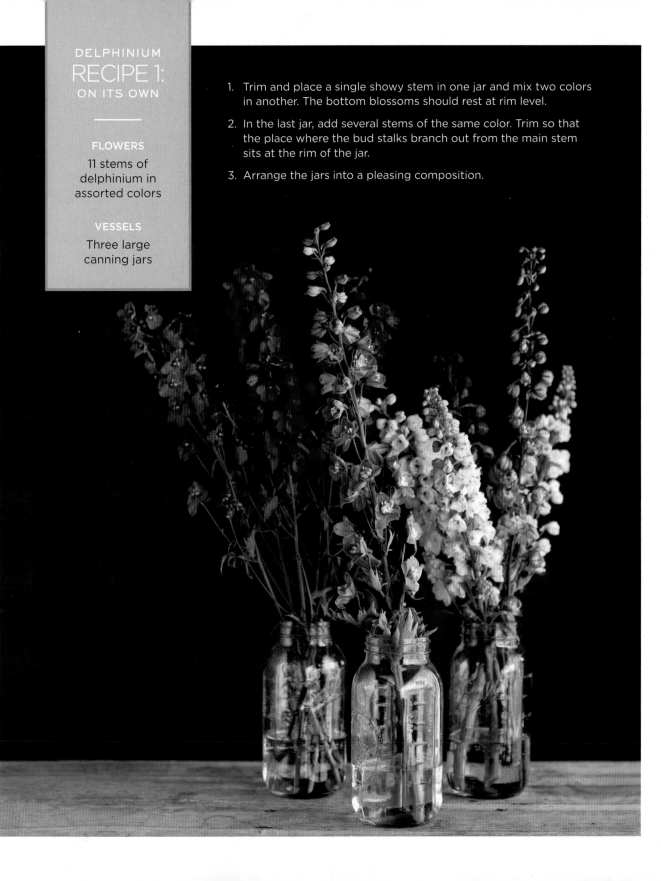

DELPHINIUM
RECIPE 1:
ON ITS OWN

———

FLOWERS
11 stems of
delphinium in
assorted colors

VESSELS
Three large
canning jars

1. Trim and place a single showy stem in one jar and mix two colors in another. The bottom blossoms should rest at rim level.

2. In the last jar, add several stems of the same color. Trim so that the place where the bud stalks branch out from the main stem sits at the rim of the jar.

3. Arrange the jars into a pleasing composition.

DELPHINIUM
RECIPE 2:
WITH COMPANY

———

FLOWERS

2 branches of
chestnut

4 assorted stems
of hydrangea

2 stems of
delphinium

3 stems of
lysimachia

VESSEL
Glass vase

1 Choose a vase with a wide bottom and a narrow neck to hold this massive collection; this style of vase will allow the stems to spread out and will create a full arrangement.

2 Trim one chestnut branch to three times the height of the vase and place it on the right side. Trim the remaining branch short and add it in on the left so that the chestnuts hang at the rim. Trim and dip the stem of the largest hydrangea in alum (see page 15) and add it to the left side, with the bloom resting above the chestnuts.

3 Trim and dip the stem of the second largest hydrangea in alum. Place it in the arrangement so that the bottom of the bloom sits at the rim of the vase, filling the space between the chestnuts. Trim and dip the remaining two hydrangea stems in alum and place them between the other blooms, creating a base of hydrangeas.

4 Trim and place the delphinium stems in the center of the composition and angle them slightly outward. Finally, trim and place the stems of lysimachia next to the delphiniums on both sides to form a group of tall spires at the top of the arrangement.

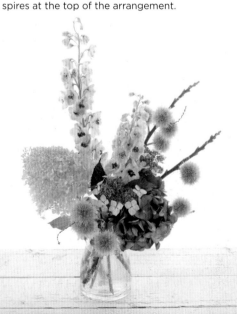

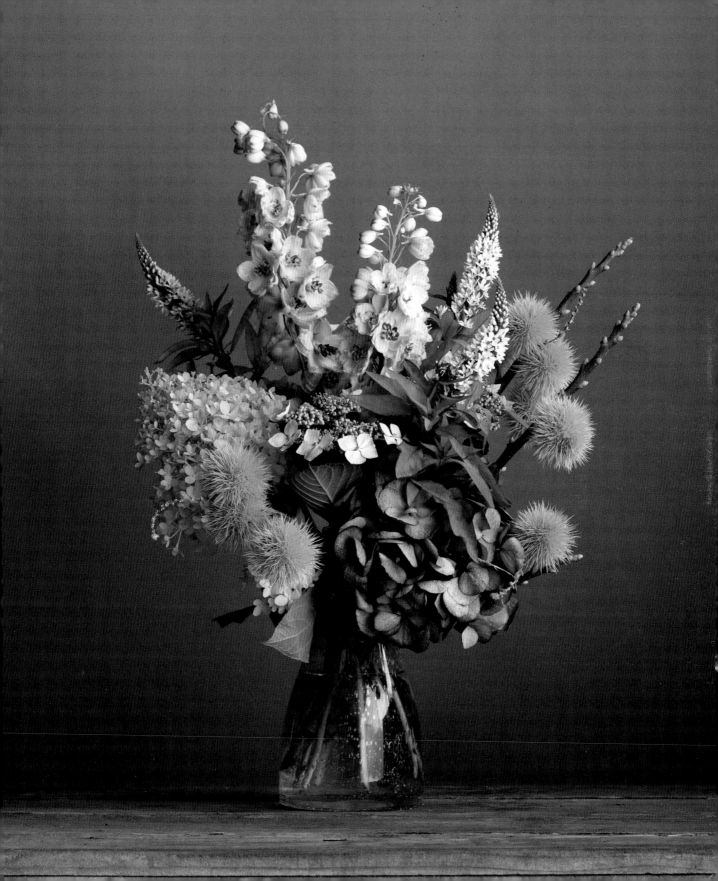

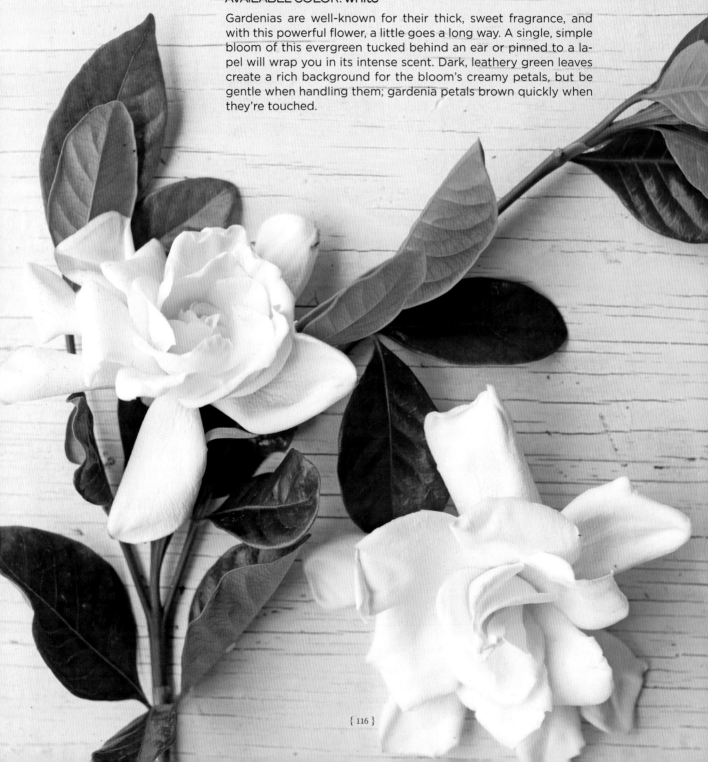

GARDENIA
(gahr-DEE-nyuh)

AVAILABLE COLOR: white

Gardenias are well-known for their thick, sweet fragrance, and with this powerful flower, a little goes a long way. A single, simple bloom of this evergreen tucked behind an ear or pinned to a lapel will wrap you in its intense scent. Dark, leathery green leaves create a rich background for the bloom's creamy petals, but be gentle when handling them; gardenia petals brown quickly when they're touched.

RECIPE 1:
ON ITS OWN

—————

FLOWERS
4 stems of
gardenia leaves

5 gardenia blooms

VESSELS
Gold glass pedestal
bowl and 2 low,
gold votive cups

1. Begin by filling all of the vessels to the very top with water to make sure the short stems all reach the water. Trim the stems of gardenia leaves and place two in each votive cup to create a base for the gardenias to rest upon. If gardenia leaves aren't available, use foliage that has a similar waxy quality.

2. Trim three of the gardenias, and place two blooms in one of the votive cups and one bloom in the other. The blooms should rest on the leaves, right at the rim of the votive.

3. Trim the remaining blooms and float them in the pedestal bowl.

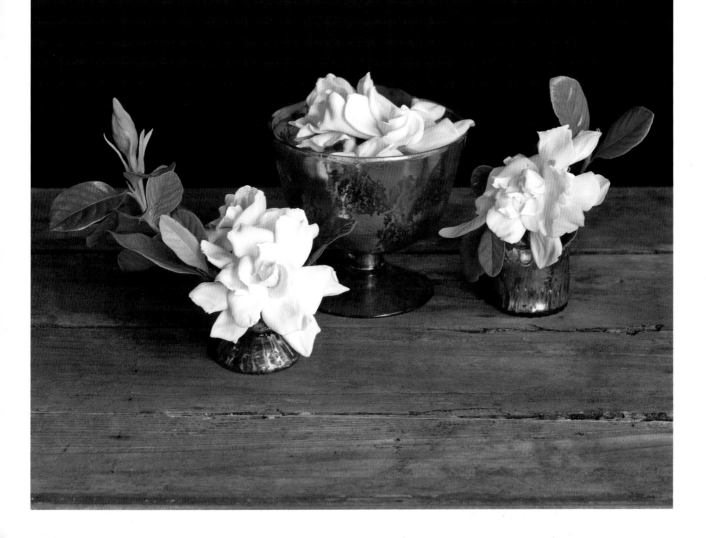

1 Single gardenias are commonly used to adorn simple hairstyles, but a head wreath shows off the flowers' wild side. Lay out the stems of rosemary, gently bending them to create a rounded shape, keeping in mind the size of the wearer's head.

2 Take one length of wire and wrap it around two stems of rosemary several times to join the stems together. Twist the ends of the wire together tightly, then trim to a 1-inch length and tuck into the rosemary. Repeat the process three more times, joining each stem of rosemary to the next until there is a wreath of securely connected stems. Using the same wiring technique, attach the leaves of Boston ivy to the wreath.

3 Cut the spray of oregano into sections and create two small bundles, each with three or four blooms. Use the wiring technique above to attach one bundle on top of the Boston ivy and the other on the opposite side.

4 Add the two lisianthus stems on top of the oregano and Boston ivy, wiring into place. Trim any visible long stems that may be hanging off of the wreath, and place it on the wearer's head. Decide where the gardenias will be positioned, then remove the wreath and carefully wire on the gardenias and leaves.

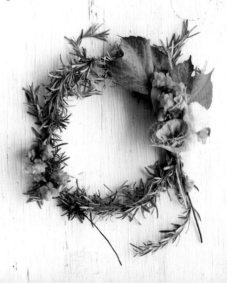

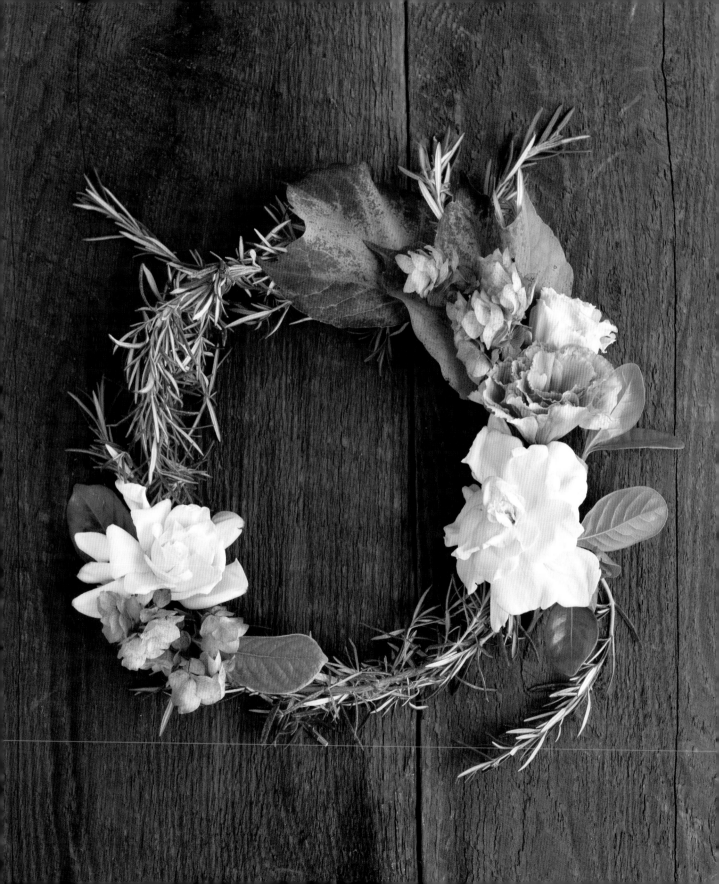

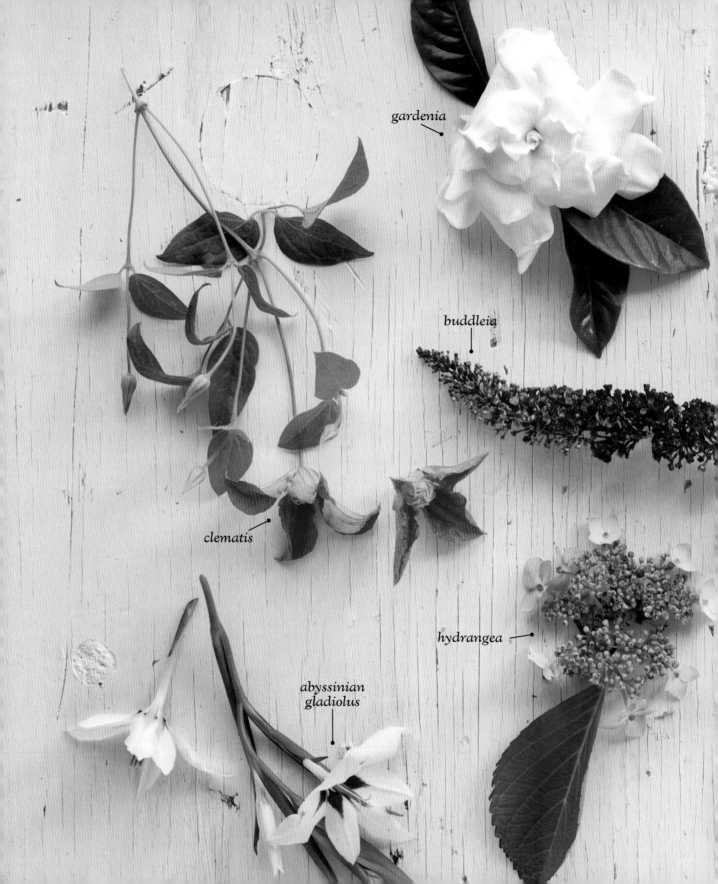

gardenia

buddleia

clematis

hydrangea

abyssinian
gladiolus

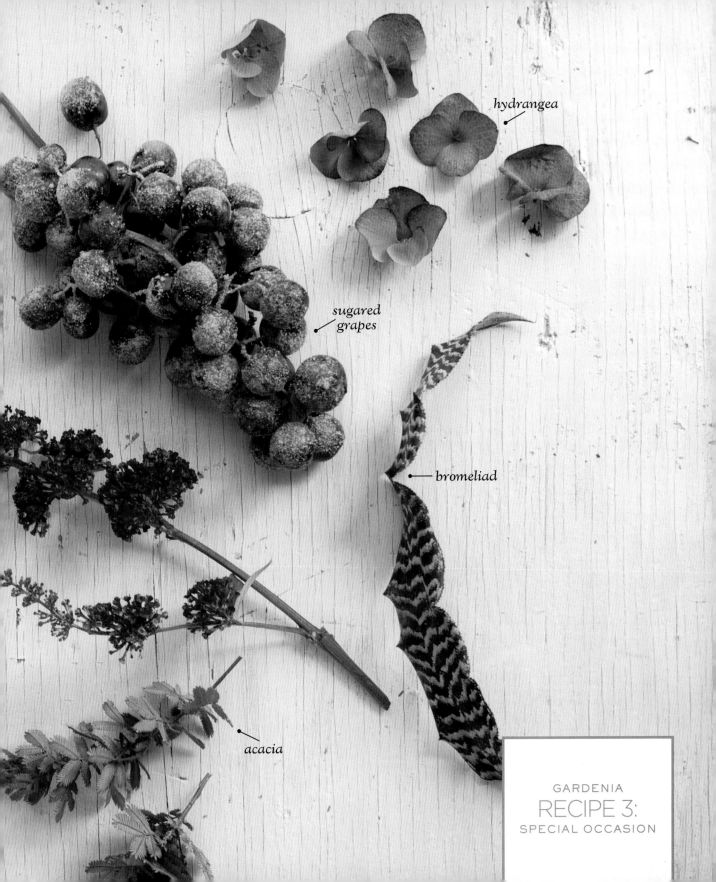

hydrangea

sugared
grapes

bromeliad

acacia

GARDENIA
RECIPE 3:
SPECIAL OCCASION

RECIPE 3:
SPECIAL OCCASION

FLOWERS

3 stems of acacia

1 skewered bromeliad

3 stems of hydrangea

3 stems of buddleia

7 stems of clematis

11 stems of Abyssinian gladiolus

3 stems of gardenia with leaves

2 bunches of sugared grapes

VESSELS

Brass urn, gold cup, black cake pedestal

1 Trim and add the stems of acacia to the urn, then add the skewered bromeliad so that it hangs over the rim on the front right side.

2 Trim the largest stem of hydrangea so that the bloom will sit at the center of the composition, then dip the stem in alum (see page 15) and add the hydrangea to the urn. Trim the remaining stems of hydrangea so that the blooms will sit a few inches above the larger bloom, dip the stems in alum, and add the hydrangeas to the left side.

3 Trim and add the stems of buddleia to the back center of the urn so that their spires arc out equidistantly to the left, center, and right.

4 Cluster five trimmed stems of clematis in the center of the arrangement, above the bromeliad. Turn the stems so that the blooms face in different directions. Trim and add the remaining two stems of clematis so that they arc out on the lower left side of the arrangement.

5 Trim and add four stems of Abyssinian gladiolus, clustering the blooms on the upper left side a few inches above the hydrangea. Add two more stems, trimming so that the blooms arc next to the clematis on the right.

6 In the small gold cup, trim and add the stems of gardenia. Add the remaining stems of Abyssinian gladiolus to the cup, trimming so that the blooms are clustered in the center.

7 Finish by draping one bunch of sugared grapes over the black pedestal, and laying the remaining bunch in front of the urn.

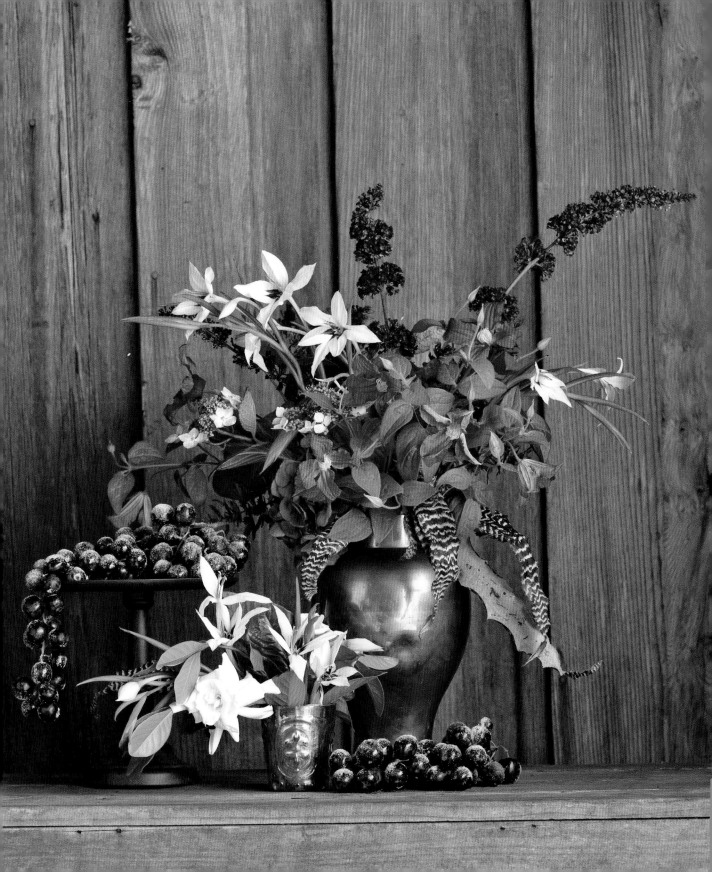

GERANIUM
(jer-AY-nee-um)

AVAILABLE FOLIAGE COLORS: green, bicolor

The joy of geraniums lies in their crinkled, velvety, and fragrant foliage. Some varieties are as small as a wee snail, others as large as a butter plate. Their leaves have splashes of bright yellow, pink, or dark chocolate, making them an exciting mixer for most flowers, and their mouthwatering fragrance ranges from coconut to apple-nutmeg. Consider keeping a resident geranium from which to clip small bits for lots of different arrangements.

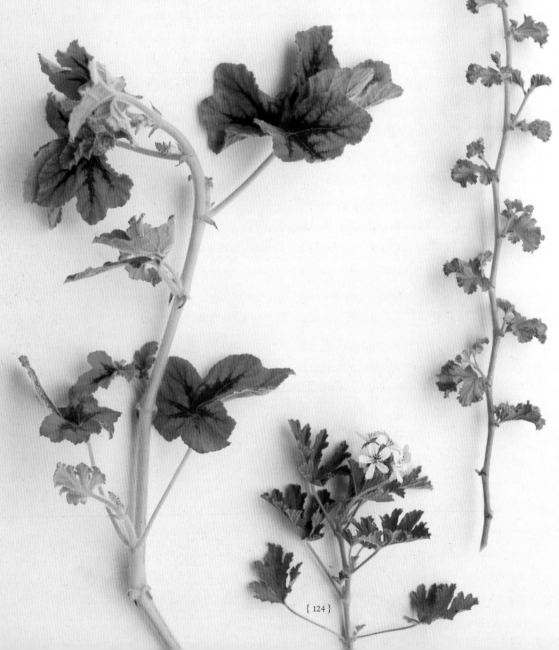

GERANIUM
RECIPE 1:
ON ITS OWN

FLOWERS

7 stems of geranium, assorted varieties

VESSEL

Flat-sided glass vase

1. Trim the largest-leafed stems and place them in the vase first.

2. Trim the stems with smaller leaves next, adding them so that the tips are at different heights.

3. Prune a few leaves in order to create some interesting negative spaces in the composition.

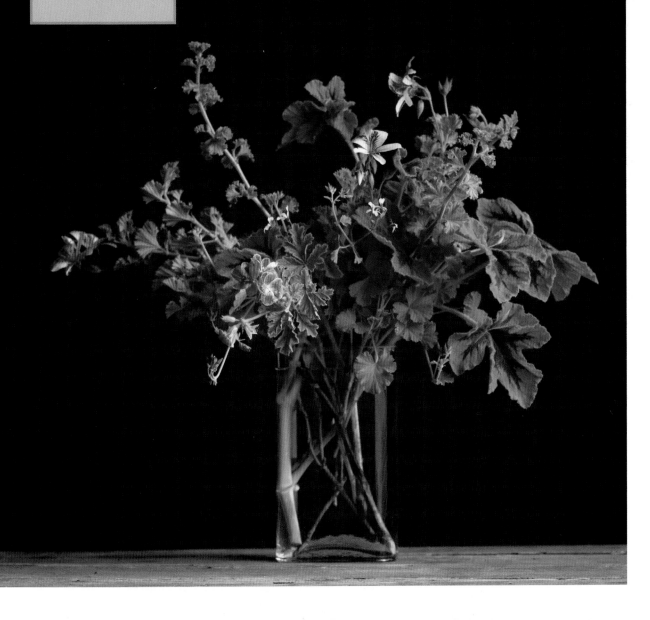

RECIPE 2:
WITH COMPANY

———

FLOWERS

5 stems of short
honeysuckle

3 stems of long
honeysuckle

3 wild plum
branches with fruit

2 geranium stems

VESSEL
Metallic glass

| Choose a glass that matches the flowers' golden color.

2 Trim and add the short stems of honeysuckle, with the lowest leaves at the rim of the glass.

3 Trim and add the long stems of honeysuckle, turning them so that they arc up and out in different directions.

4 Trim and add two of the wild plum branches in the center, and the remaining branch so that it hangs low over the front rim of the glass. Finish by trimming the geranium stems and tucking them in near the overhanging branch of wild plum.

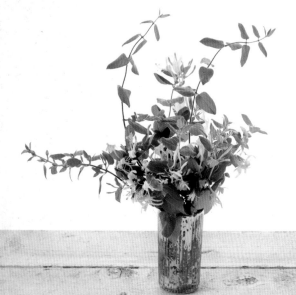

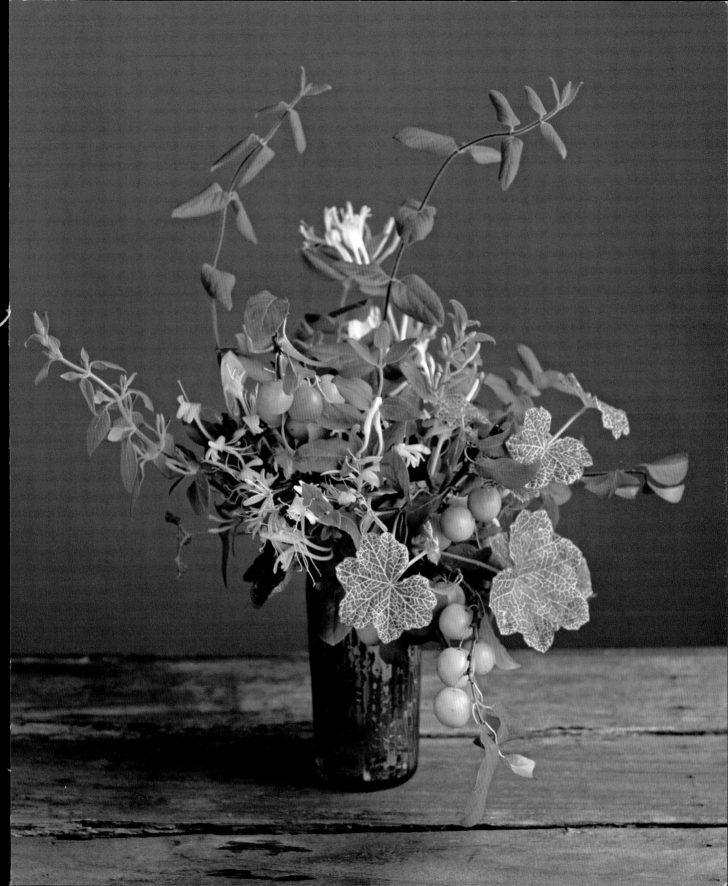

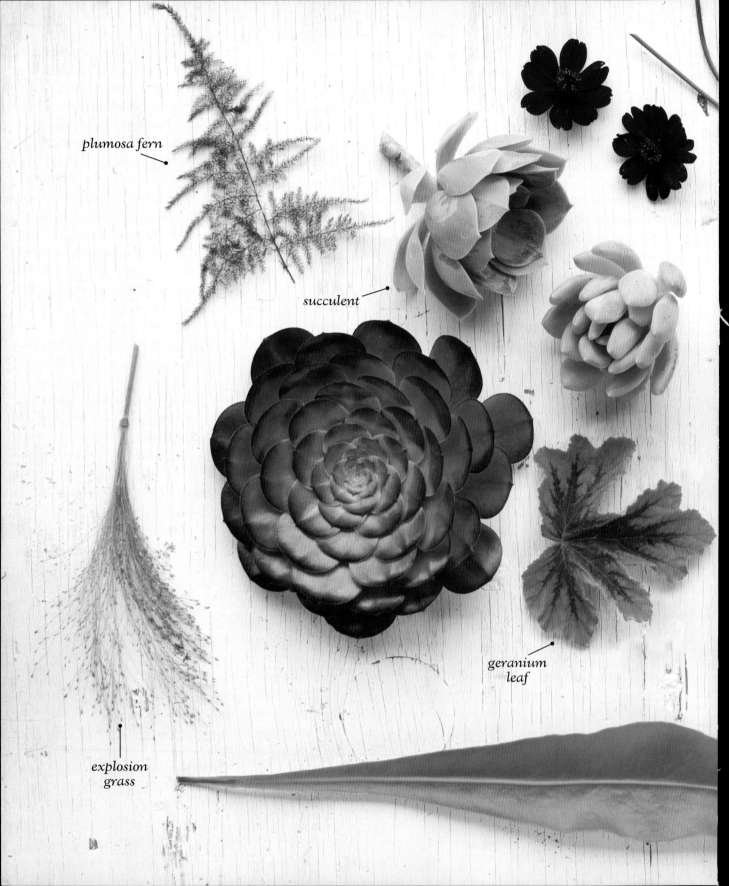

plumosa fern

succulent

geranium leaf

explosion grass

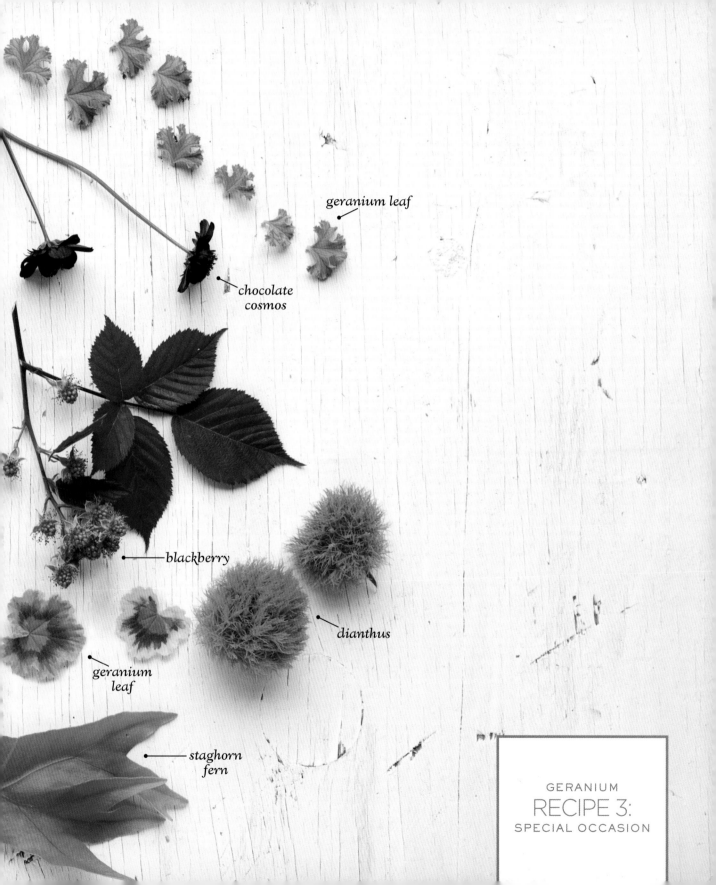

geranium leaf

chocolate
cosmos

blackberry

dianthus

geranium
leaf

staghorn
fern

RECIPE 3:
SPECIAL OCCASION

FLOWERS

10 stems of assorted geranium leaves

3 fronds of plumosa fern

5 skewered succulents

2 fronds of staghorn fern

3 stems of blackberry

3 stems of dianthus

6 stems of chocolate cosmos

3 sprays of explosion grass

VESSEL

Tall wooden box

1 Place a watertight liner in the box so that it is not visible above the rim. Trim and place the seven largest, bushiest stems of geranium leaves in to form a base.

2 Trim and add the fronds of plumosa fern next, allowing them to cascade over the front and to one side of the box.

3 Place the largest succulent on the other side of the box, resting the skewered stem on the rim for support.

4 Trim and place the staghorn fern fronds at different heights on the side opposite the large succulent.

5 Trim and layer in the stems of blackberry and dianthus, followed by the remaining three geranium stems as a gestural touch on the right side of the box.

6 Cluster the remaining skewered succulents around the largest one, letting them rest atop the layers of foliage.

7 Finish by trimming and carefully adding in the stems of chocolate cosmos and explosion grass.

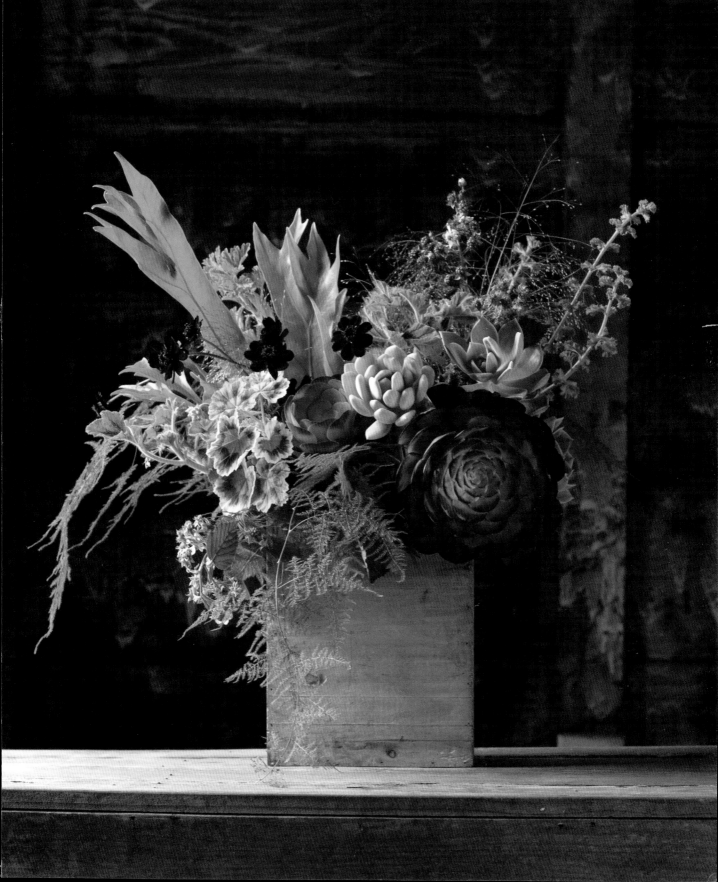

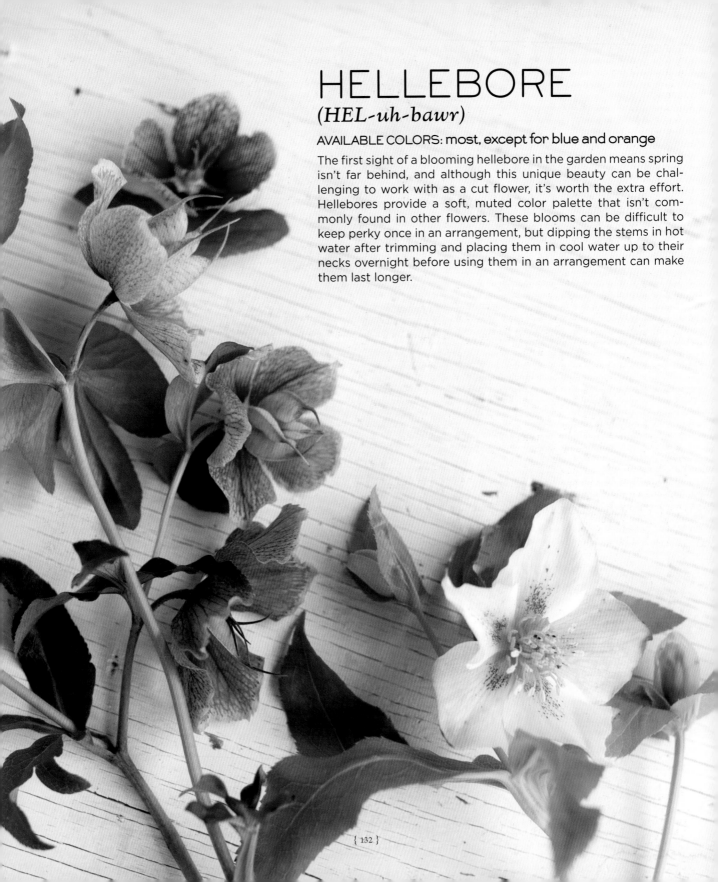

HELLEBORE
(HEL-uh-bawr)

AVAILABLE COLORS: most, except for blue and orange

The first sight of a blooming hellebore in the garden means spring isn't far behind, and although this unique beauty can be challenging to work with as a cut flower, it's worth the extra effort. Hellebores provide a soft, muted color palette that isn't commonly found in other flowers. These blooms can be difficult to keep perky once in an arrangement, but dipping the stems in hot water after trimming and placing them in cool water up to their necks overnight before using them in an arrangement can make them last longer.

HELLEBORE
RECIPE 1:
ON ITS OWN

FLOWERS
6 stems of hellebore
in different varieties

VESSELS
3 different-sized
glass bud vases

1. Determine which stem to place in each vase according to the height of the stems.

2. Trim and place the tallest hellebore in the tallest vase.

3. Trim and place the next two tallest stems in the medium-size vase. The blooms should rest a few inches below the tallest blooms.

4. Trim and place the remaining three stems in the lowest vase so that the blooms are clustered on the rim.

5. Arrange the vases into a pleasing composition.

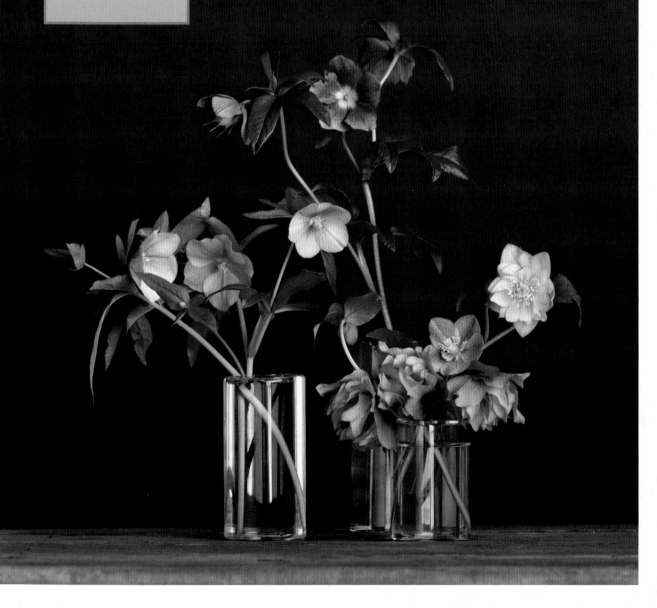

HELLEBORE
RECIPE 2:
WITH COMPANY

FLOWERS

2 stems of
mock orange

4 stems of hellebore

3 olive branches

4 tulips

VESSEL

Handmade
ceramic vase

Choose a tall vase with clean lines that will emphasize the height of this arrangement.

2 Trim the stems of mock orange so that their height is twice that of the vase, letting them lean to the left side.

3 Trim the stems of hellebore and add them to the front and right side of the vase, allowing some of the blooms to hang down over the rim.

4 Trim the olive branches and add one toward the back center of the arrangement. Place the remaining two branches in the lower right side of the vase so that they arc out to the right. Trim and add three tulips to the center and right side, resting the blooms just above the rim. Trim and add the remaining tulip stem so that it's slightly higher than the others on the right side.

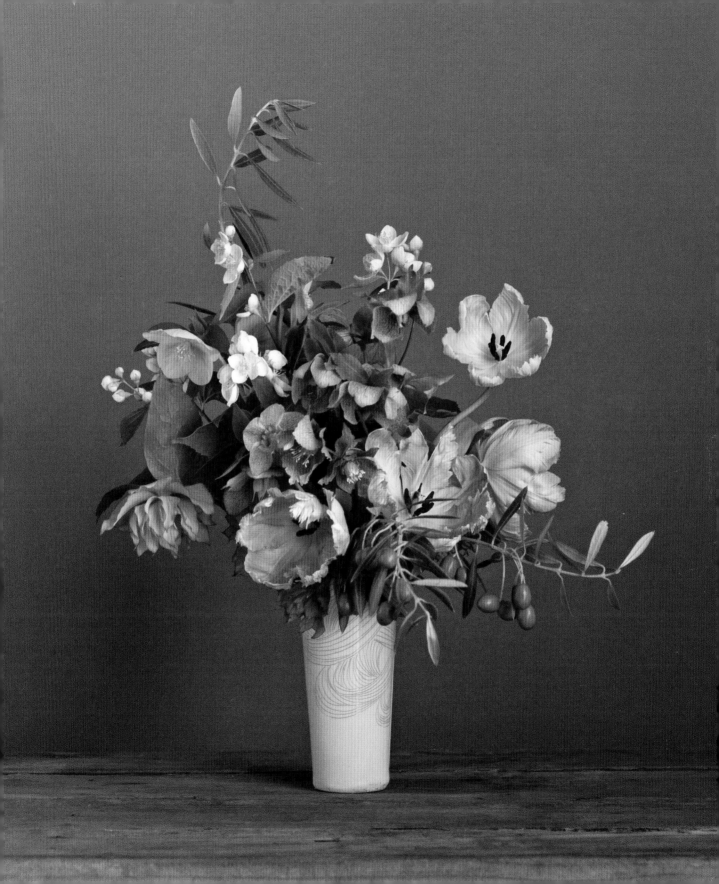

HYACINTH *(HY-ah-sinth)*

AVAILABLE COLORS: blue, pink, purple, white, yellow

These fragrant spring bulbs are easily forced even when indoors, and their bright white roots look stunning when displayed in clear glass. Individual blossoms can also be cut from the stems and strung for a petite garland. Select stalks with buds that are still tightly closed; they are lovely to watch and smell as they open. Beware their slippery sap—it can cause skin irritation and may be poisonous to other flowers.

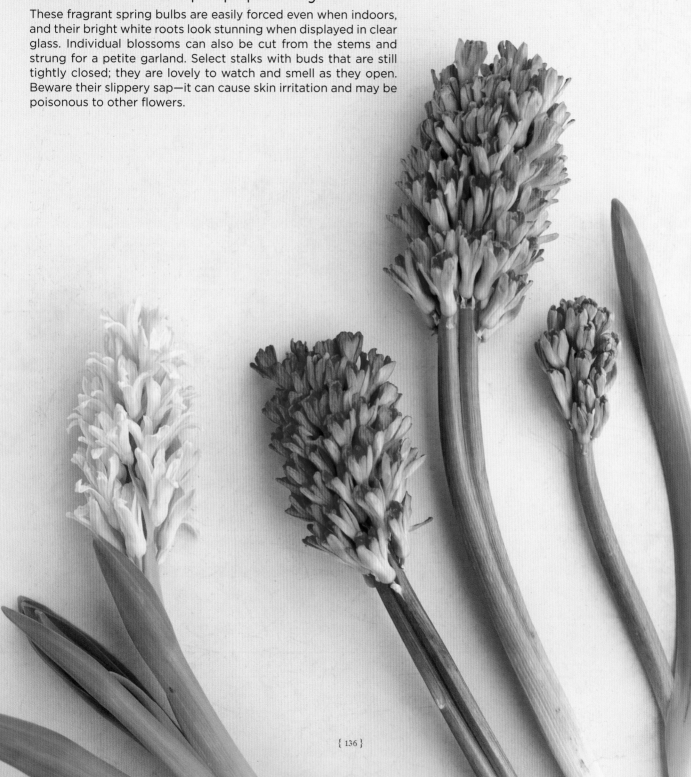

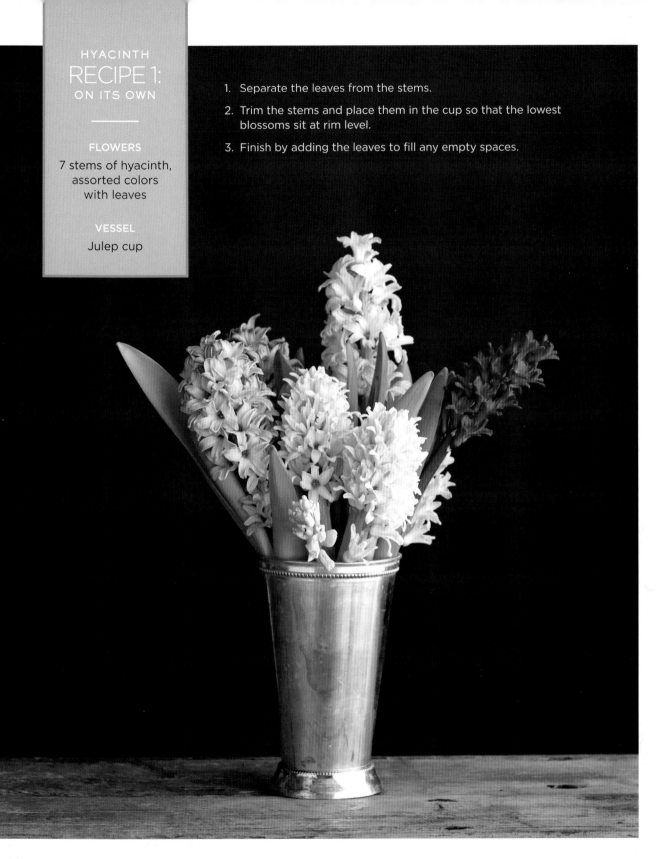

HYACINTH
RECIPE 1:
ON ITS OWN

———

FLOWERS
7 stems of hyacinth,
assorted colors
with leaves

VESSEL
Julep cup

1. Separate the leaves from the stems.

2. Trim the stems and place them in the cup so that the lowest blossoms sit at rim level.

3. Finish by adding the leaves to fill any empty spaces.

HYACINTH
RECIPE 2:
WITH COMPANY

FLOWERS

5 sprigs of mint

5 stems of hyacinth

3 stems of
ranunculus

VESSEL

Handmade ceramic
creamer

1 | Choose a creamer in a dark shade that contrasts with the flowers' springlike pastel colors.

2 | Trim the sprigs of mint and add them to the creamer so that the bottom leaves rest on the rim.

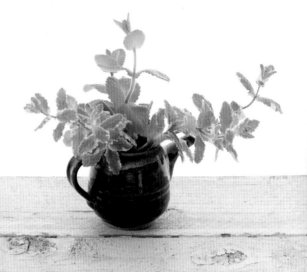

3 | Trim and add the hyacinth stems in a low cluster to one side of the creamer. Adjust the mint sprigs so that they pop up between the flowers.

4 | Trim and add two stems of ranunculus to the left side of the creamer so that the blooms line up with the top of the hyacinth. Finish by trimming and nestling the third stem of ranunculus among the hyacinth.

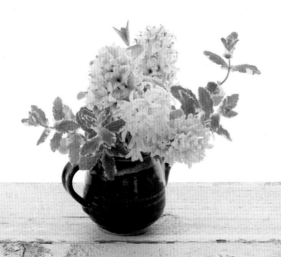

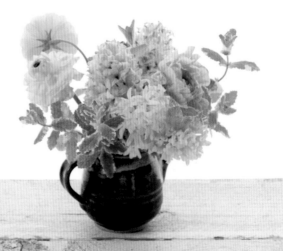

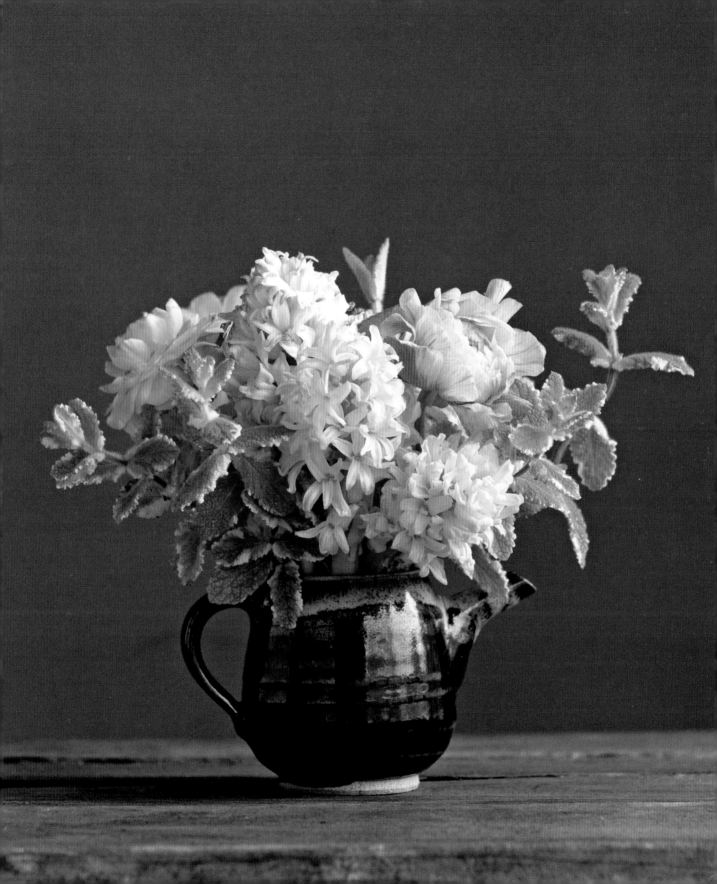

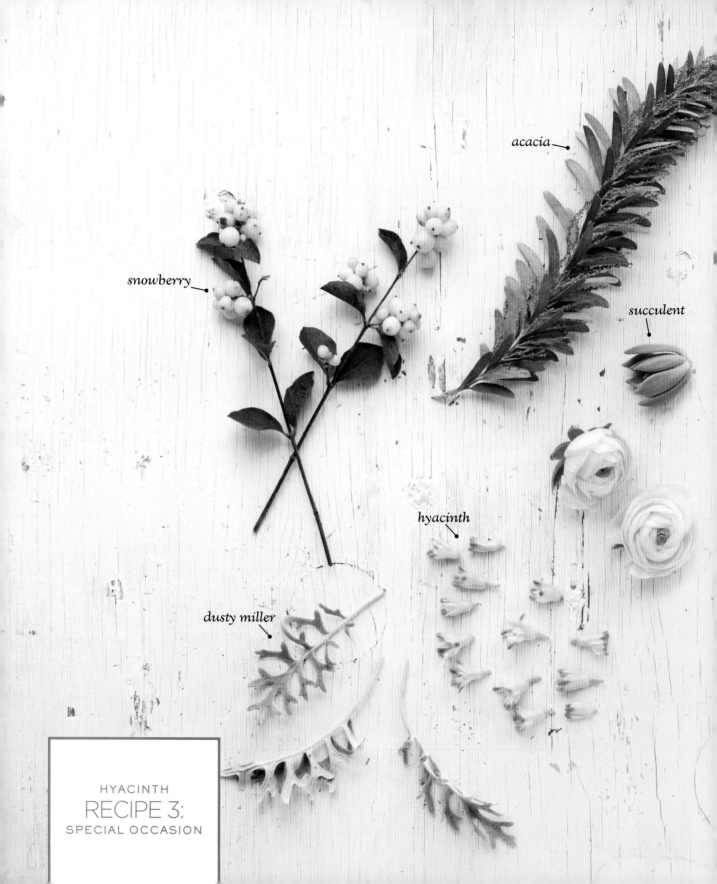

acacia

snowberry

succulent

hyacinth

dusty miller

HYACINTH
RECIPE 3:
SPECIAL OCCASION

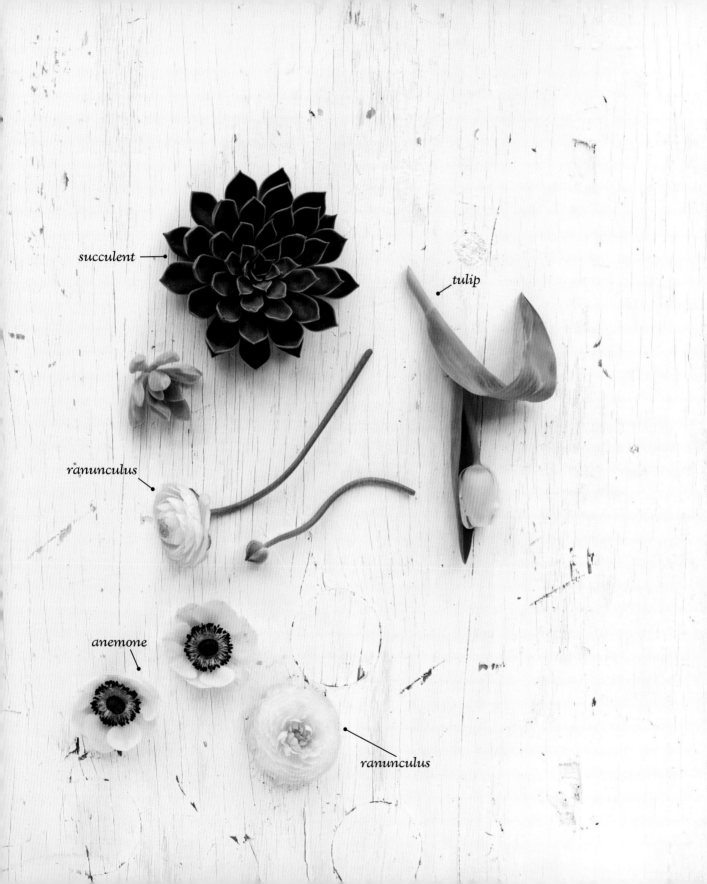

succulent

tulip

ranunculus

anemone

ranunculus

RECIPE 3:

SPECIAL OCCASION

FLOWERS

3 branches of acacia

1 stem of dusty miller

4 succulents, 1 large and 3 small

4 stems of hyacinth

3 branches of snowberries

5 tulips

3 stems of ranunculus

2 anemones

VESSEL

Glass apothecary jar

1 Trim and add one branch of acacia so that it drapes over the front left side of the jar. Trim and add the remaining branches to the back of the jar, with the longest branch arcing up and to the left. Trim and add the stem of dusty miller to the front.

2 Wire the large succulent (see page 16) and rest it on the rim of the right side of the vase.

3 Trim the stems of hyacinth and add one stem between the two branches of acacia on the left; place another stem in the back behind the succulent. Cluster the remaining two stems at the front, trimming so that the bottom blooms rest at the rim of the jar.

4 Trim and add the snowberries, placing the tallest two branches on the right side in the back, and the third branch to the center of the arrangement so that the berries sit just above the hyacinth.

5 Place four trimmed tulip stems on the left side so that the blooms in the middle are shorter and the ones farthest to the left are longer. Add the last tulip, trimming so that the bloom sits just below the hyacinth on the right side.

6 Add two stems of ranunculus and anemones to the center and right side of the arrangement, trimming to varied heights. Trim and add the last stem of ranunculus to the back left, balancing the tall stems of snowberries on the right.

7 Wire the small succulents and cluster them above the large succulent.

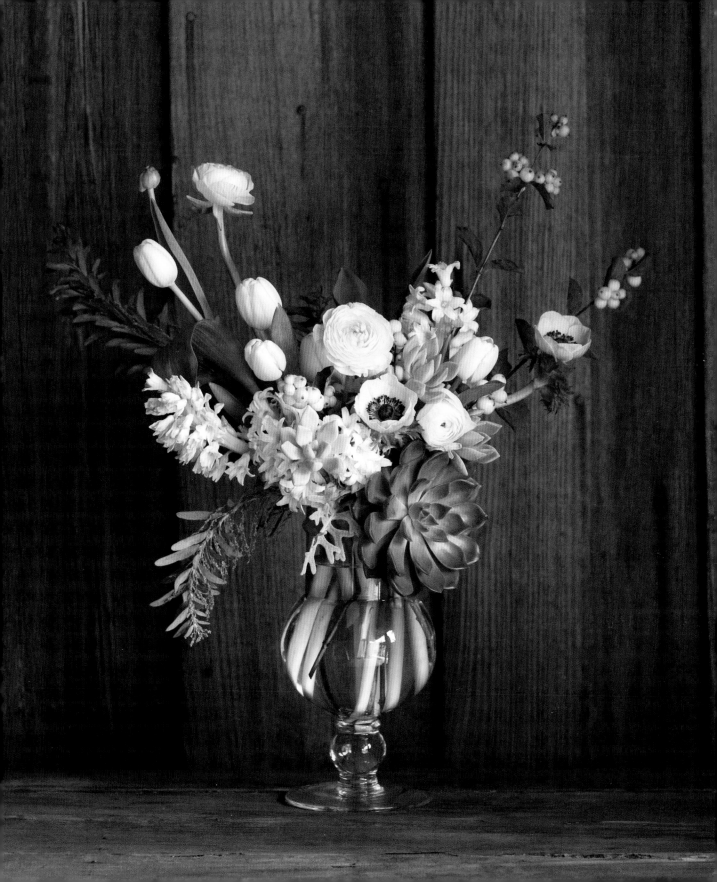

HYDRANGEA
(hi-DREYN-juh)

AVAILABLE COLORS: blue, green, pink, purple, white

The cotton-candy-like clusters of hydrangea make it an ideal base to feed other flowers through in an arrangement. And because its large head is filled with so many florets, a single stem can feel like a full bouquet. *Hydra* means "water" in Greek, so it shouldn't be a surprise that hydrangeas like to drink; check their water level daily and top off as needed. Dip freshly cut stems into alum powder (a pickling spice) before adding into an arrangement to help prevent blooms from wilting (see page 15).

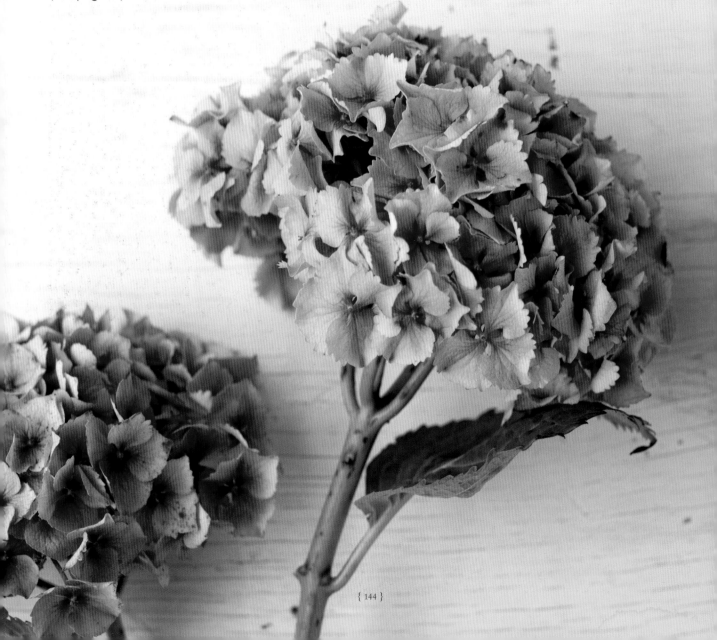

HYDRANGEA
RECIPE 1:
ON ITS OWN

FLOWERS
12 assorted stems
of hydrangea

VESSELS
Long and low
wooden box;
9 small bottles

1. Fill the bottles three-fourths full with water and line them up next to each other in the box.

2. Cut all the stems to a similar height. Dip the stem of a light-colored bloom in alum (see page 15), and add it to the bottle at the left side of the box. Make sure the bottom of the bloom hangs a few inches over the rim of the box.

3. Continue the process with the rest of the hydrangeas, gradating the color of the flowers from light to dark as you move from left to right.

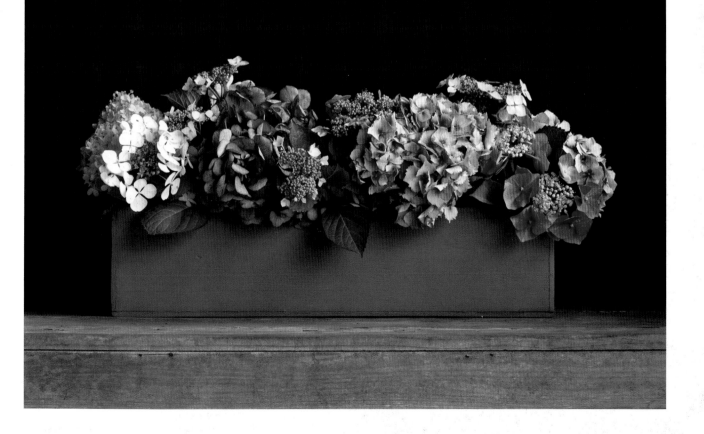

FLOWERS

1 stem of hydrangea

5 branches of
blackberries

9 wired and
skewered succulents
(see page 16)

8 stems of
flowering oregano

MATERIALS

3-foot length of
1-inch ribbon

Hold the stem of
hydrangea at the base
just below the leaves.

2 Add the branches of blackberry to the
grouping in hand, feeding them through
the florets of the hydrangea so that the
berries sit just above the bloom.

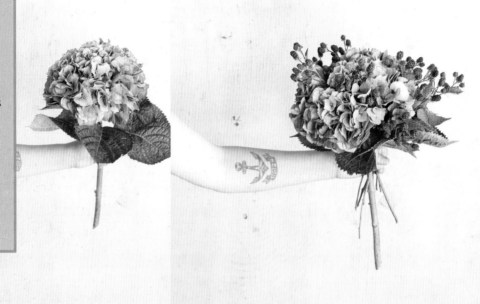

3 Feed the succulents into the
hydrangea so that the bottoms of the
succulents are resting on the florets,
clustering them more densely on the
left side.

4 Add one stem of flowering oregano
to the back left so that it arcs to
the left and slightly above the other
elements. Scatter the remaining stems
of oregano throughout. Then tape the
base of the bouquet under the leaves
of the hydrangea with floral tape.
Finish by trimming the stems and
wrapping and tying the ribbon around
the base to cover the floral tape.

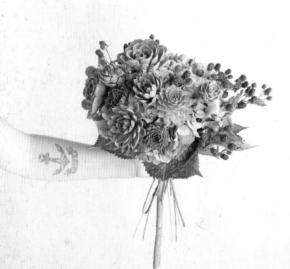

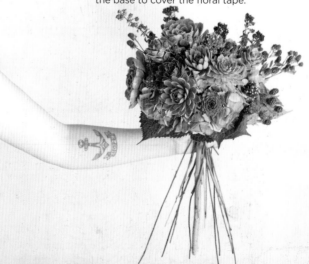

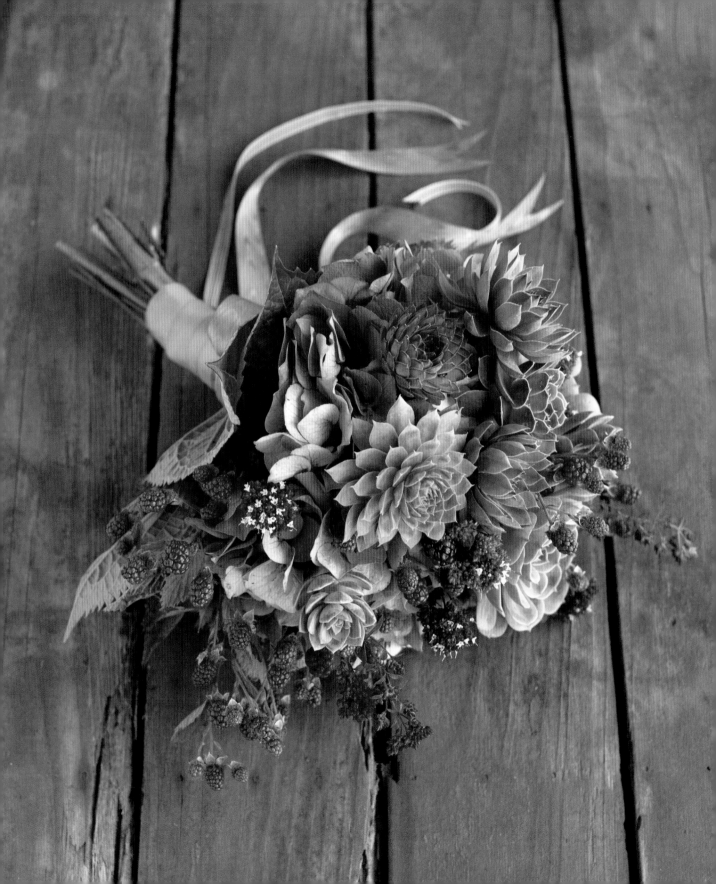

HYPERICUM BERRY
(hi-PARE-ih-kum BER-ee)

AVAILABLE COLORS: brown, cream, green, peach, pink, red

More commonly known as Saint-John's-wort, hypericum flowers bloom yellow with a pincushionlike center. After blooming, they give way to the plant's shiny, berrylike fruit. These berries are not edible and won't leave stains or messes if they fall off their branches, making them much easier to deal with than other decorative berries. Long-lasting out of water, the stems add unique shape and texture to boutonnieres and wreaths.

FLOWERS

6 stems of
hypericum berries

3 stems of berzelia

5 stems of
flowering mint

5 stems of
ranunculus

VESSEL

Vintage tin

1. Create a loose bunch of the hypericum berry stems in your hand, lining up the lowest berries. Remove all the leaves, trim the stems, and place them in the tin together so that the berries rest on the rim.

2. Trim and add the stems of berzelia through the base of hypericum so that the round ends sit just above the berries.

3. Trim and add the stems of the mint next to the berzelia so that the flowers sit a few inches higher than the base layer.

4. Finish by adding the ranunculus, trimming four stems to rest on top of the base layer in the front, and one stem so that it arcs up a few inches above the base on the right.

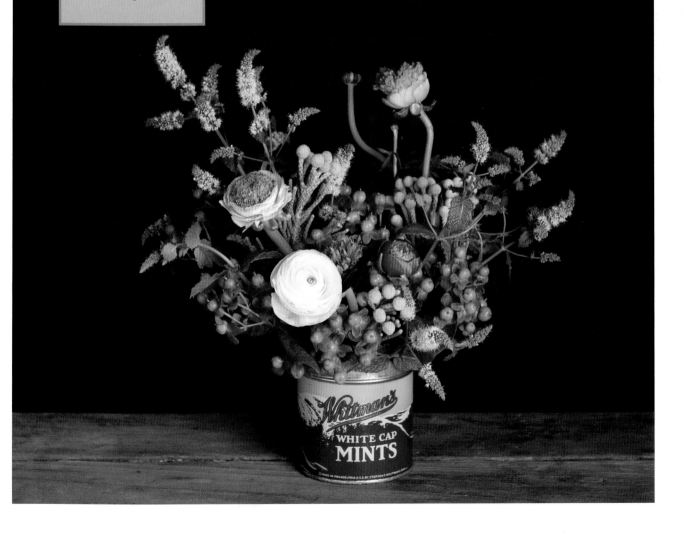

HYPERICUM BERRY
RECIPE 2:
ON ITS OWN

FLOWERS

30 stems of
hypericum berries

MATERIALS

10-inch wire
wreath frame

20-gauge
paddle wire

2-foot length
of ribbon

Cut the hypericum
stems to about
6 inches long and
remove the leaves
below the berries.

2 In your hand, lay two stems on top of
each other to create a small bundle
and place it on the frame. While
pinching the stems together at the
base of the berries, wrap the paddle
wire around the bundle and frame
several times. Do not cut the wire
from the paddle until the wreath is
completed.

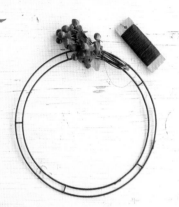

3 Make a second small bundle and
lay it on top of the first, covering
the stems of the first bundle with
the berries of the second. Hold the
bundle on the frame and wrap the
paddle wire around the bundle and
frame several times. Continue making
and attaching the small bundles of
hypericum around the frame.

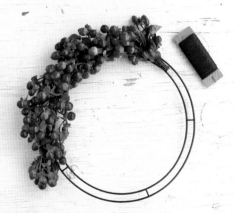

4 Finish by placing the last bundle
on the frame, tucking the stems
underneath the berries of the first
bundle. No parts of the frame or
stems should be visible. Carefully
wrap the paddle wire around the last
bundle and the frame several times.
Cut the wire and tuck the end inside
the wreath and attach a ribbon for
hanging.

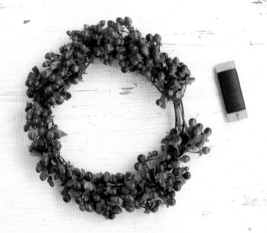

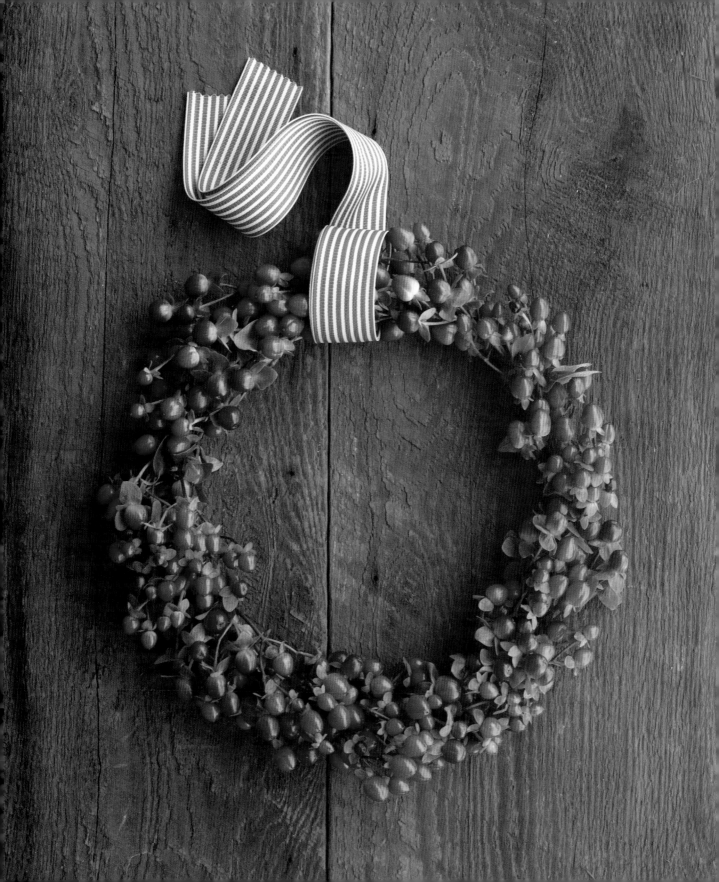

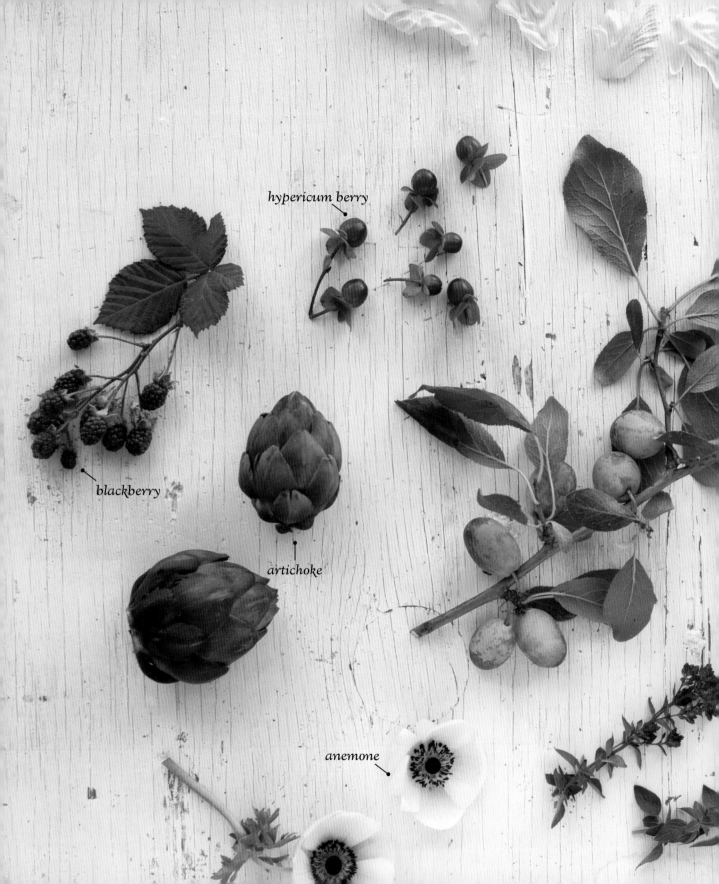

hypericum berry

blackberry

artichoke

anemone

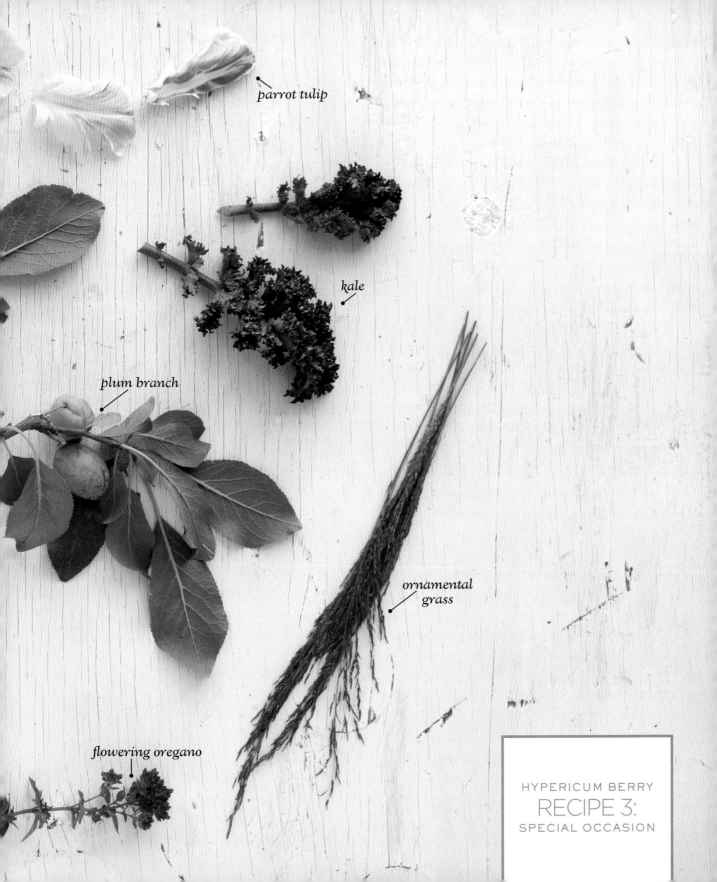

parrot tulip

kale

plum branch

ornamental grass

flowering oregano

RECIPE 3:

SPECIAL OCCASION

FLOWERS

1 forked branch of plum

1 stem of kale

4 artichokes

3 stems of blackberries

3 stems of hypericum berries

4 parrot tulips

4 anemones

6 stems of ornamental grass

3 stems of flowering oregano

VESSEL

Metal cylinder

1 Start by trimming the plum branch so that the fork sits wedged tightly inside the cylinder, allowing one section of the branch to stand up tall in the center and the other section to arc far out on the left side. Trim and add the kale on the right side of the cylinder so that the bottom leaves rest on the rim.

2 Trim and add two of the artichokes to the center and left side, so that the bottoms of the heads start a few inches above the rim. Add the remaining artichokes, trimming them taller so that the heads pop up next to the tall section of plum.

3 Add in two stems of blackberries and three stems of hypericum berries, trimming so that the berries fill in around the artichoke in the center. Trim and add the remaining stem of blackberries so that it cascades over the rim on the left side of the cylinder.

4 To balance the long branch of plum and the artichokes on the left side of the composition, add the stems of tulips and the anemones, trimming so that the blooms sit lower in the center and higher on the right.

5 Trim and add the stems of ornamental grass to the lower left side so that the tips arc down near the plum. Finish by adding in the trimmed stems of flowering oregano to the upper right side.

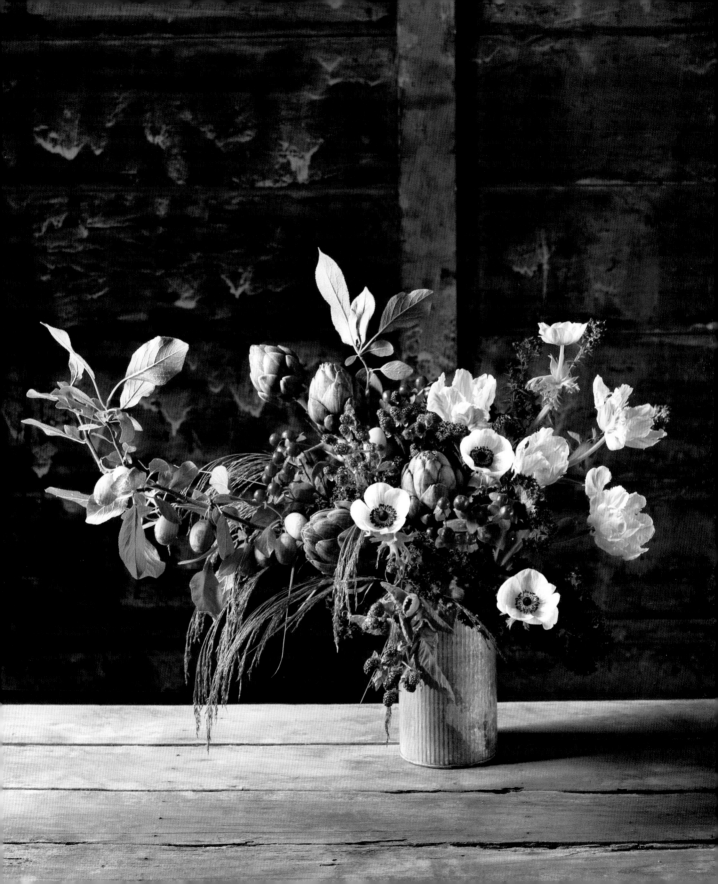

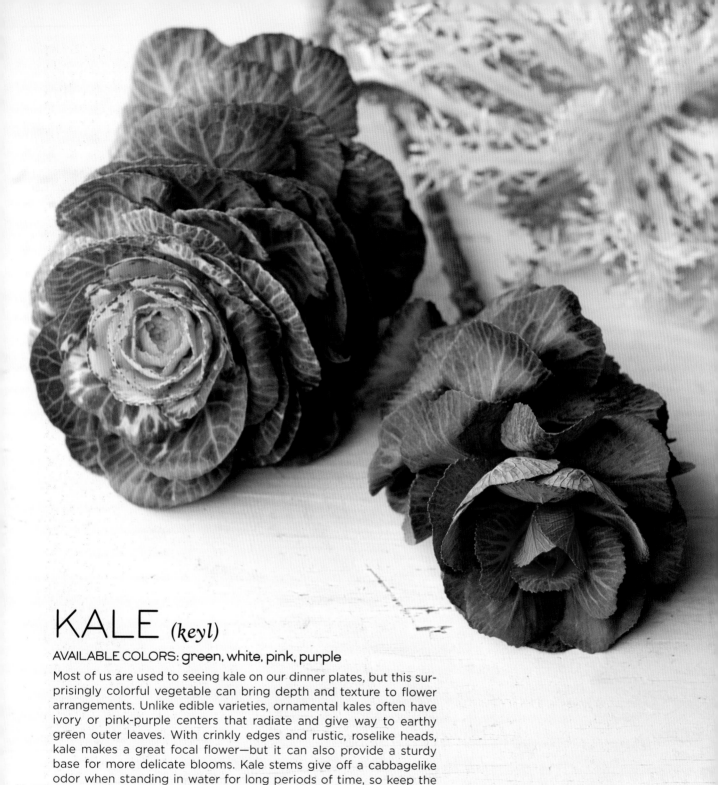

KALE *(keyl)*

AVAILABLE COLORS: green, white, pink, purple

Most of us are used to seeing kale on our dinner plates, but this surprisingly colorful vegetable can bring depth and texture to flower arrangements. Unlike edible varieties, ornamental kales often have ivory or pink-purple centers that radiate and give way to earthy green outer leaves. With crinkly edges and rustic, roselike heads, kale makes a great focal flower—but it can also provide a sturdy base for more delicate blooms. Kale stems give off a cabbagelike odor when standing in water for long periods of time, so keep the waterline as low as possible and change the water daily.

KALE

RECIPE 1:
ON ITS OWN

———

FLOWERS

3 stems of kale,
assorted varieties

VESSELS

3 laboratory
beakers, in assorted
heights

1. Trim and add the longest stem of kale to the tallest beaker so that the lowest leaves rest at the rim.

2. Next, add the kale with the largest head to the medium beaker, trimming so that the bottom leaves rest on the rim of the beaker.

3. Trim and add the remaining stem to the smallest beaker.

4. Arrange the beakers into a pleasing composition, and then turn the heads of kale so that they lean in different directions.

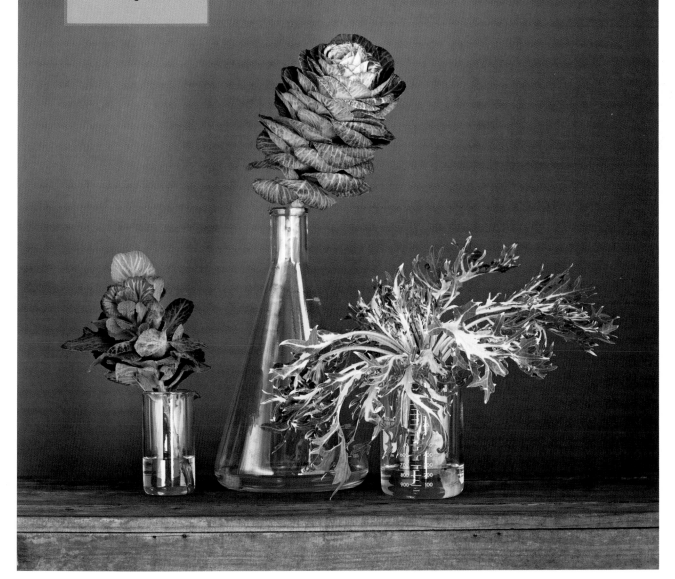

RECIPE 2:
WITH COMPANY

———

FLOWERS

2 stems of rose hips

3 stems of sedum

2 stems of
leucadendron

2 stems of kale

7 marigolds

VESSEL

Handmade
ceramic vase

Select a vase with colors
that complement the
palette of the flowers.

2 Trim and add one stem of rose hips
to the back center, and one stem to
the front right side of the vase. Add
the stems of sedum next, trimming
so that they are clustered front and
center. Add the leucadendron so that
the ends stick out several inches from
the sedum on the left and right sides.

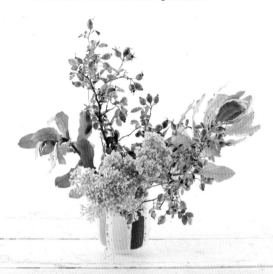

3 Trim and place one stem of kale in
the center so that the head rests
on the sedum; trim the other stem
slightly longer and place it so
that it is angled to the back of
the composition.

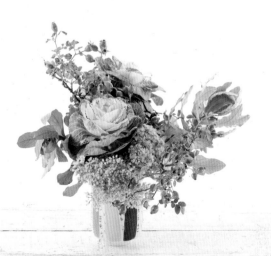

4 Trim and add three stems of
marigolds, clustering them low in
the center to the right of the kale.
Finish by trimming and adding the
remaining stems so that the blooms
sit a few inches above the other
flowers at varied heights.

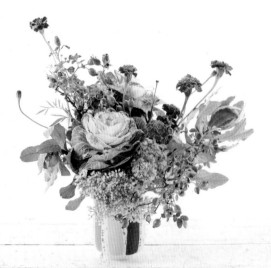

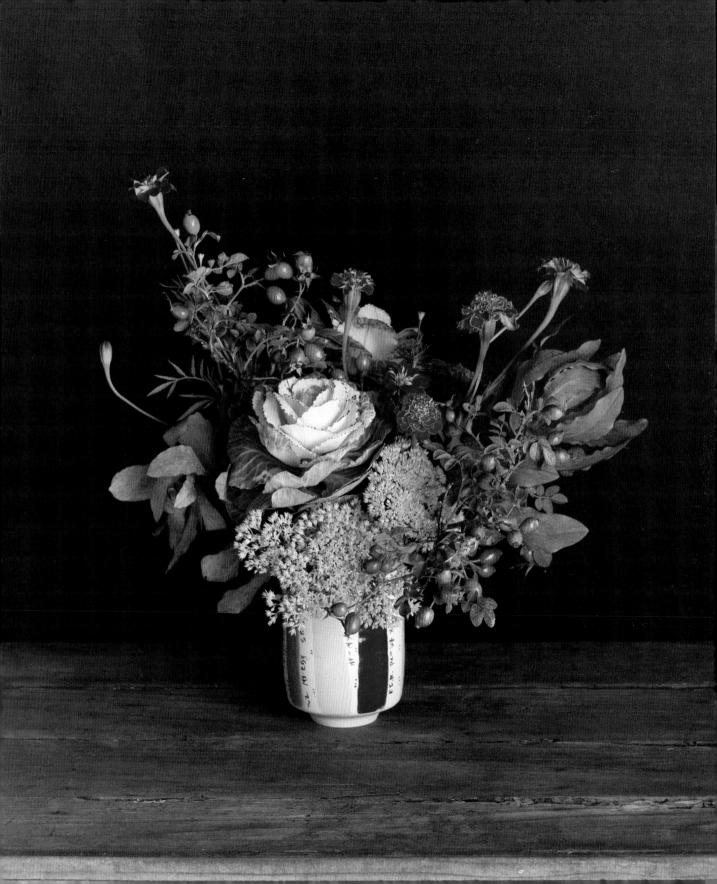

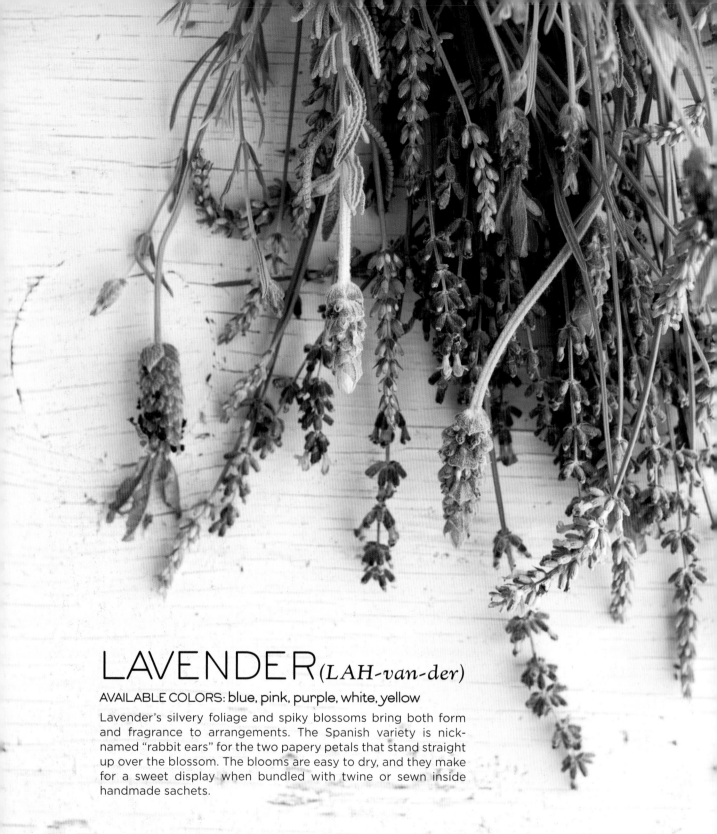

LAVENDER *(LAH-van-der)*

AVAILABLE COLORS: blue, pink, purple, white, yellow

Lavender's silvery foliage and spiky blossoms bring both form and fragrance to arrangements. The Spanish variety is nick-named "rabbit ears" for the two papery petals that stand straight up over the blossom. The blooms are easy to dry, and they make for a sweet display when bundled with twine or sewn inside handmade sachets.

LAVENDER

RECIPE 1:
ON ITS OWN

FLOWERS
3 bunches of
lavender, assorted
varieties

VESSELS
3 cups with
metallic accents

1. Choose an appropriate cup for each lavender variety, taking into account bunch size and stem length.

2. Begin with the variety that has the tallest stems. Loosely line up the bottom blooms, creating a small bunch in your hand. Trim the stems to a length that is approximately twice the height of the first cup. Place the bunch in the cup.

3. Repeat with the other two lavender varieties, turning the stems so that the heads arc out at interesting angles. Arrange the cups into a pleasing composition.

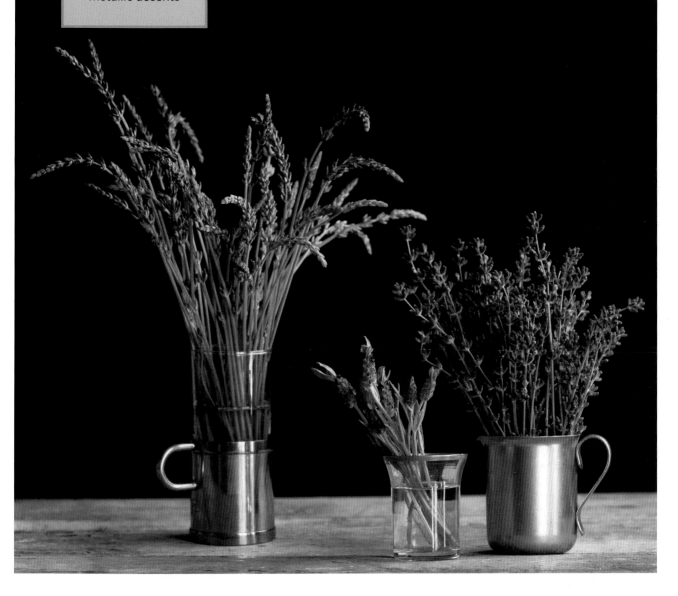

1 Choose a pedestal cup with a shallow bowl to showcase the graceful drape of the flowers. Create small bundles of the ingredients (short herbs from a farmers' market work perfectly) and secure with rubber bands, keeping each type of flower separate. Make two small bunches with the sage.

2 Trim and place the monarda bunch so that it drapes over one side of the cup.

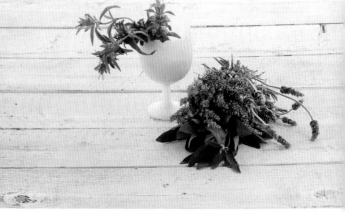

3 Trim and place the lavender bunch with the bushiest foliage first, with the lowest leaves starting just under the rim of the cup.

4 Trim and add the remaining bunches of lavender at the front and back of the cup. Finally, trim and add the sage, draping it over the rim on both sides of the monarda.

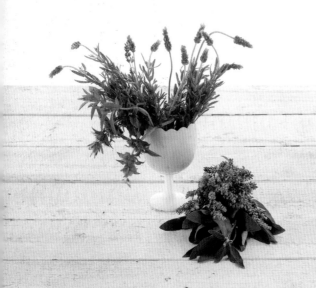
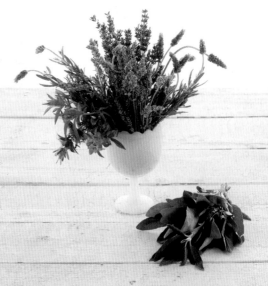

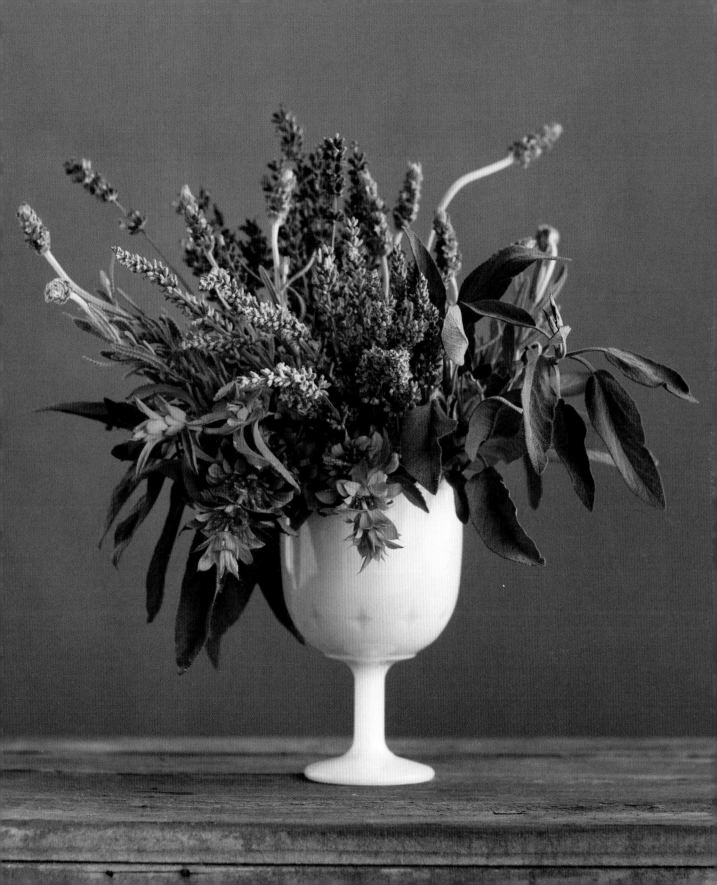

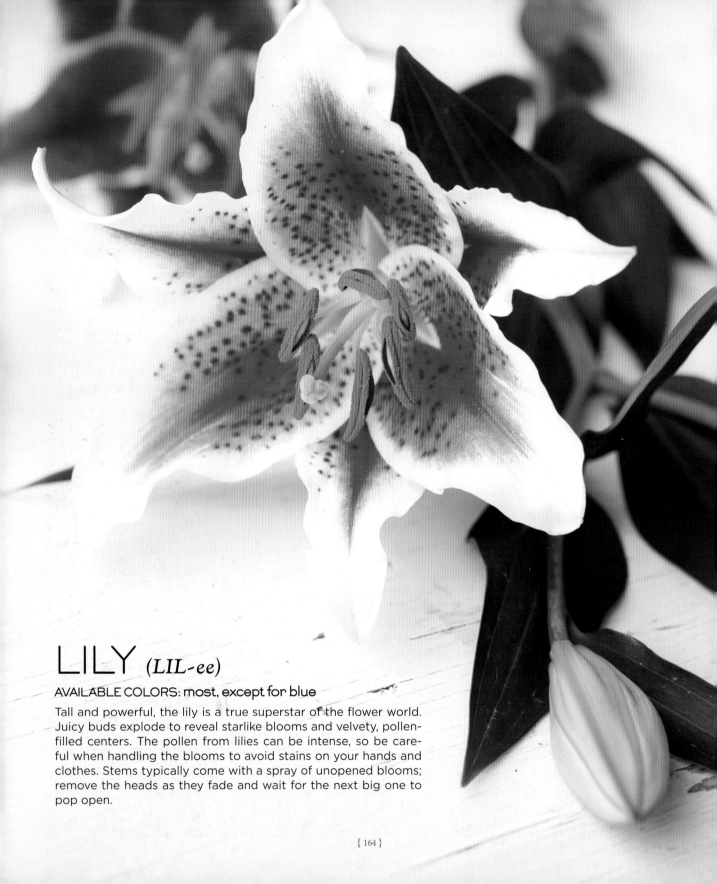

LILY (*LIL-ee*)

AVAILABLE COLORS: most, except for blue

Tall and powerful, the lily is a true superstar of the flower world. Juicy buds explode to reveal starlike blooms and velvety, pollen-filled centers. The pollen from lilies can be intense, so be careful when handling the blooms to avoid stains on your hands and clothes. Stems typically come with a spray of unopened blooms; remove the heads as they fade and wait for the next big one to pop open.

LILY
RECIPE 1:
ON ITS OWN

FLOWERS
4 lilies with buds
and blooms

VESSEL
Tall glass cylinder

1. Make a tape grid across the top of the cylinder so that the openings on the grid are approximately the same width as the lily stems (see page 17).

2. Trim the first stem and place it through an opening in the grid on the right side so that the blooms are angled to the right. Repeat with the next two stems, placing them through openings in the grid that are next to each other.

3. Trim and place the remaining stem next to the others but leaning to the left, creating a triangular shape in the arrangement.

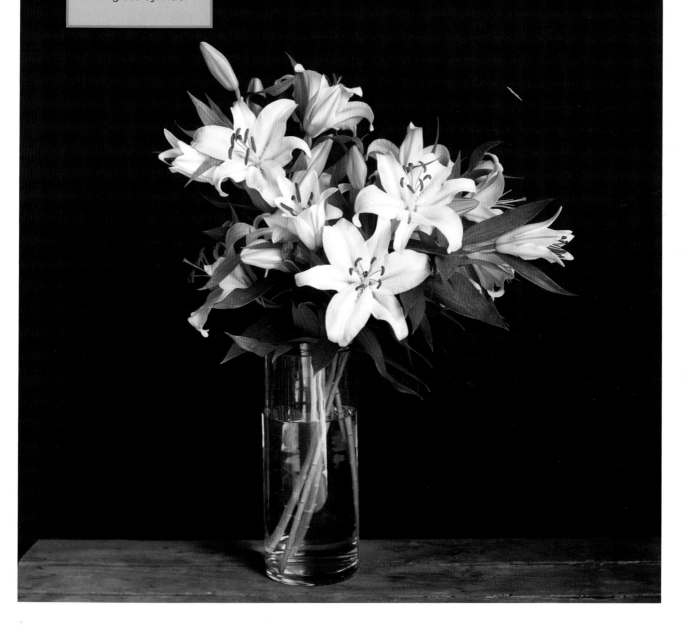

RECIPE 2:
WITH COMPANY

FLOWERS

3 small branches of
hawthorn berries

3 sprays of
alstroemeria

2 lilies

3 stems of cyclamen

VESSEL

Enamel cup

A small, low cup is
the perfect vessel for
a few large blooms.

2 Trim and add two branches of
hawthorn berries to the left side of
the cup and one to the right side so
that the clusters of berries and leaves
rest on the rim.

3 Trim and add the alstroemeria sprays
low and in between the branches of
hawthorn to provide a base for the
other stems.

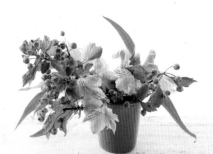

4 Add the lilies, trimming the stems so
that they sit low in the cup with the
lowest blooms resting on the rim.
Finish by trimming and adding two
stems of cyclamen on the left, and
one stem on the right.

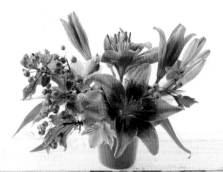

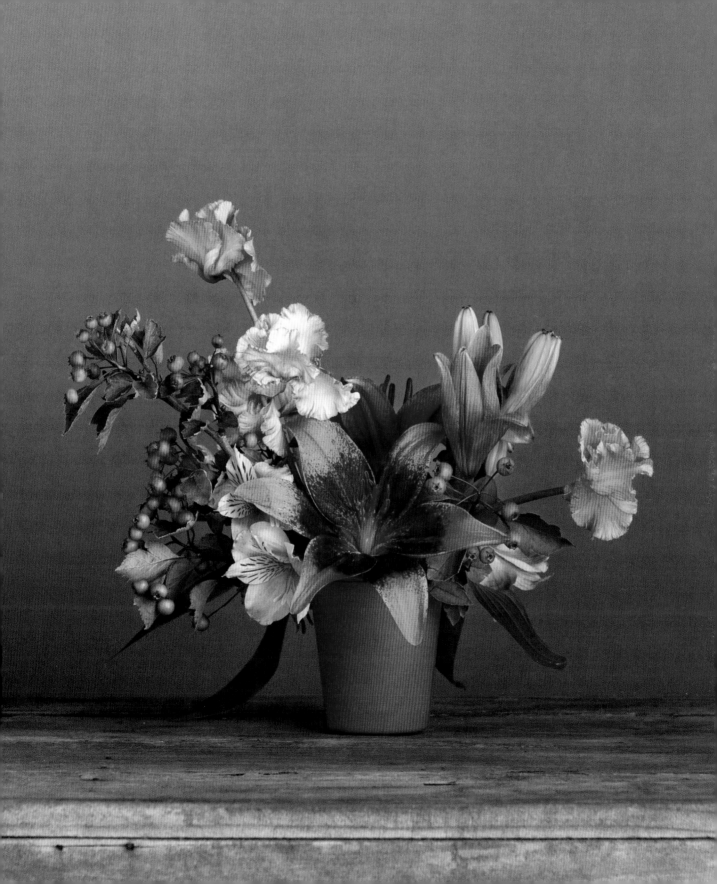

LISIANTHUS
(liz-ee-AN-thus)

AVAILABLE COLORS: pink, purple, white

Despite its delicate appearance, lisianthus is a tough little flower that thrives in the hot grasslands of the United States and Mexico. So it's no surprise that lisianthus can last a few weeks in an arrangement. When the full petals of this bell-shaped flower swirl open, it could easily be mistaken for a rose, but it's much hardier. Look for stems with mature buds, or, to ensure longevity, with only one or two open blooms.

LISIANTHUS
RECIPE 1:
ON ITS OWN

———

FLOWERS

20 open blooms
of lisianthus

VESSEL

Dark-colored
wineglass

1. Place a flower frog in the bottom of the glass and secure with floral putty.

2. Trim the first stem and add it to the glass so that the bottom of the bloom rests right at the rim. Add the next bloom in the same way, working around the entire rim. The edges of the blooms should touch.

3. Continue to trim and add blooms to the center of the composition until you create a dome shape.

LISIANTHUS
RECIPE 2:
WITH COMPANY

———

FLOWERS

5 stems of lisianthus

4 stems of
amaranthus

5 roses

3 branches of
viburnum berries

4 small feathers

VESSELS

3 small glass cups

1 | Choose three small cups of uniform size and shape to create a wide and airy arrangement. (Our cups came wrapped in burlap.)

2 | Trim six open blooms from the stems of lisianthus and set them aside. Cut apart the lisianthus stems into 8-inch sections (page 14). Trim and add two pieces to each cup. Trim and add a third piece to the cups on the right and left, angling the tips so that they reach out wide on both sides. Trim and add two of the reserved open blooms to each cup, keeping the bottom of the blooms close to the rims.

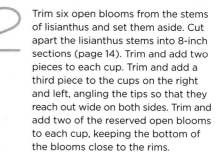

3 | Trim and add one stem of amaranthus to each cup so that the bottom of the bloom rests on the rim. Add the remaining stem to the center cup so that the tip of the bloom sits at the highest point in the composition.

4 | Trim and place two roses in the cups on the ends and one in the center cup, clustering them around the open blooms of lisianthus. Next, trim the branches of viburnum berries and add one to each cup. Finish by tucking in the feathers around the roses.

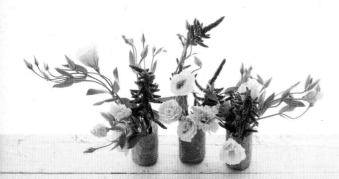

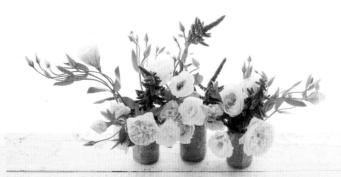

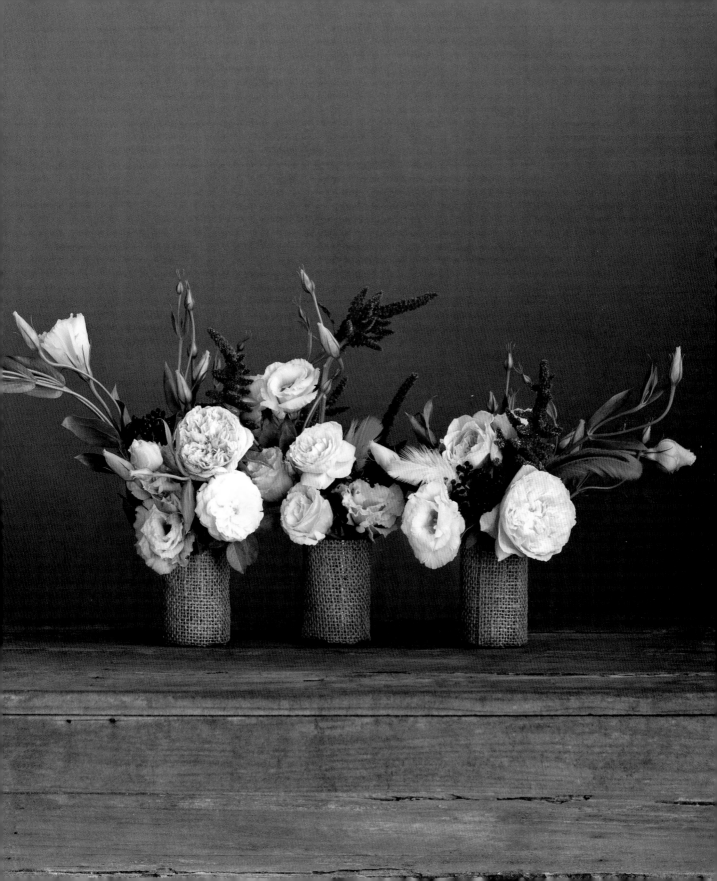

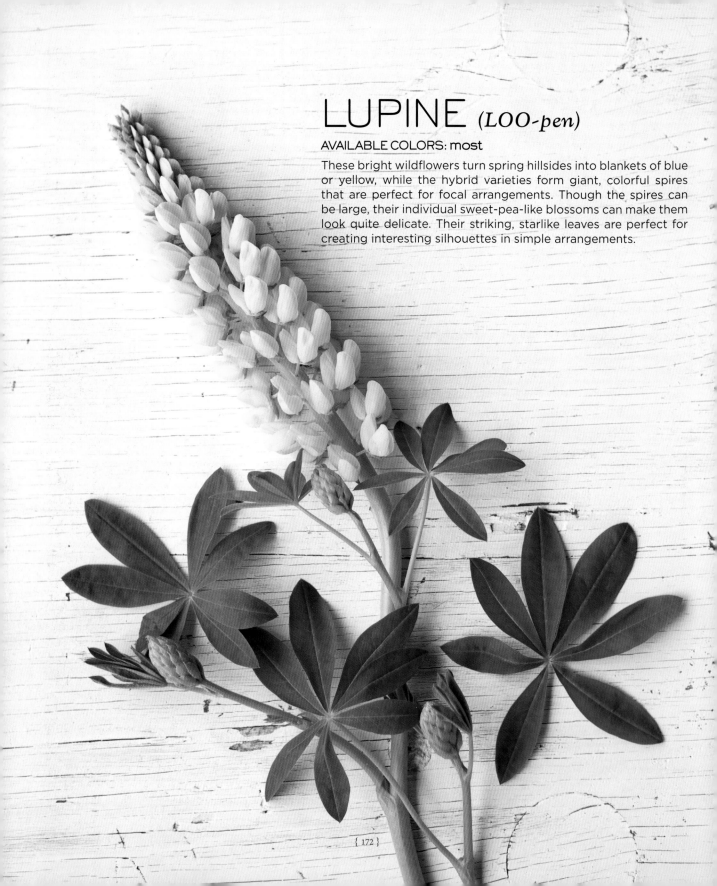

LUPINE *(LOO-pen)*

AVAILABLE COLORS: most

These bright wildflowers turn spring hillsides into blankets of blue or yellow, while the hybrid varieties form giant, colorful spires that are perfect for focal arrangements. Though the spires can be large, their individual sweet-pea-like blossoms can make them look quite delicate. Their striking, starlike leaves are perfect for creating interesting silhouettes in simple arrangements.

LUPINE

RECIPE 1:
ON ITS OWN

———

FLOWERS
3 stems of lupine
with leaves

VESSEL
Handmade
ceramic cup

1. Select a flower frog large enough to fill the bottom of the cup and use floral putty to hold it in place.

2. Cut the leaves from the stems and secure them in the frog at gravity-defying angles. One leaf should arc up several inches above the rim on the right side.

3. Trim and add two stems of lupine so that the blooms fill the center of the composition.

4. Place the last lupine so that its spire juts out to echo the arc of the leaf on the opposite side of the cup.

Choose a tall but narrow vase that will support the spires.

2 Trim and place the stems of lupine in the vase one at a time, being careful not to smash the delicate leaves together. Once all the stems are added, remove a few leaves from the front of the composition to make space for the additional ingredients.

3 Trim and add the dahlias, creating a cluster of three blooms in the front and one slightly higher in the back. Trim and add the last stem high on the left side to balance out the tallest lupine on the right.

4 Trim and add two of the scabiosa stems on the left, letting them drape out to the left side of the vase. Finish by trimming and adding the remaining stems in the center at the front and back of the composition.

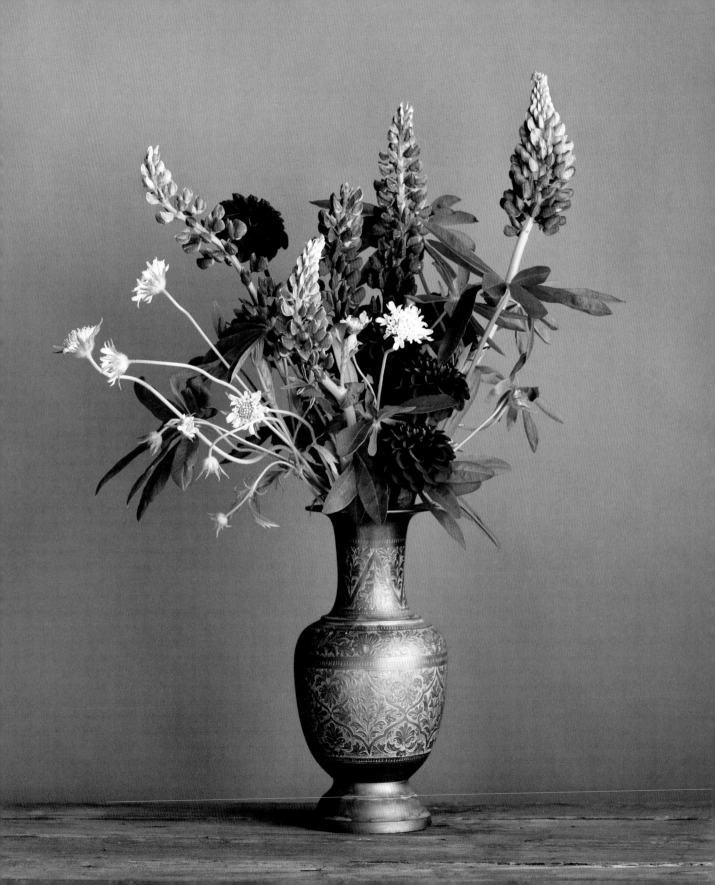

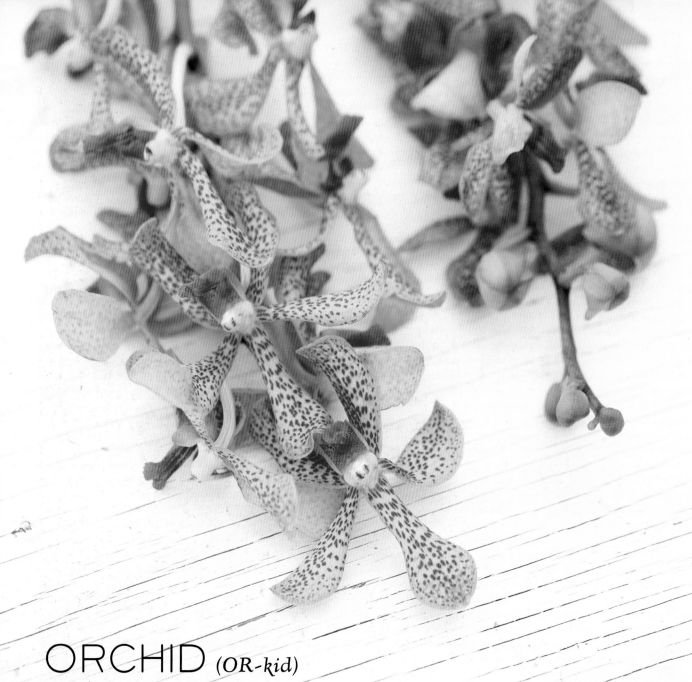

ORCHID *(OR-kid)*

AVAILABLE COLORS: most, except for blue

With more than twenty thousand different species, orchids are
members of one of the largest families in the plant kingdom. Some
orchids thrive on high branches, while others love dark, dank for-
est floors; their unusual colors, shapes, and patterns have made
orchids a perennial favorite. Resilient varieties *phalaenopsis* and
cymbidium are the most common types available, although they
come in many shapes and sizes.

ORCHID
RECIPE 1:
ON ITS OWN

———

FLOWERS
6 stems of orchids

VESSEL
Ceramic trophy urn

1. Secure a flower frog to the bottom of the urn with floral putty.

2. Trim and add the stems of orchids to the urn so that the lowest blooms rest on the rim. Position the stems so that they arc in different directions; the blooms should be evenly distributed.

FLOWERS

6 stems of rosehips

17 scabiosa pods

6 orchid blooms,
trimmed and placed
in water tubes

MATERIALS

12-foot length of
dried honeysuckle
vine

1 Loosely coil the
honeysuckle vine into
the shape of a wreath.

2 Wrap a single point with wire on the
left side so that one side is gathered
tightly and the other side is loose.

3 Add three stems of rosehips above
and below the gathered spot, weaving
the lower part of the stems into the
wreath. Adjust so that the stems
loosely follow the curve of the wreath
along the top and bottom and secure
with wire.

4 Add two groupings of scabiosa pods
to the top of the wreath just above
the gathered spot, and a second
grouping with the remaining pods
below it, tucking the stems into the
wreath and securing with wire. Finish
the arrangement by clustering the
water-tubed orchid blooms around
the gathered spot to obscure the
wiring. Change the water every few
days to extend the life of the blooms.

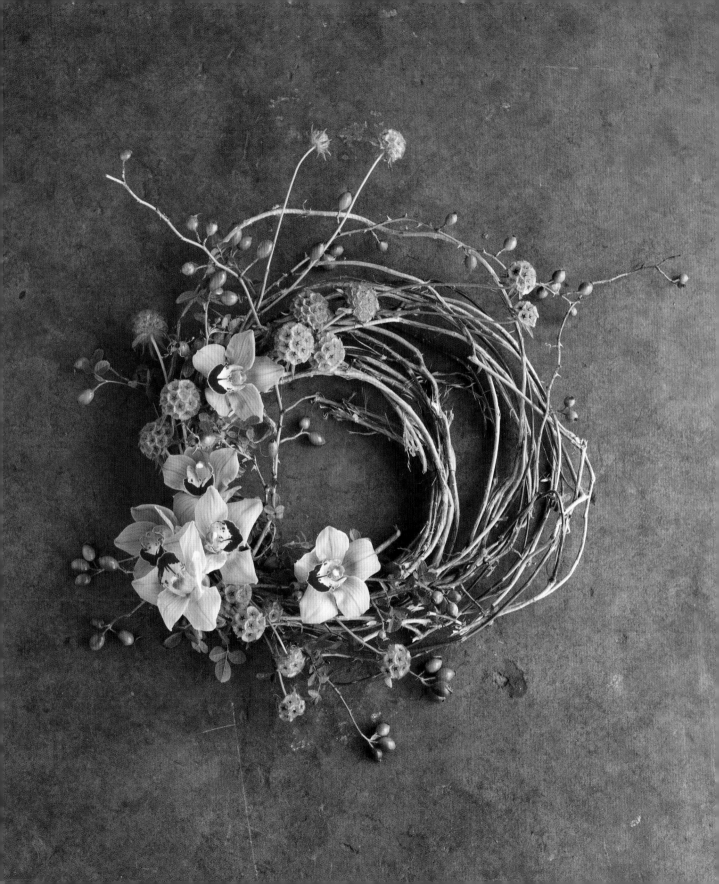

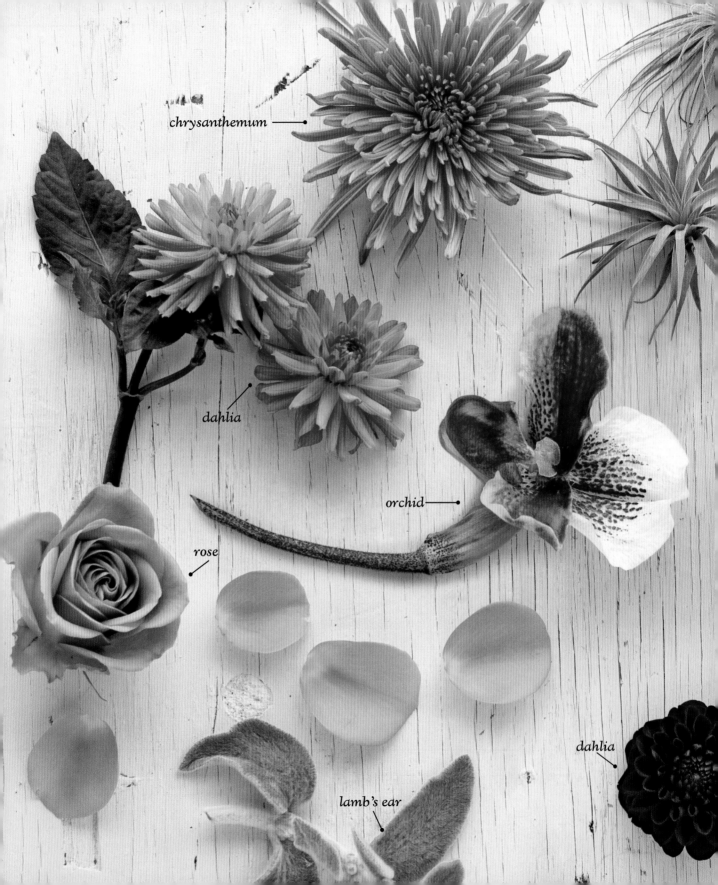

chrysanthemum

dahlia

orchid

rose

dahlia

lamb's ear

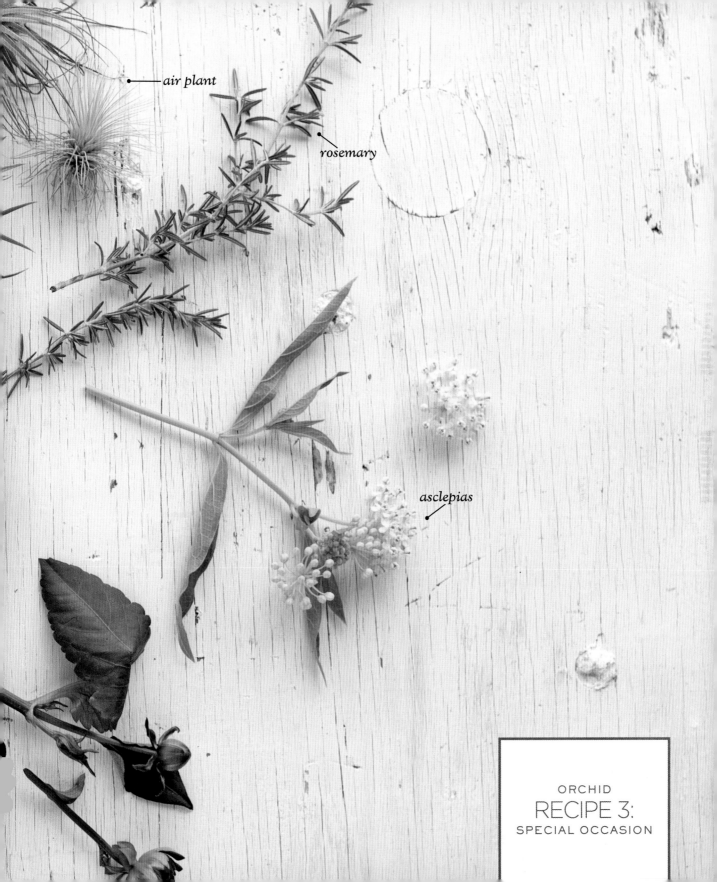

air plant

rosemary

asclepias

ORCHID

RECIPE 3:
SPECIAL OCCASION

FLOWERS

2 stems of rosemary

4 dahlias

4 chrysanthemums

2 orchids

2 stems of lamb's ear

2 roses

5 stems of asclepias

4 skewered air plants

VESSEL

Silver pedestal bowl

1 Use floral putty to affix a large flower frog to the bottom of the bowl.

2 Trim and add the stems of rosemary to the bowl, letting the stems cascade down the left and right sides. Add one dahlia and one chrysanthemum between the rosemary, trimming so that the blooms sit at the rim of the bowl.

3 Place the two orchids facing each other in the bowl, trimming so that the bottoms of the blooms rest on the rim. Trim and add one stem of lamb's ear next to each orchid.

4 Trim and add one chrysanthemum to the front right side at the rim of the bowl, filling the space between the two orchids. Trim and add the roses to the center of the composition and the remaining chrysanthemums to the back left side of the arrangement behind the roses.

5 Trim and add the remaining dahlias to the left and upper right so that the blooms sit above the other flowers.

6 Cluster four stems of trimmed asclepias and one air plant around the orchid on the right. Finish by adding the remaining air plants and trimmed asclepias on the upper left side.

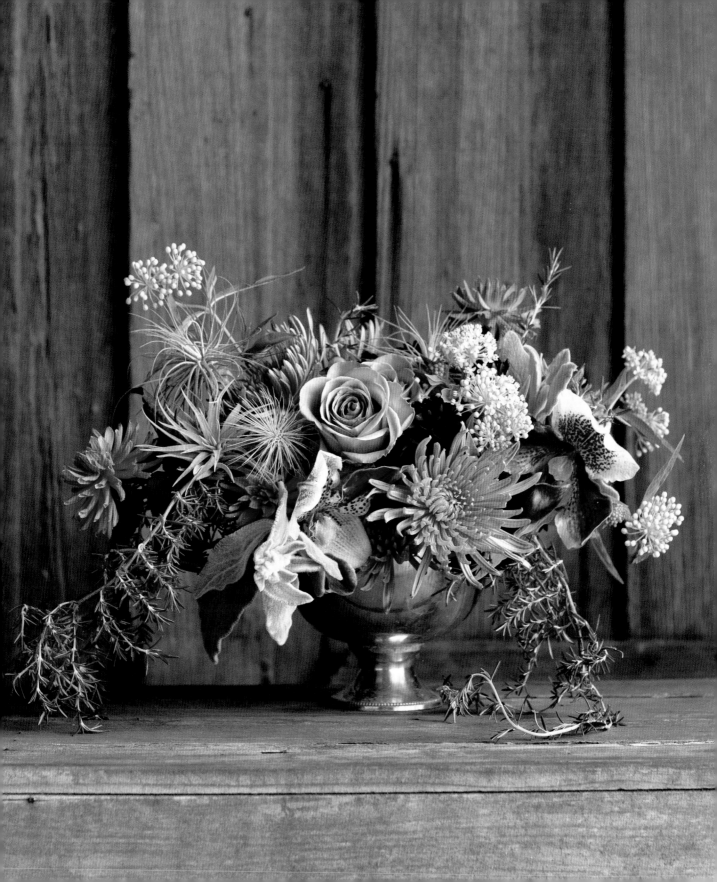

PEONY *(PEE-oh-nee)*

AVAILABLE COLORS: most, except for blue

These regal flowers flaunt large, scented blooms and a dazzling array of forms that resemble everything from fried eggs to ballet skirts. Peonies are coveted for wedding bouquets and table settings no matter the season. The 'Coral Charm' variety undergoes an amazing transformation, opening from a tight ball to a giant, hot-pink flower that fades to antique cream just before its petals drop. Select buds that are just open enough to show their colors so that you can enjoy them as long as possible.

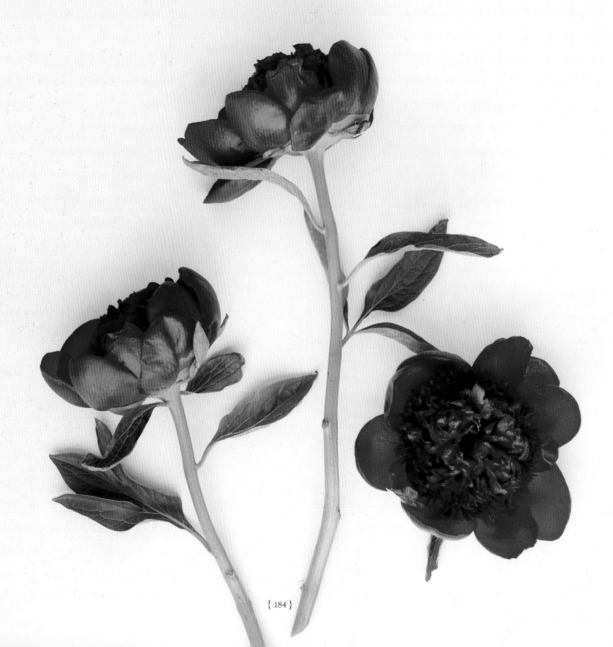

PEONY

RECIPE 1:
ON ITS OWN

FLOWERS
9 peonies (the same variety at different stages of openness)

VESSELS
2 blue mason jars

1. Trim and add three stems to the first jar so that the blooms rest 2 inches above the rim.

2. Trim and add four stems to the same jar so that the bottoms of the blooms sit just above the first three flowers, creating a tight mass of blooms.

3. Trim and add the last two stems to the second jar so that the blooms sit at slightly different heights, a few inches above the rim.

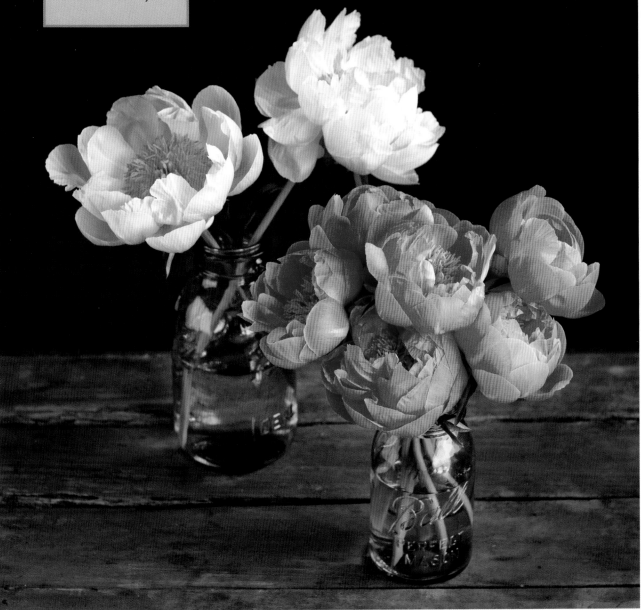

FLOWERS

7 branches of viburnum berries, cut into sections (see page 14)

5 peonies

7 poppies, a mix of buds and flowers

9 stems of flowering oregano

VESSEL

Low wooden box

1 Choose a large, low box to create a centerpiece that won't block conversation. Place a watertight liner in the box so that it is not visible above the rim. Create a tape grid (see page 17) on the box with 1-inch-square openings.

2 Trim the viburnum berry branches and place them in the grid so that the berries drape over the sides, hiding the tape.

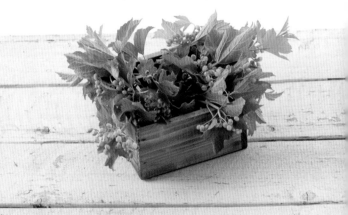

3 Trim and add the peonies through the grid so that the bottoms of the blooms rest on either the base layer or the rim of the box. Create a cluster of three on one side and two on the other.

4 Trim and burn the stems of the poppies (see page 15) and add the poppies to the box, filling the empty spaces around the peonies. Finish by trimming and adding in the oregano, letting the stems arc out several inches from the composition.

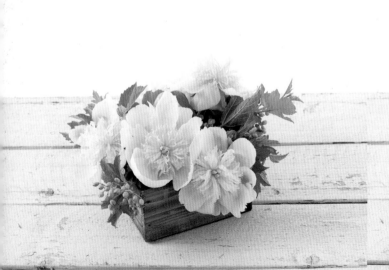

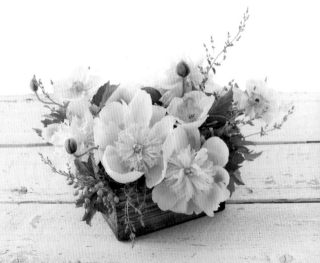

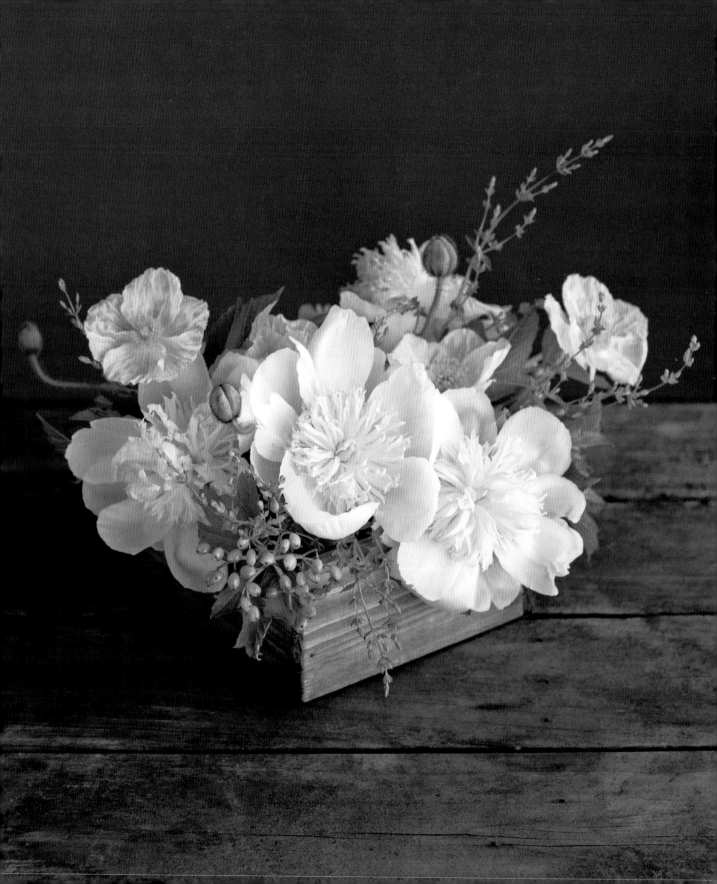

POPPY *(POP-ee)*

AVAILABLE COLORS: cream, orange, peach, red, white

With tissue paper petals and skinny, tendril-like stems, poppies are so ethereal, they seem to practically float on air. Their tight, furry, unopened buds are a striking combination next to the colorful explosion of an open bloom. The opiates extracted from the seeds of the opium poppy have made the flower a symbol of sleep, peace, and even death for centuries. Burning the end of a poppy stem immediately after cutting and right before adding it to water will extend its life in an arrangement.

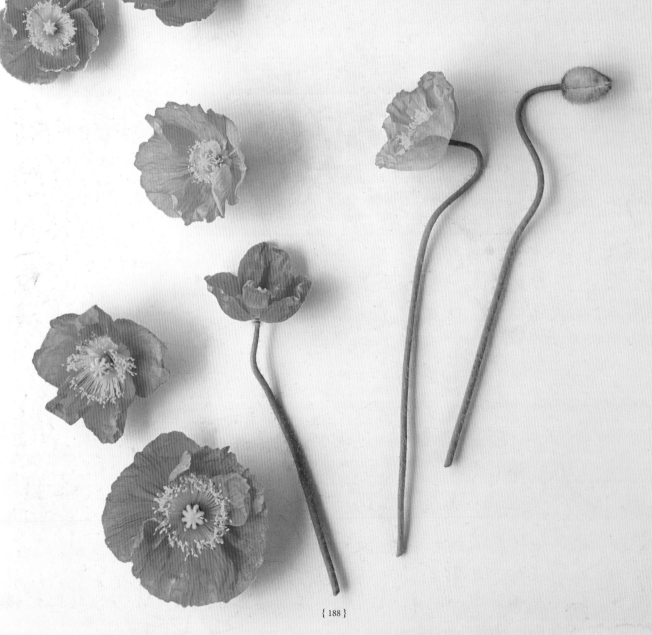

POPPY
RECIPE 1:
ON ITS OWN

———

FLOWERS
20 poppies

VESSEL
Handmade
ceramic vase

1. Attach a flower frog to the bottom of the vase with floral putty.

2. Trim and burn the stems (see page 15) and add the poppies to the vase at varying heights so that each stem has its own space within the arrangement, and no blooms are touching.

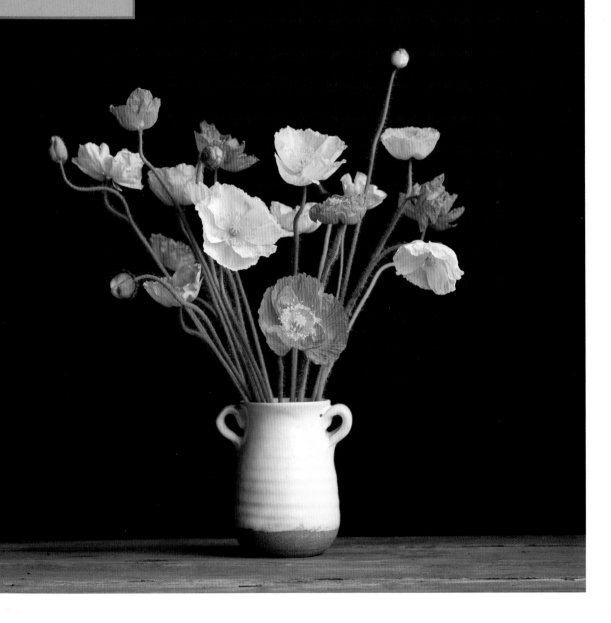

FLOWERS

3 stems of jasmine

1 stem of ranunculus

2 roses

3 lilies

5 poppies

VESSEL

Glass bottle

Choose a bottle with a narrow neck and a small shape for this diminutive arrangement.

2 Trim and add the stems of jasmine so that the lower leaves rest on the rim of the bottle.

3 Trim and add the stems of ranunculus and roses, clustering them toward the front so that the heads of the flowers rest about one inch above the rim of the bottle.

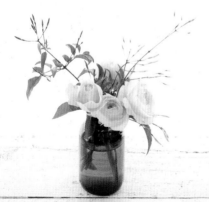

4 Trim and add the lilies in a group behind the ranunculus and in between the stems of jasmine. Trim two of the poppy stems, burn the stems (see page 15), and add to the rose and ranunculus cluster. Finish by trimming the remaining poppy stems so that the blooms will sit several inches above the cluster, burning the stems, and adding the poppies to the arrangement.

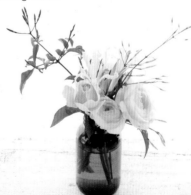

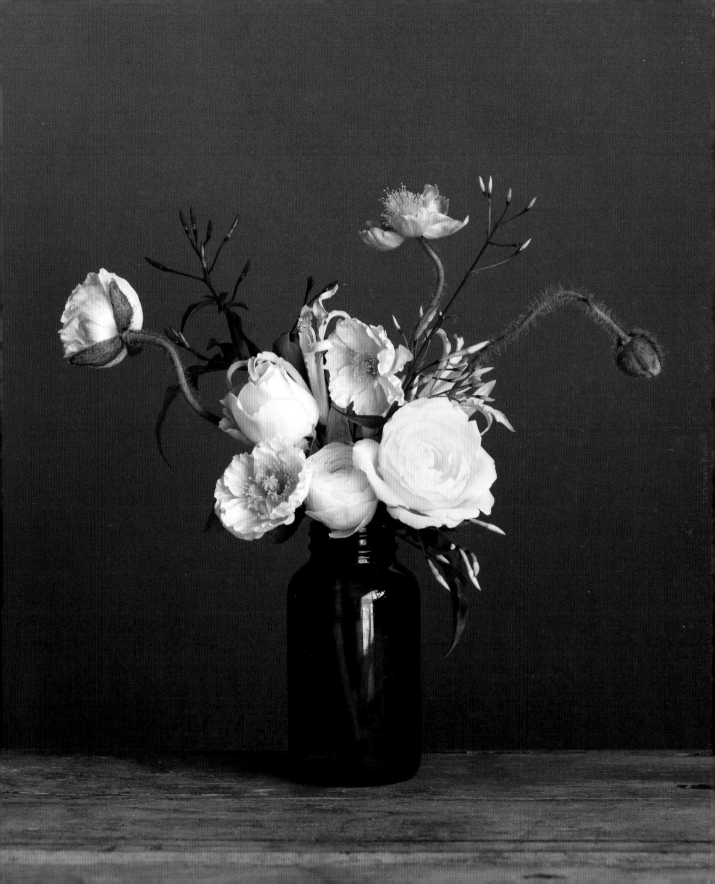

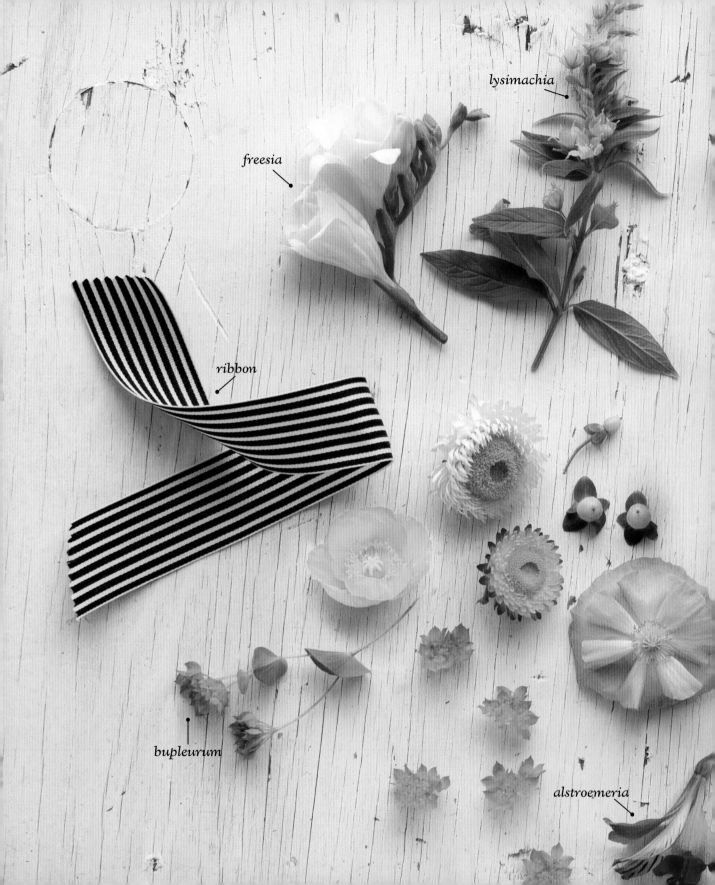

lysimachia

freesia

ribbon

bupleurum

alstroemeria

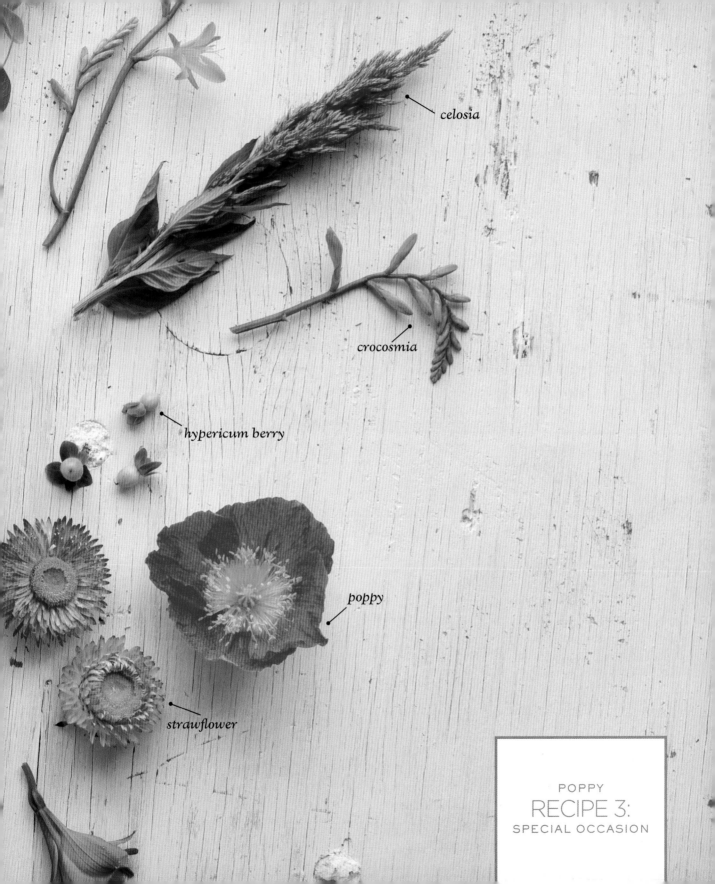

celosia

crocosmia

hypericum berry

poppy

strawflower

POPPY
RECIPE 3:
SPECIAL OCCASION

RECIPE 3:

SPECIAL OCCASION

FLOWERS

3 sprays of alstroemeria

3 sprays of bupleurum

8 strawflowers

2 stems of celosia, plume and crested variety

4 stems of hypericum berries

4 stems of freesia

2 stems of crocosmia

5 poppies

2 stems of lysimachia

MATERIALS

3-foot length of 1-inch ribbon

1 Hold the two sprays of alstroemeria in your hand a few inches below where the blooms begin to branch out from the main stems. Add two sprays of bupleurum to the bunch on both sides of the alstroemeria.

2 Nestle three strawflowers and one stem of celosia low in the bouquet, between the alstroemeria blooms.

3 Add the stems of hypericum berries behind the other stems in the bunch so that the berries sit a few inches higher than the rest of the elements. Add the stems of freesia so that the lowest blooms are nestled between the hypericum berries.

4 Add the remaining stem of celosia and the remaining five strawflowers to the back of the bunch so that the blooms sit above the hypericum berries. Add the stems of crocosmia and the remaining stems of alstroemeria and bupleurum high and in the back so that they are the tallest elements in the bouquet.

5 Place the poppies in the center of the bunch, feeding the stems through the hypericum berries, and turn so that the blooms face in different directions.

6 Finish by adding the lysimachia, feeding the stems through the bouquet next to the freesia on the right side.

7 Tie the ribbon tightly around all the stems in the bouquet at the place where you were holding it and finish with a bow. Trim the stems to an even length.

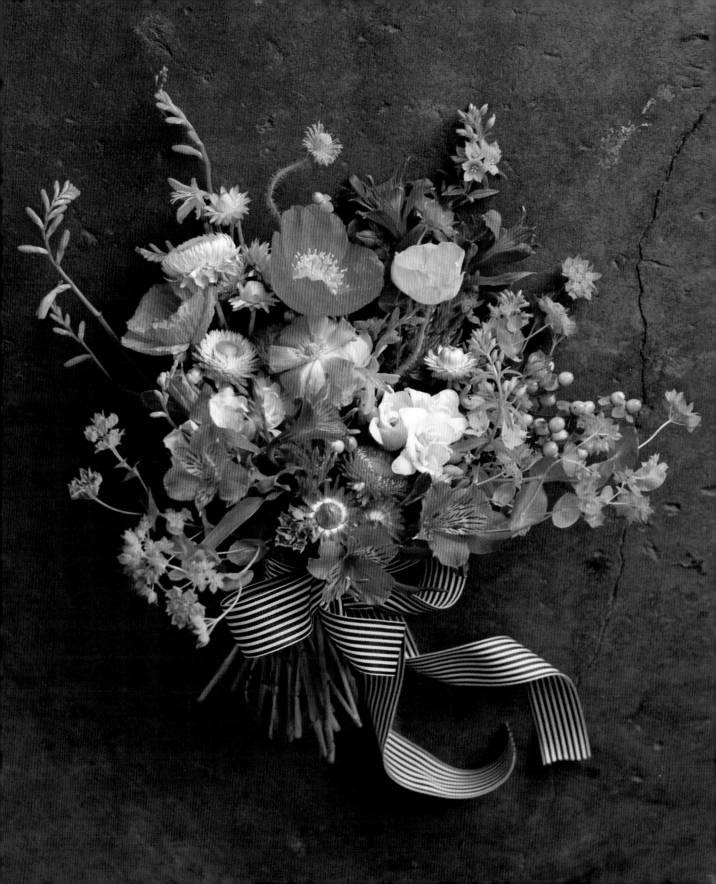

PROTEA *(PRO-tee-ah)*

AVAILABLE COLORS: pink, orange, red, white, yellow

Though they sometimes resemble sea creatures more than flowers, long-lasting proteas pack a textural punch. The astonishing variety of blooms range in form from giant furry bowls to needle-packed pincushions. Their assorted leaf structures provide protection in the heat of their natural climate, but the leathery rounds or needles also add great visual interest in the vase.

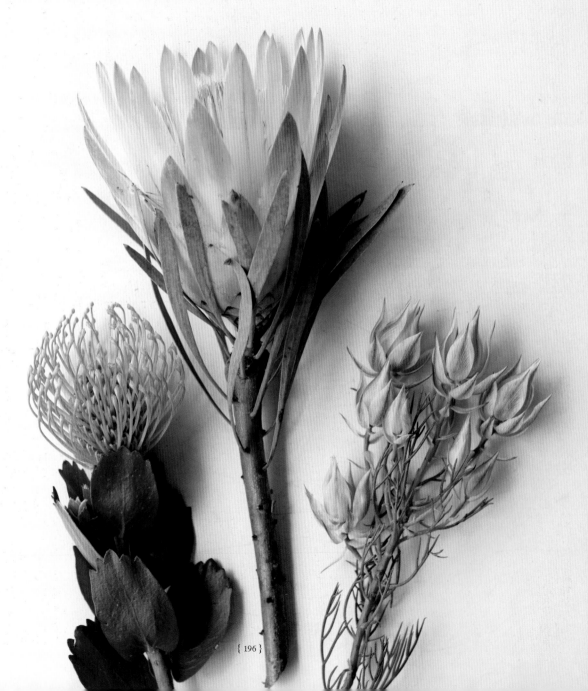

FLOWERS

4 pincushion
proteas

VESSEL

Glass jar with
metal grid lid

1. Clean all the leaves from the bottom of the stems that will be
 below the lid.

2. Trim three stems so that the blossoms are about the same height,
 and place them through the holes in the grid, keeping them
 clustered to one side.

3. Trim and add the last stem so that the blossom sits just above
 the others.

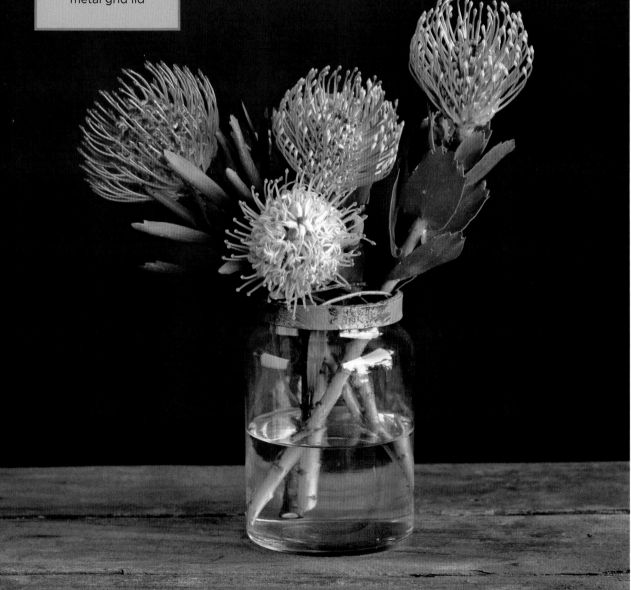

PROTEA
RECIPE 2:
WITH COMPANY

———

FLOWERS
1 king protea

3 sprays of
smoke bush

3 sprays of protea

5 stems of yarrow

3 stems of sedum

VESSEL
Oval ceramic vase

1 Choose a low, wide vase with a chicken wire form (see page 17) inside to support this dense combination.

2 Trim and add the stem of the king protea so that the bloom rests on the rim to one side of the vase. Trim and add the sprays of smoke bush, placing them in an airy cluster opposite the protea.

3 Trim the sprays of protea so that the bottom blooms start about an inch above the rim of the vase. Insert them through the wire frame so that they stand in a horizontal line running across the center of the composition.

4 Trim and place all the yarrow stems in a tight, low cluster at the front of the vase, filling the space under the protea. Finish by adding in the stems of sedum, trimming one to pop out through the yarrow at the front of the vase and the others at the back.

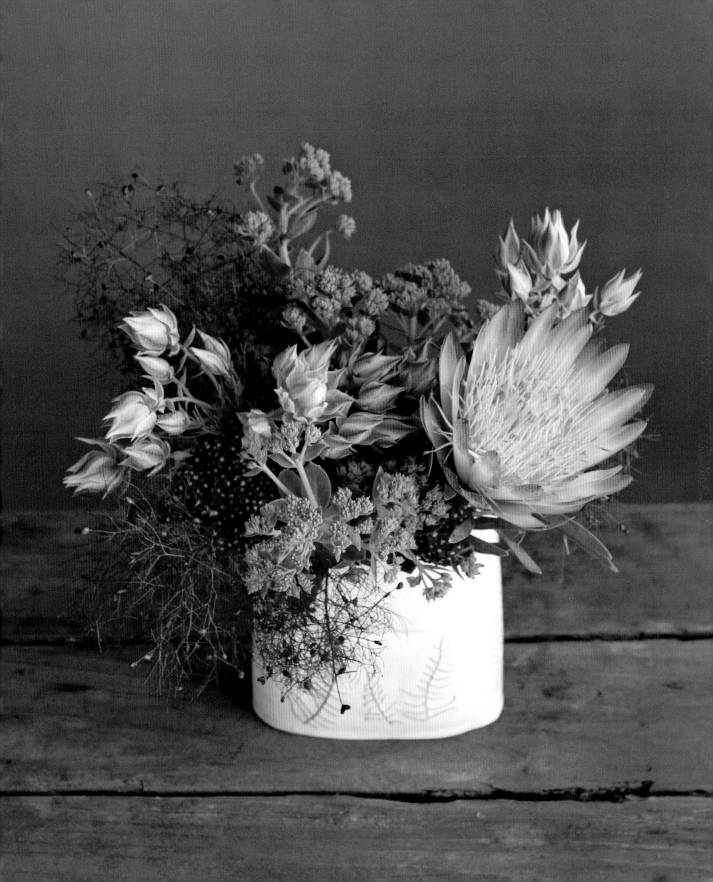

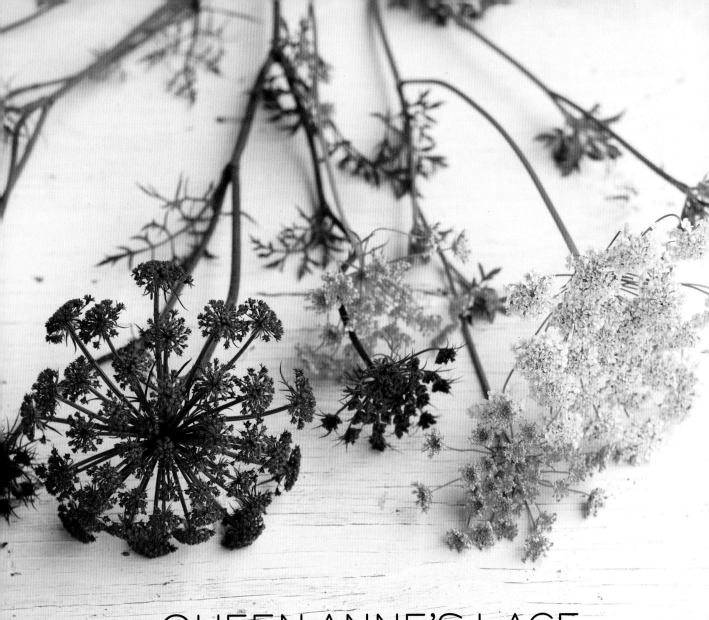

QUEEN ANNE'S LACE
(kween anz leys)

AVAILABLE COLORS: purple, white

Queen Anne's lace grows like a weed in many places, so it's easy to overlook this dainty yet hardy floral firework. The name Queen Anne's lace is commonly applied to several unrelated species of similarly blooming plants, all with spindly yet sturdy stems and feathery, fernlike foliage. Queen Anne's lace can stand alone beautifully, but it adds amazing depth and texture to arrangements when used as an accent flower.

QUEEN ANNE'S
LACE

RECIPE 1:

ON ITS OWN

———

FLOWER

1 stem of Queen
Anne's lace

VESSEL

Ceramic bud vase

1. Trim the stem to a height of around three times the height of the vase.

2. Gently push the stem into the vase, letting the place where the lower bud forks out rest inside the neck. This will provide support and allow the stem to stand up.

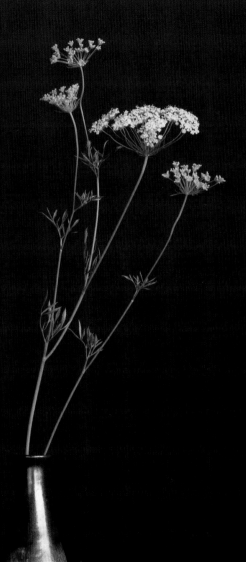

RECIPE 2:
WITH COMPANY

FLOWERS

10 stems of Queen
Anne's lace

6 zinnias

10 cornflowers

3 stems of
chocolate cosmos

VESSEL

Shallow oval dish

1 A low, long vase or dish almost disappears within the arrangement, allowing the flowers to take center stage. Place two large flower frogs side by side in the dish and secure with floral putty.

2 Cut the open blooms from the stems of Queen Anne's lace. Trim and layer them over the entire dish so that the frogs are not visible and the blooms rest just above rim level. Cut seven tighter blooms from the stems of Queen Anne's lace and insert them through the layer of the lower blooms, clustering six on the left side and one on the right.

3 Trim and add five zinnias clustered together on the right side of the composition to balance the taller Queen Anne's lace on the left. Add the remaining zinnia on the left side.

4 Add a grouping of six cornflowers on one side of the zinnias and a grouping of four on the opposite side, trimming the stems so that the blooms sit at a similar height. Finish by trimming the chocolate cosmos and placing them at three different heights on the left side, letting the buds and leaves stick up several inches above the Queen Anne's lace.

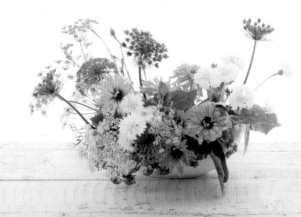

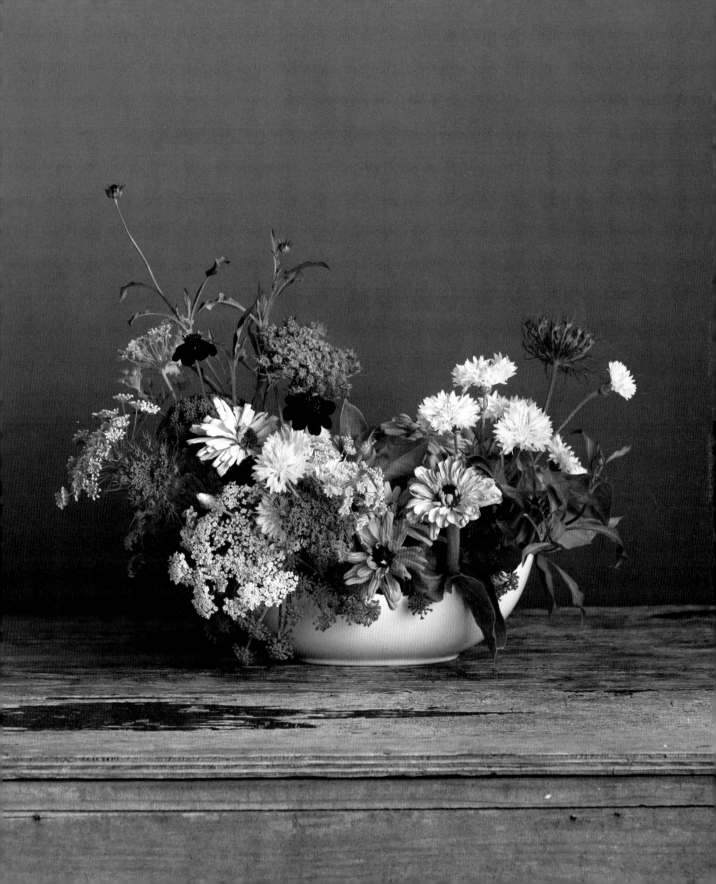

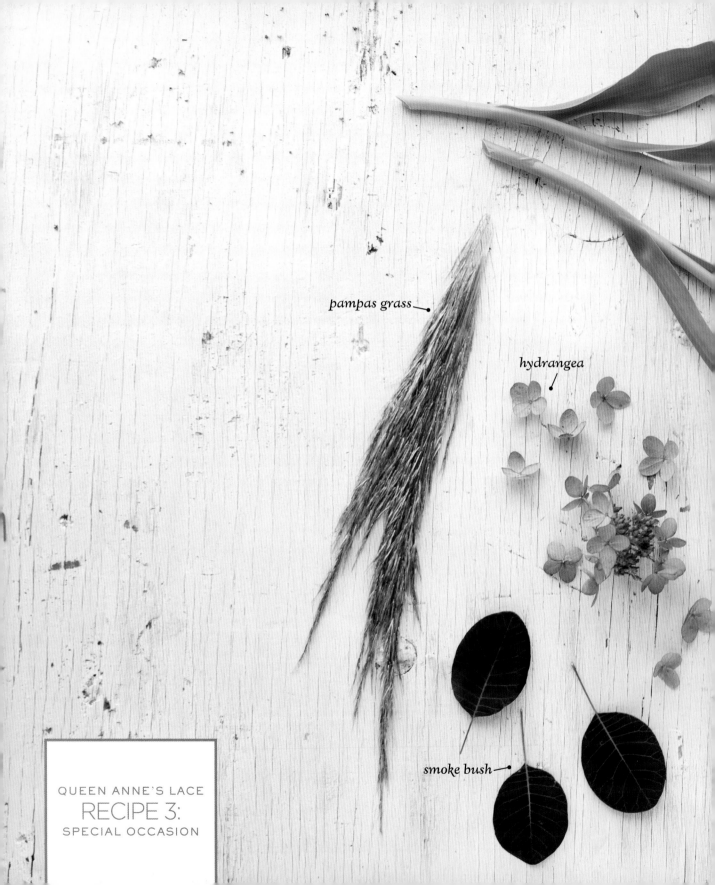

pampas grass—

hydrangea—

smoke bush—

QUEEN ANNE'S LACE
RECIPE 3:
SPECIAL OCCASION

queen anne's lace

tulip

buttonweed
seed pods

amaranthus

RECIPE 3:

SPECIAL OCCASION

FLOWERS

2 stems of amaranthus

2 hydrangeas

3 stems of pampas grass

9 tulips

1 branch of smoke bush

3 sprays of buttonweed with seed pods

2 stems of Queen Anne's lace

VESSEL

Fluted cylindrical vase

1 Trim and add the stems of amaranthus to the front left side of the vase so that the foliage is low and cascades over the rim of the vase.

2 Trim the hydrangea stems, dip the stems in alum, and add to the arrangement so that the bottoms of the blooms rest at the rim of the vase, placing one stem to the left and one to the back right side.

3 Cluster the stems of pampas grass, trimmed to a similar height, on the left side.

4 Line up the bottom leaves of the tulips, trim, and add as a bunch at an angle on the right, so that their heads are all clustered in one area.

5 Tuck the trimmed branch of smoke bush in the front so that it rests above the amaranthus, and add the sprays of buttonweed seed pods on the left, tucked under the pampas grass and hydrangea bloom.

6 Finish by trimming and adding the stems of Queen Anne's lace on the right, leaving the stems long enough so that they arc out above the tulips at two different heights to balance the pampas grass on the left.

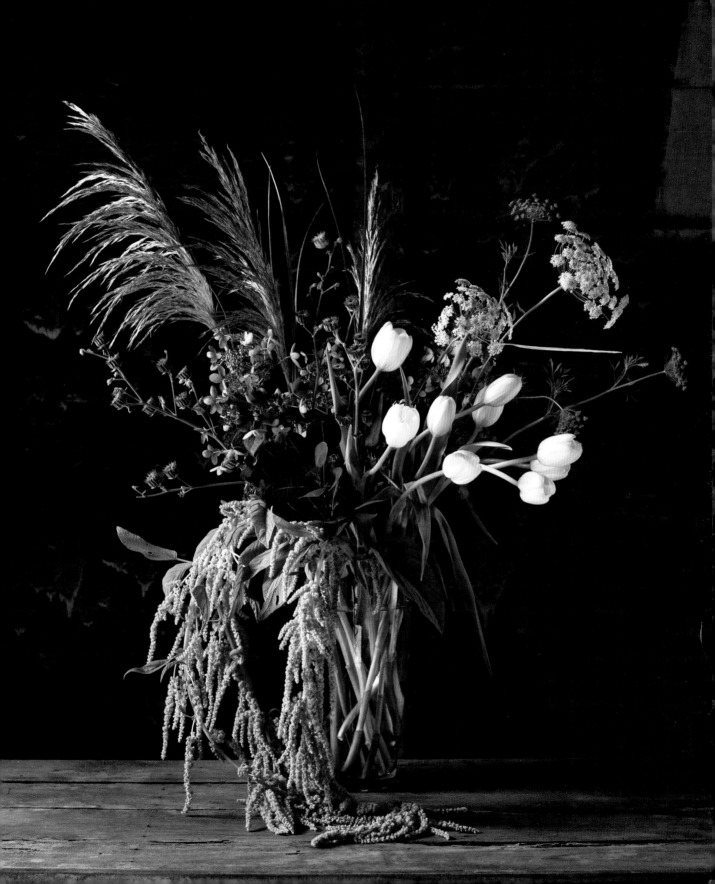

RANUNCULUS
(rah-NUN-kew-lus)

AVAILABLE COLORS: most, except for blue

Ranunculus, which resemble small garden roses, have abundant layers of papery petals and feathery foliage. Unusual varieties with green centers or variegated petals add unexpected texture to bouquets. Their delicate, hollow stems are prone to rot, so the water level in the vase needs to be kept low. If the stems start to droop and bend, cut them very short and cluster them in a small vase in order to get a few more days from the blooms.

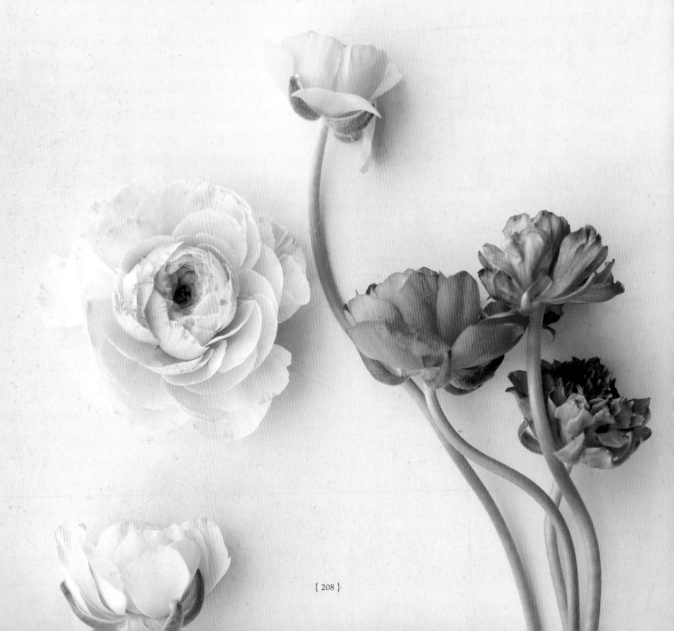

RANUNCULUS
RECIPE 1:
ON ITS OWN

FLOWERS
15 to 20 stems of
ranunculus

VESSEL
Handmade
ceramic vase

1. Remove all the leaves from the stems.

2. Using most of the flowers, create a round, clustered bouquet in your hand.

3. Secure the stems together with a rubber band about an inch below the blooms.

4. Trim the stems slightly shorter than the height of the vase and place them so that the blooms rest on the rim.

5. Trim the remaining stems longer than the rest of the blooms in the cluster and tuck them in on the left and right sides of the vase, creating a wider composition.

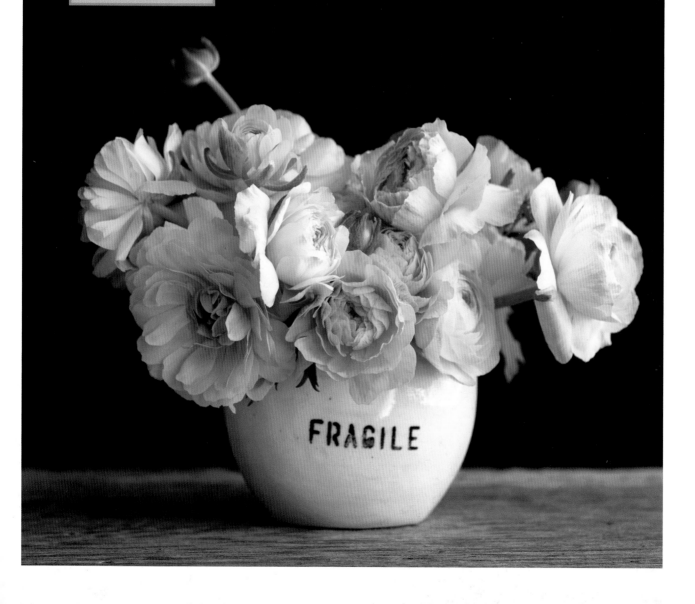

1 | Choose colorful cans that will complement the flowers' cheery palette. Line them with small jars if the cans aren't watertight.

2 | Pull the sweet pea stems together into two small bunches, lining up the lowest level of leaves. The height of the stems will be uneven and natural. Trim the stems and place a bunch in each can so that the bottom foliage hits the rim.

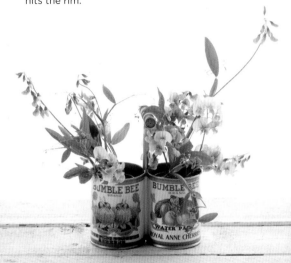

3 | Trim and add some mint to each can, filling in the empty spaces between the sweet peas.

4 | Trim and add six ranunculus stems to each can so that the blossoms sit at slightly different heights above the base layer. Trim and add the remaining stem to the can on the left, leaving it long to echo the sweet pea bud on the right side. Finish by trimming and adding in the stems of veronica, placing a few in each can and turning the stems so that the spires arc in different directions.

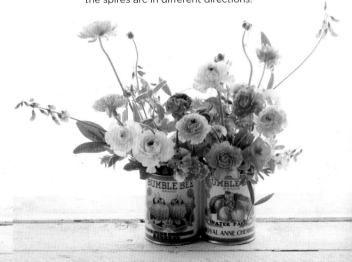

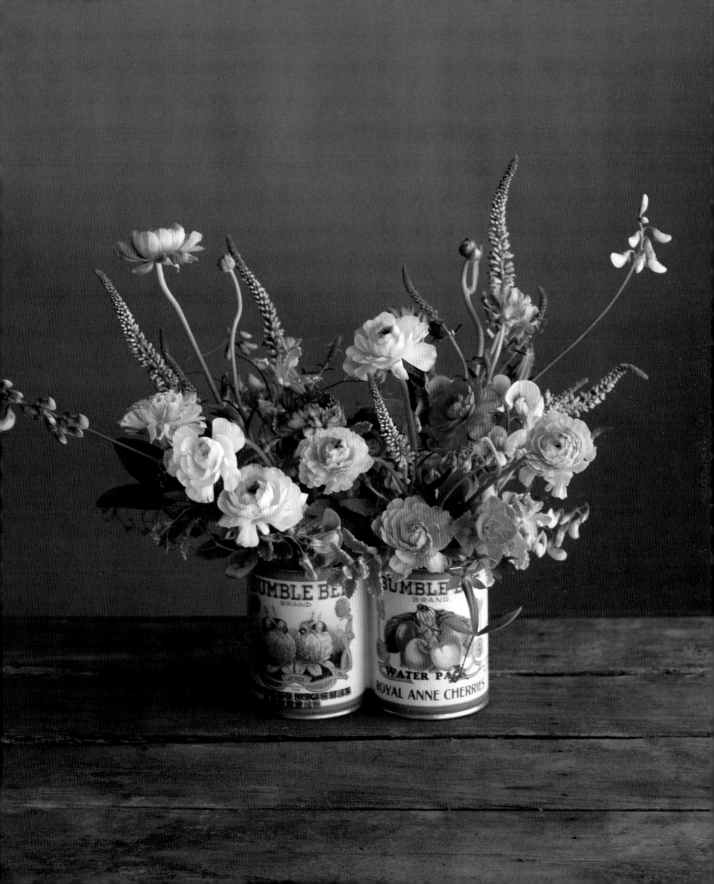

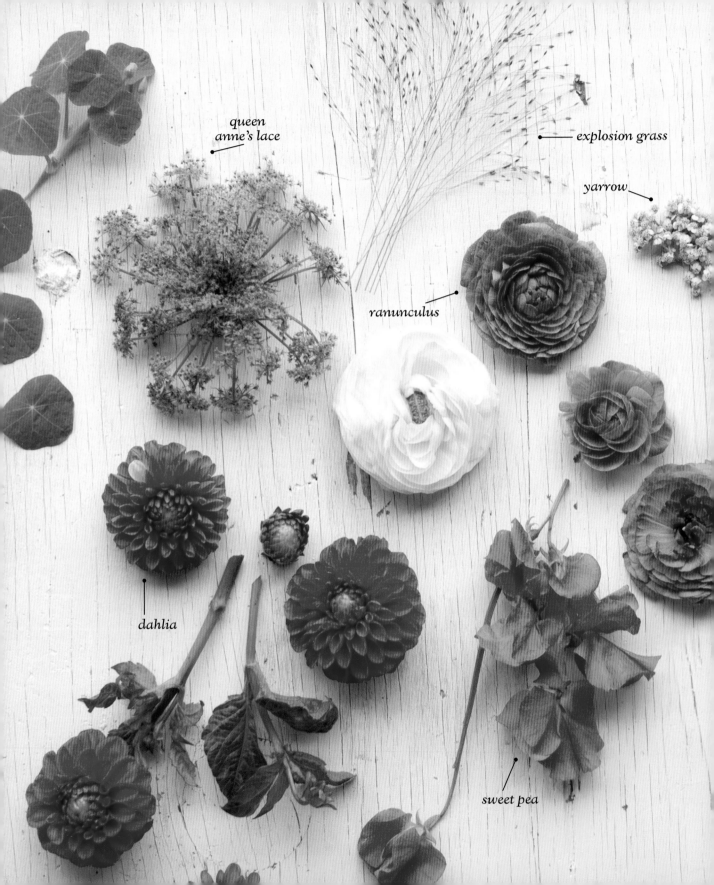

queen
anne's lace

explosion grass

yarrow

ranunculus

dahlia

sweet pea

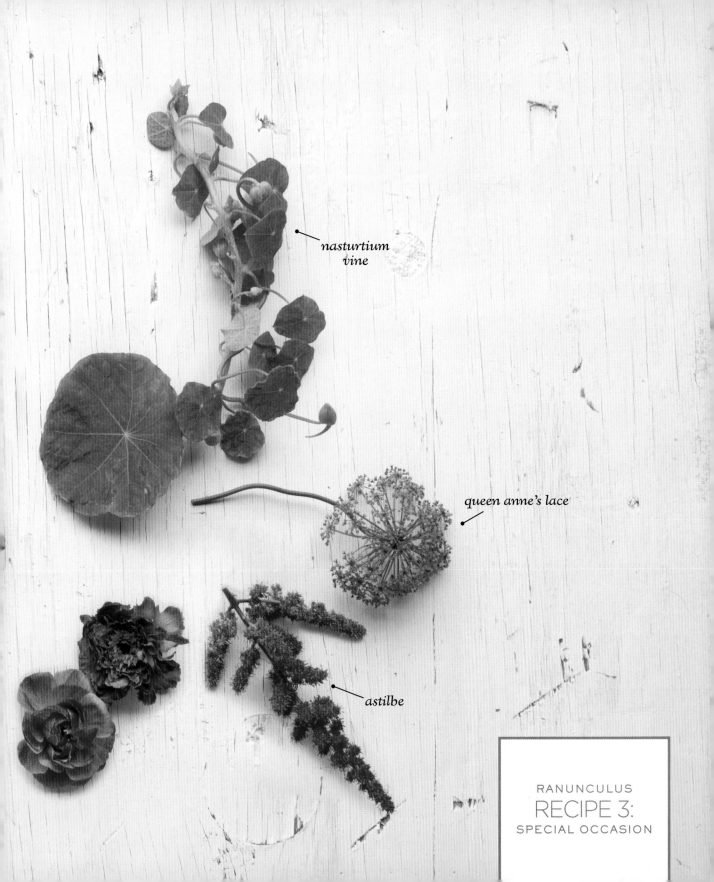

nasturtium
vine

queen anne's lace

astilbe

RANUNCULUS
RECIPE 3:
SPECIAL OCCASION

RECIPE 3:
SPECIAL OCCASION

FLOWERS
10 dahlias

7 nasturtium vines

25 stems of ranunculus

6 stems of Queen Anne's lace

10 stems of sweet pea

5 stems of astilbe

5 stems of yarrow

5 stems of explosion grass

VESSEL
Galvanized metal three-tiered tray

1 Line each tray with shallow cups so that they are not visible above the rims. Use floral putty to attach the cups to the tray to prevent them from tipping over. Use floral putty to attach a small flower frog inside each cup.

2 Start by cutting the dahlias into short sections (see page 14) so that all the leaves and flowers can be used. Add them to some of the cups on each level.

3 Trim and place the nasturtium vines so that a few cascade down from each level.

4 Add most of the ranunculus stems to the cups, trimming them to slightly different lengths, but keeping them short enough to fit under the trays. Allow a few longer stems to arc up or down around the outer edges of the middle tier.

5 Trim and fill the empty spaces around the ranunculus with the stems of Queen Anne's lace, sweet pea, astilbe, and yarrow, and finish with the stems of explosion grass.

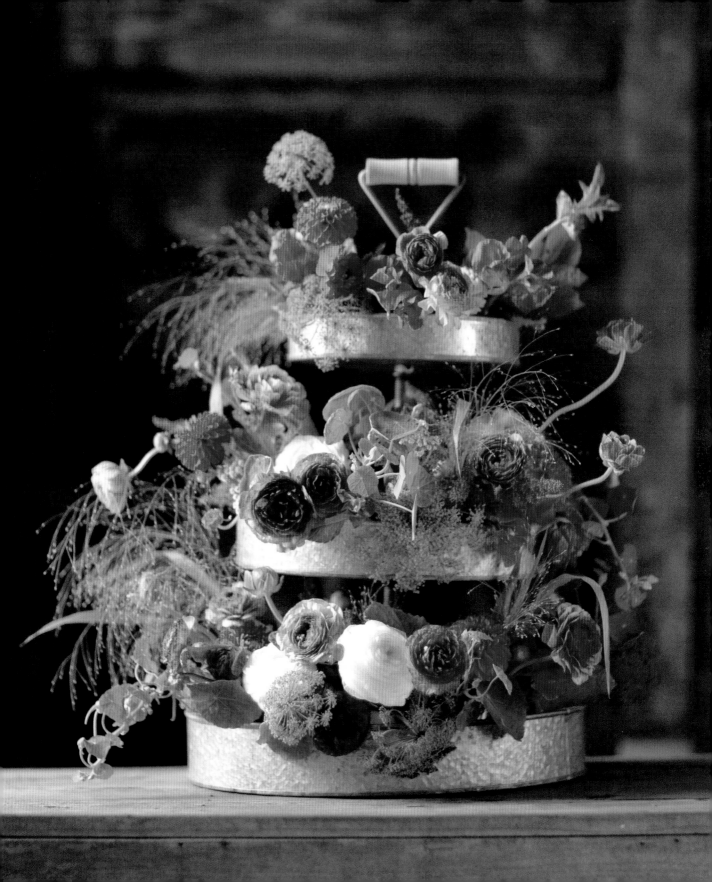

ROSE *(rohz)*

AVAILABLE COLORS: most, except for blue

Roses are everywhere. Standard varieties can be found at super-markets across the country and are bred for their shelf life and size; many are imported from Central or South America. Garden roses are a little harder to come by, but the delicate layers of pet-als and strong fragrance set them apart from the standard variet-ies. Use warm water in the vase and gently blow into the center of your roses to separate petals for a more open look.

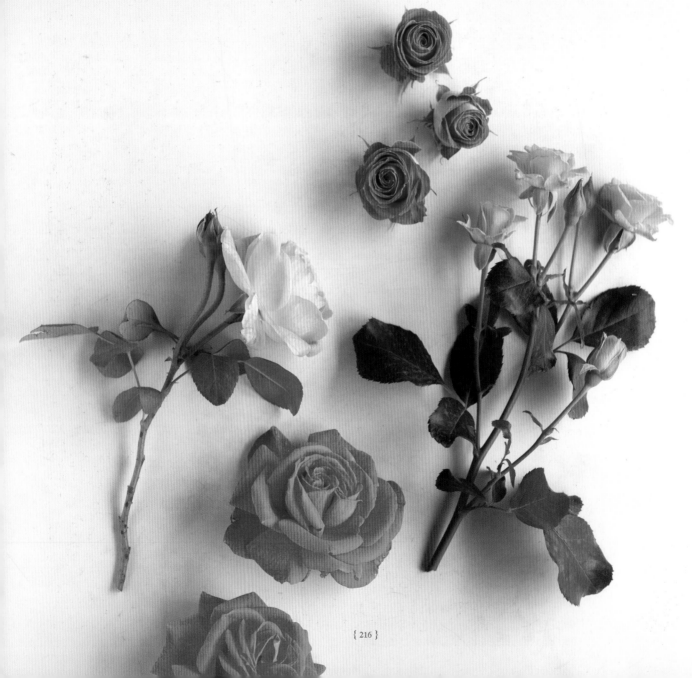

ROSE
RECIPE 1:
ON ITS OWN

———————

FLOWERS

5 stems of
multiheaded roses

VESSELS

5 bottles of various
shapes and sizes

1. Size up your stems and decide which bloom would be best for each bottle, pairing the tallest rose with the tallest bottle and the smallest rose with the shortest bottle.

2. Trim and place all the roses in their partnered bottles, making sure that the blooms stand at various heights.

3. Arrange the bottles into a pleasing composition.

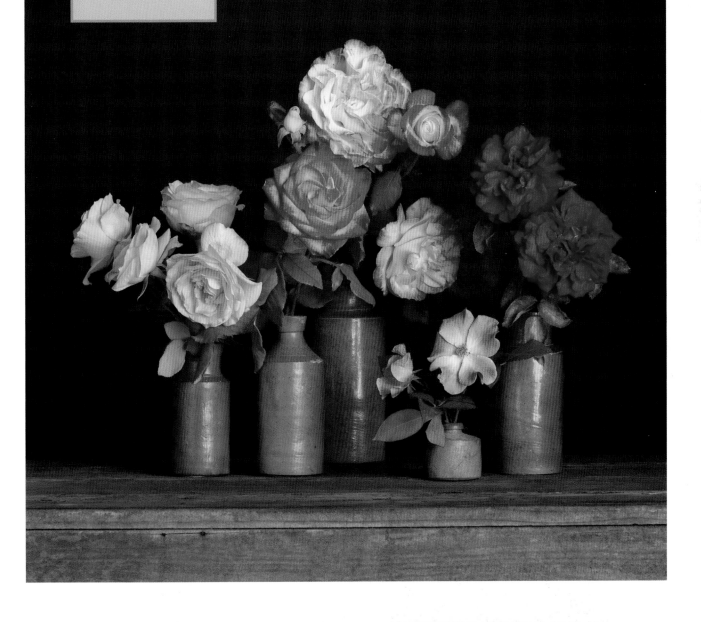

ROSE
RECIPE 2:
WITH COMPANY

FLOWERS

4 stems of
lamb's ear

6 roses

2 chrysanthemums
(spider)

4 stems of asclepias

VESSEL

Handmade ceramic
cylindrical vase

1 Choose a vase of a muted palette to match the flowers in this subdued arrangement.

2 Remove the lower leaves from the lamb's ear, and trim and add three stems to the left side of the vase so that the lowest leaves rest at the rim. Reserve one stem to add later.

3 Trim and add five roses to the vase so that the bottoms of the blooms rest at rim level. Trim and add the remaining rose on the right side so that the bloom sits a few inches higher.

4 Trim and add one chrysanthemum on the right side so that the bottom of the bloom rests at rim level. Trim and add the other chrysanthemum to the back side of the arrangement. Trim and add one stem of asclepias so that the bloom sits a few inches above the roses on the left side. Finish by adding the remaining stems of asclepias and the last lamb's ear to fill any empty spaces.

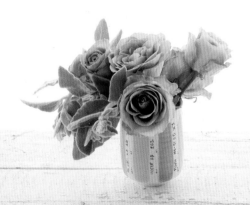

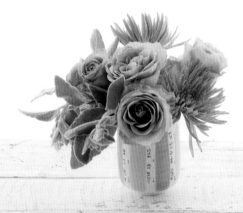

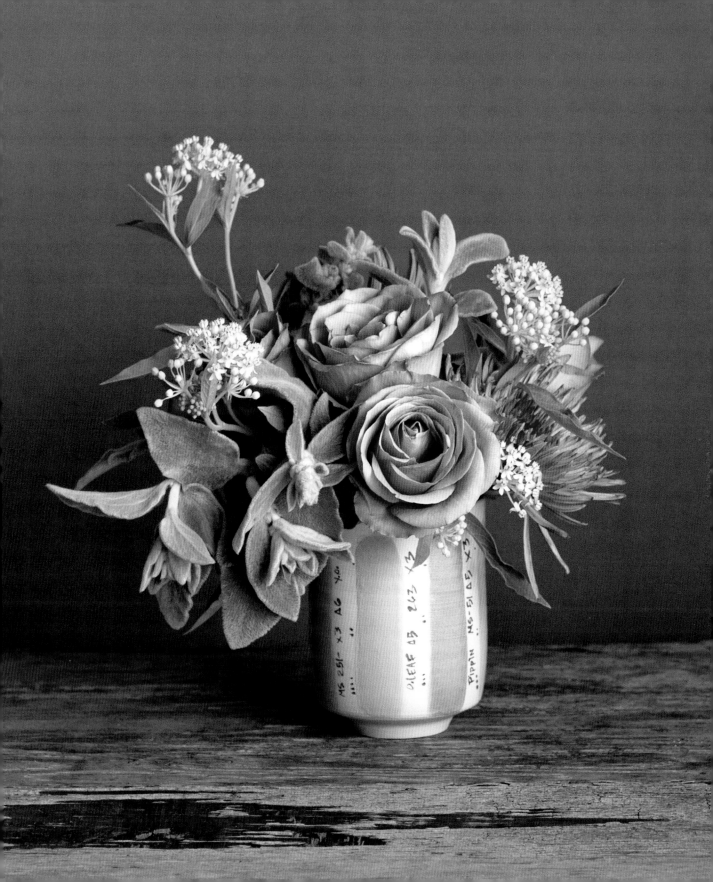

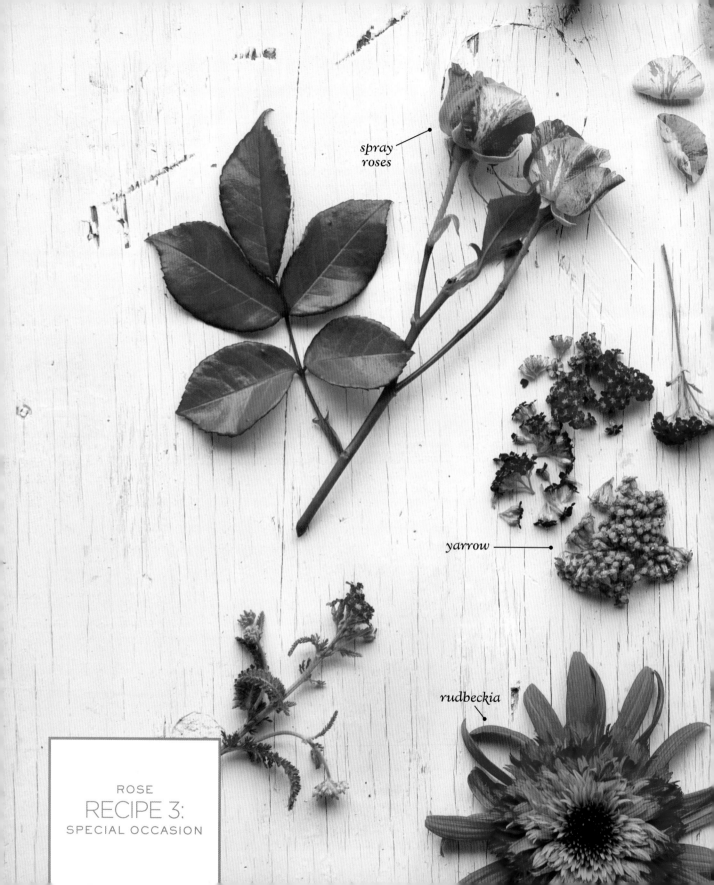

spray
roses

yarrow

rudbeckia

ROSE
RECIPE 3:
SPECIAL OCCASION

heuchera leaf

carnation

dahlia

*sweet potato
vine leaf*

RECIPE 3:
SPECIAL OCCASION

FLOWERS
7 assorted sweet potato vine leaves

5 heuchera leaves

5 carnations

3 dahlias

5 stems of rudbeckia

3 spray roses

8 stems of yarrow

VESSEL
Metal tin

1 Place a ball of chicken wire in the bottom of the tin to create a large flower frog.

2 Begin by trimming and adding most of the sweet potato vine and heuchera leaves, letting them cascade over the rim. Reserve a few leaves to add in at the end.

3 Trim and add half of the carnation, dahlia, and rudbeckia stems right next to one another around the rim, then add the remaining large flowers to fill the center, forming a low, domed shape.

4 Next, add the spray roses to fill any large gaps between the other flowers. Trim so that the bottoms of the blooms sit at the top of the flowers below them to create a layered look.

5 Finish by trimming and adding a few clusters of yarrow and the remaining sweet potato vine and heuchera leaves.

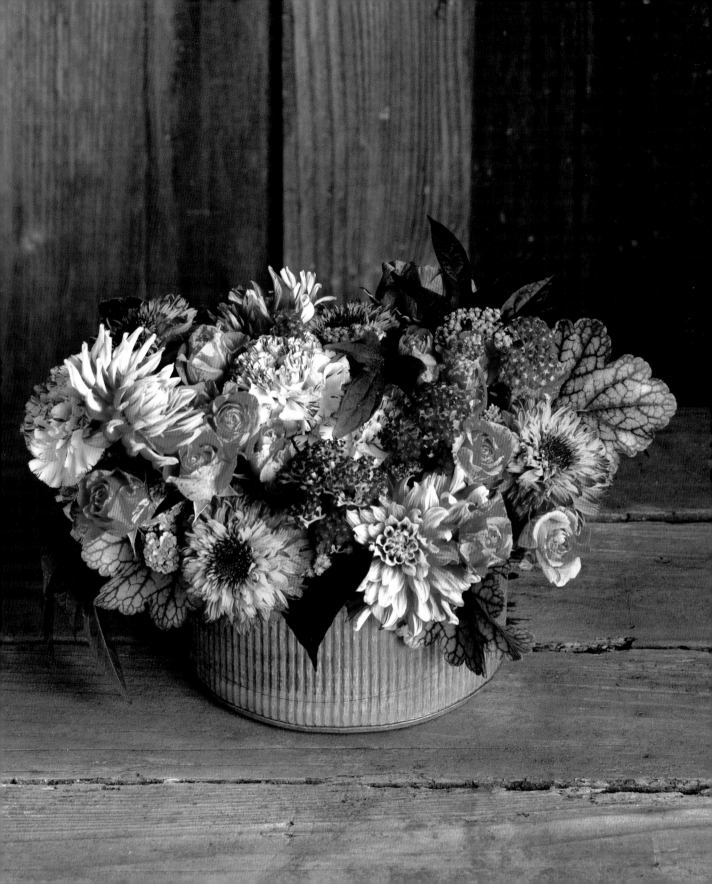

SCABIOSA
(ska-bee-OH-sa)

AVAILABLE COLORS: blue, pink, purple, red, white

Scabiosa is a little flower that is near and dear to our hearts. Its diminutive blooms have tons of wild character, straddling the line between delicate and rustic. Long, flexible stems gently curve in interesting directions, holding small, scruffy buttonlike blooms. If left on the plant to bloom, some varieties dry into geometric globes that add unexpected character to arrangements.

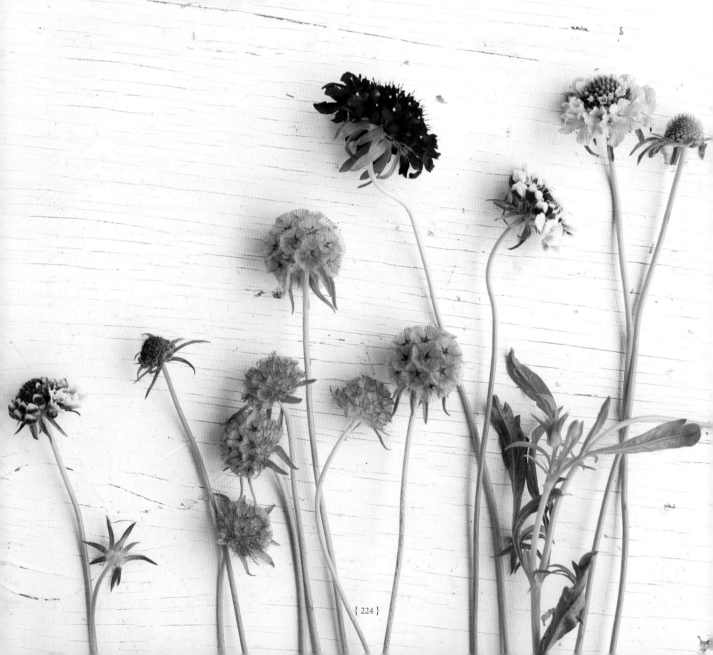

SCABIOSA
RECIPE 1:
ON ITS OWN

FLOWERS
20 stems of
scabiosa

VESSEL
Vintage glass
canning jar

1. Take the stems in hand and line them up so that the forks are approximately at the same place. Trim all the stems at once and place them in the jar.

2. Turn the stems so that the blooms face in different directions.

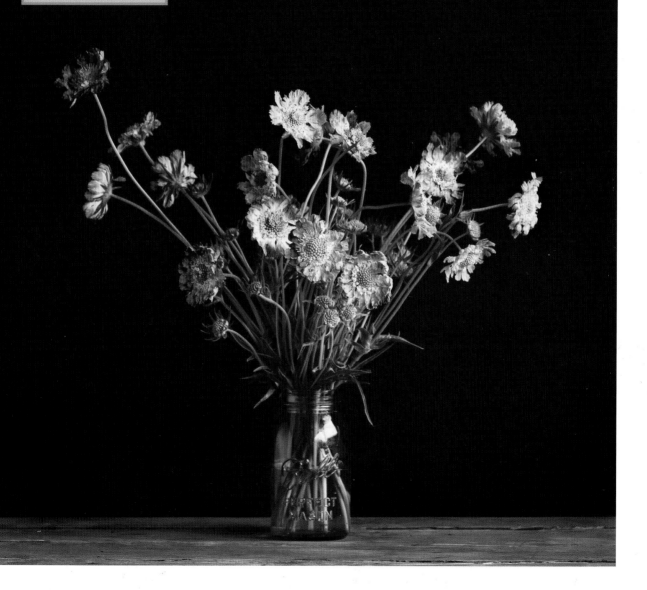

SCABIOSA
RECIPE 2:
WITH COMPANY

FLOWERS
3 branches of acacia

3 dahlias

2 stems of veronica

9 stems of scabiosa

VESSEL
Ceramic cup

A tall cup with a narrow opening supports longer stemmed elements.

2 Trim and add the branches of acacia to the right, left, and back of the cup.

3 Trim and add the dahlias to the center of the cup so that their blooms rest on top of each other and at the rim of the cup.

4 Trim and add the stems of veronica on the right, nestling them underneath the dahlia blooms. Finish by trimming and adding the stems of scabiosa throughout the arrangement, leaving some stems long so that they arc out, and some stems shorter and tucked tightly around the dahlias.

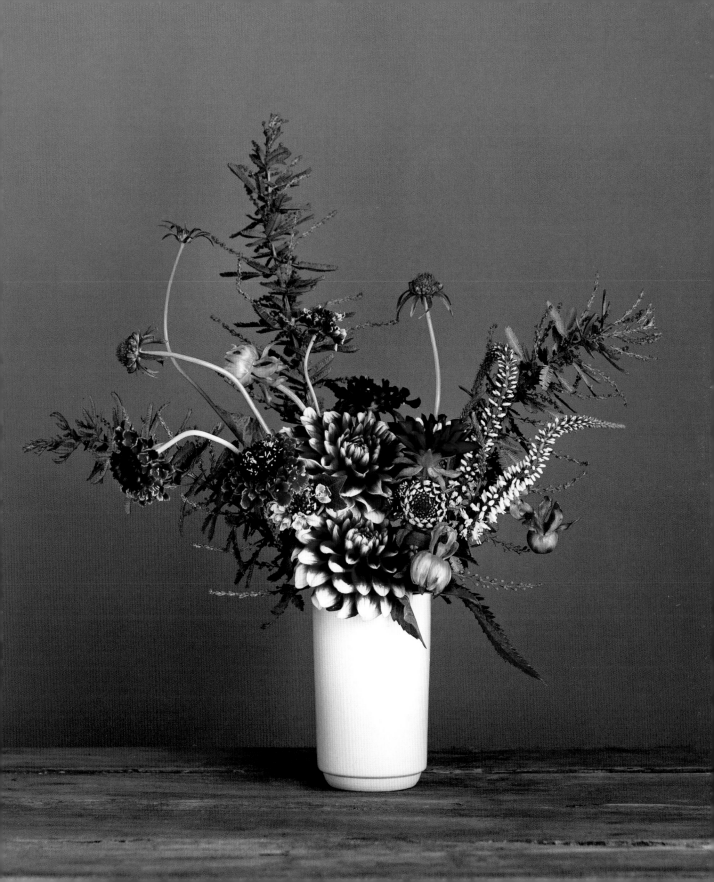

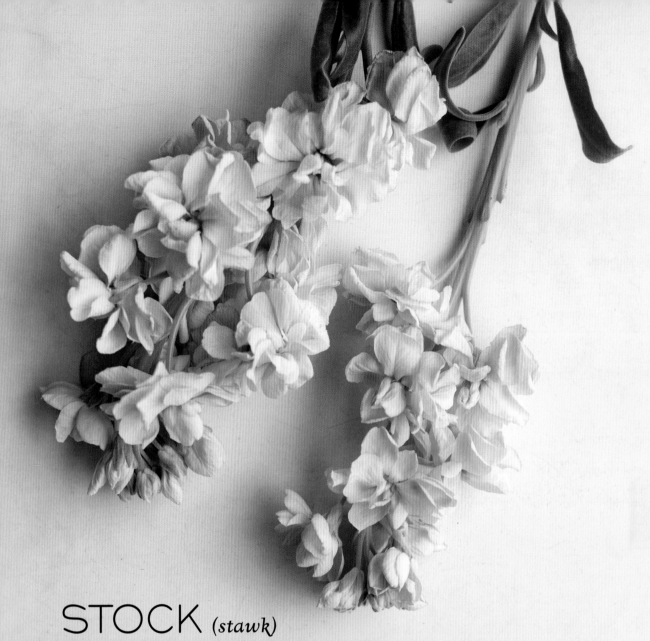

STOCK (*stawk*)

AVAILABLE COLORS: peach, pink, purple, white, yellow

With a strong, spicy fragrance and colorful blooms, it's hard to believe that stock shares a family with the likes of broccoli and cauliflower. Stock's columns of florets are an ideal accent flower, and its rich scent gives an added kick to arrangements and bouquets. It does have one thing in common with the cruciferous vegetables that share its family tree: a stinky stem. Once submerged in water, stock's stem degrades quickly, so change water often to avoid the less appealing odiferous effect of an otherwise sweet-smelling flower.

FLOWERS

8 stems of stock, in
two colors

VESSEL

Shallow, handmade
ceramic vase

1. Attach a flower frog to the bottom of the vase with floral putty.

2. Remove the lower few blooms from a stem of stock. Trim and place it in the vase so that the lowest blooms rest on the rim.

3. Continue trimming and adding stems, creating a clustered look by separating the colors on either side of the vase.

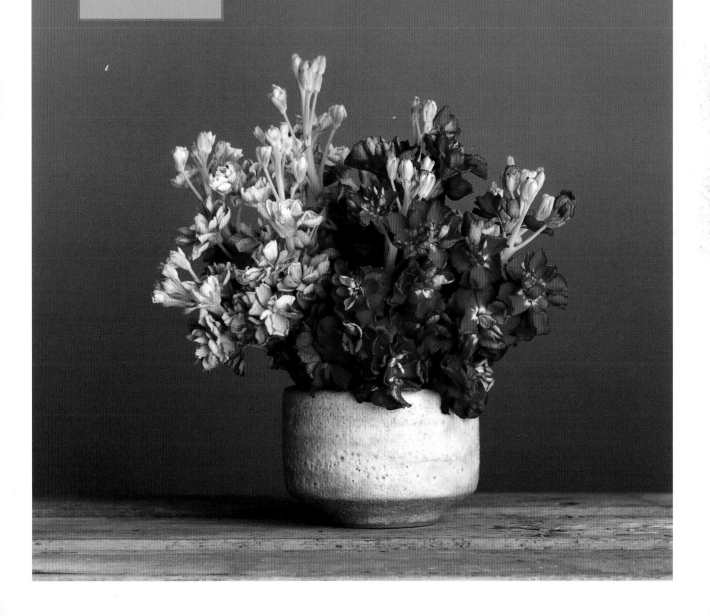

An urn with a wide opening will support this bloom-heavy arrangement. Place a flower frog in the bottom of the urn and secure with floral putty.

2 Trim and add two stems of stock to the front of the urn so that the lowest blooms rest on the rim. Trim the remaining two stems of stock so that they are a few inches taller, and add them to the back of the urn so that they arc out to the left.

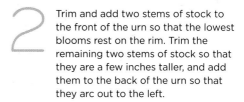

3 Trim and add the dahlias to the right side, arranging them at three different heights, with the shortest dahlia resting just above the rim of the urn and the tallest dahlia in the back.

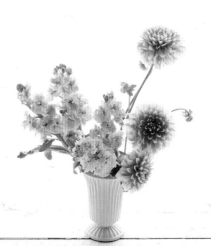

4 Trim and add the sprays of roses to the left side between the stock. Trim and add three stems of echinacea to the lower front of the arrangement, then trim and add the remaining stems to the back. Finish by trimming and adding two stems of ranunculus to the lower right side between the two shorter dahlias, and then trim and place the tallest stem of ranunculus to the left side of the arrangement.

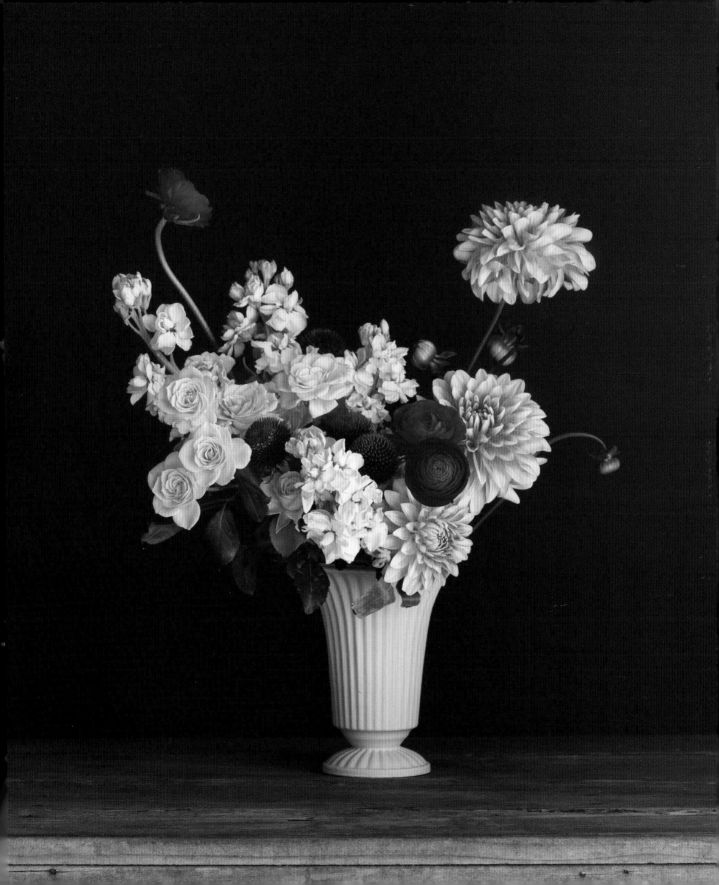

STRAWFLOWER
(STRAW-flau-er)

AVAILABLE COLORS: orange, pink, red, yellow, white

Strawflowers can be arranged fresh, and then their satiny pom-pom heads nipped off to take on a new persona as an everlasting still life. Their yellow centers also have a beautiful quality of line that changes through the stages of opening. Their foliage browns quickly, so remove the leaves and combine the blooms with other greenery to give them a fresher look.

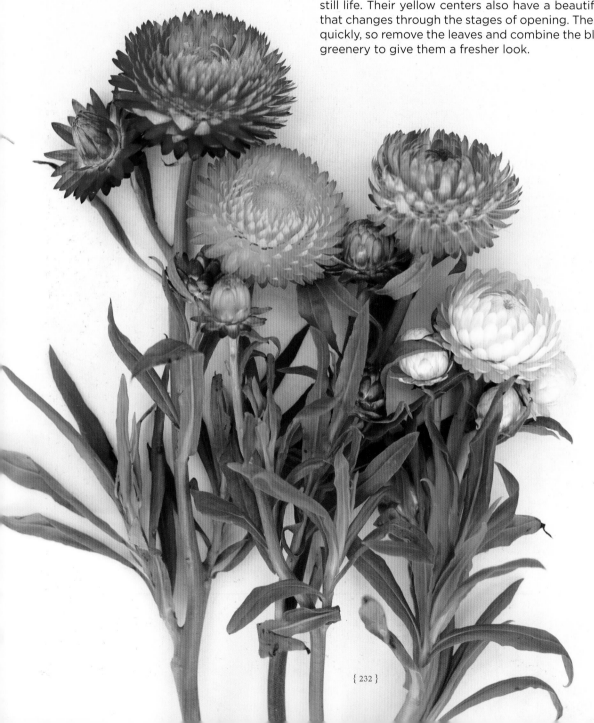

FLOWERS

9 geranium leaves

5 stems of
blackberry

10 strawflowers

VESSEL

Vintage box fitted
with three low cups

1. Trim the stems of the geranium leaves to the height of the box,
 and place them so that they sit low, concealing the cups.

2. Trim three blackberry stems and add them to the center cup
 so that there is a large cluster of berries in the middle of the
 arrangement, with some hanging low over the front edge of
 the box. Trim and add the next stem to the right cup so that
 the berries rest on the edge of the box. Trim and nestle the
 remaining stem into the left cup so that the berries stand
 upright several inches above the rim of the box.

3. Add the strawflowers, cutting the stems to different heights so
 that there is a low cluster in the center and a few taller stems
 branch upward on the sides, creating a slight U shape.

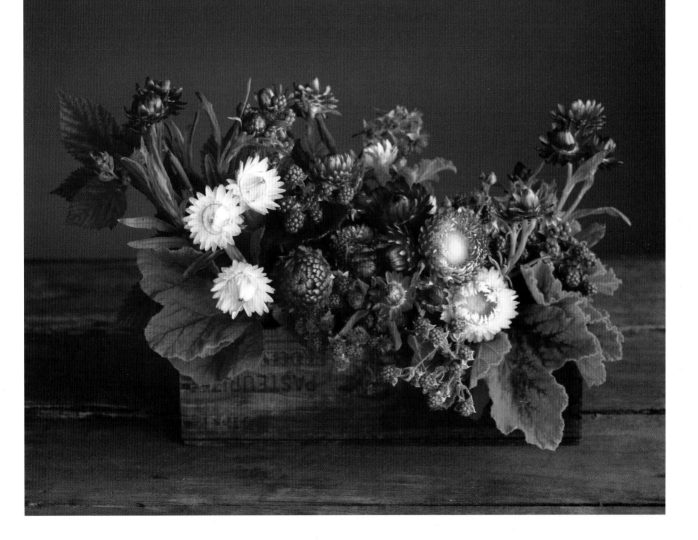

1 | Choose a tray large
enough to showcase a
bright blend of colors.
Do not add water; the
strawflowers will dry in
the tray.

2 | Start by placing a few of the light-
colored flowers in a cluster along one
edge of the tray.

3 | Add the next color grouping, nestling
the blooms close together.

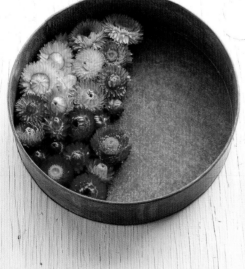

4 | Repeat until the desired color
blend is achieved and the tray is
completely filled.

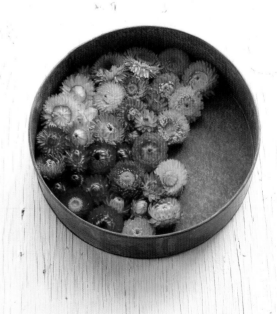

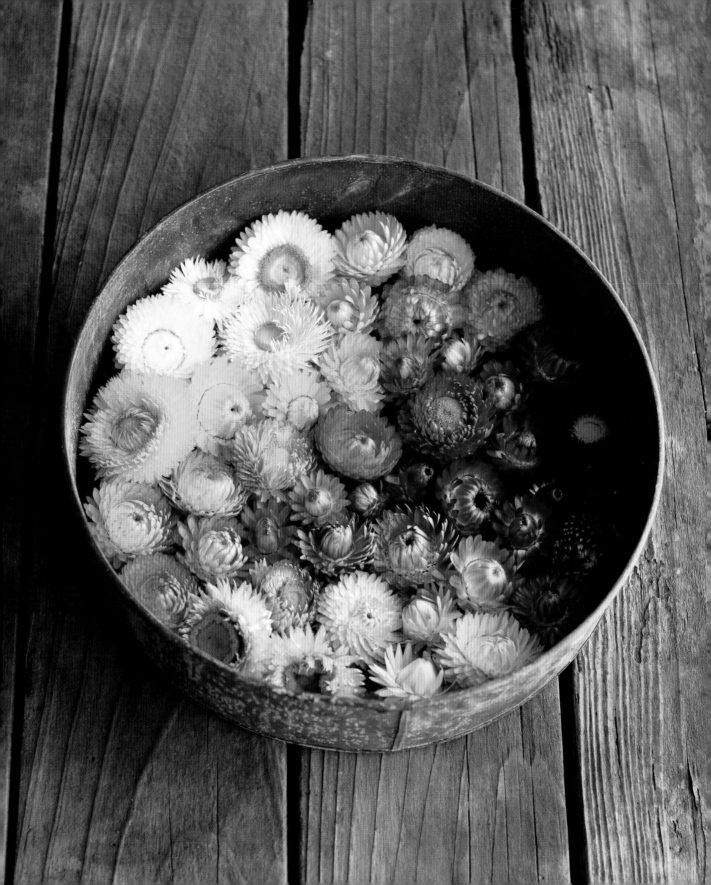

SUCCULENT (SUK-yuh-lunt)

AVAILABLE COLORS: most

The term "succulent" is used to describe any number of tenacious, water-retaining plants whose strong constitutions allow them to thrive in otherwise unfavorable conditions, such as poor soil and arid surroundings. While many succulents have lush rosette heads, others are geometric wonders with leaves that spiral, fan, twist, and corkscrew. After they have been used in an arrangement, they can be placed on top of sandy soil and they will sprout roots and grow!

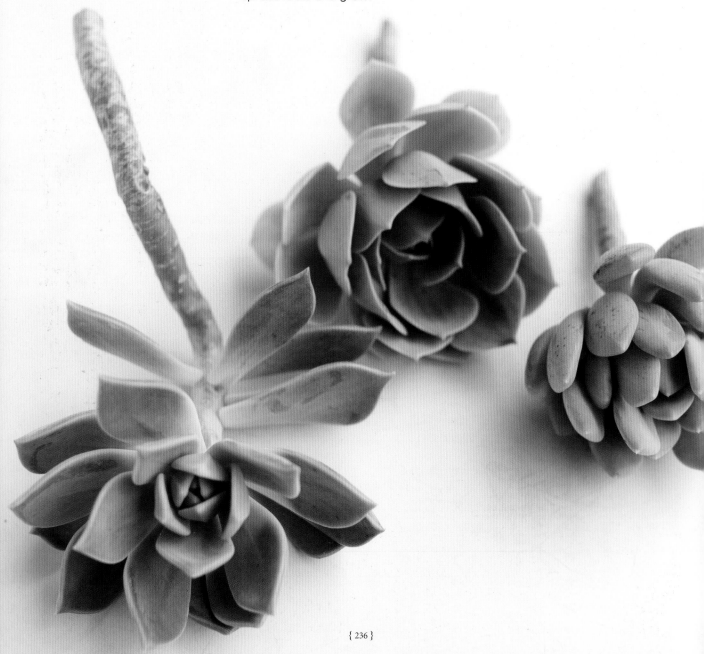

SUCCULENT
RECIPE 1:
ON ITS OWN

———

FLOWER
1 succulent with
flower stalk

VESSEL
Wood slice

1. Drill a hole in the center of the wood slice and glue a 2-inch piece of skewer in the hole.

2. Place the succulent stem onto the skewer so that the base of the leaves rests securely on the wood slice.

1 | Select a small vessel, such as a creamer, that will nicely hold an arrangement of short garden clippings. Place a flower frog in the bottom and secure with floral putty.

2 | Trim and add the largest geranium leaves so that they sit on the rim of the creamer. Trim and add the smaller leaves so that they sit a few inches higher than the rim.

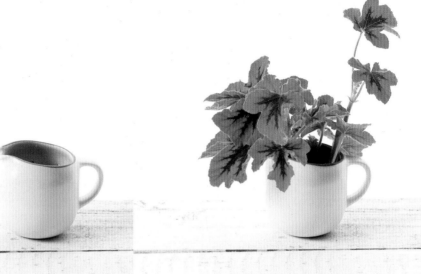

3 | Trim and tuck in the clusters of flowering thyme around the geranium leaves.

4 | Trim and layer in the violas, leaving a space in the center of the composition for the succulents. Then carefully nestle the largest succulent into the creamer so that it floats on the greenery, and cluster the smaller succulents around it.

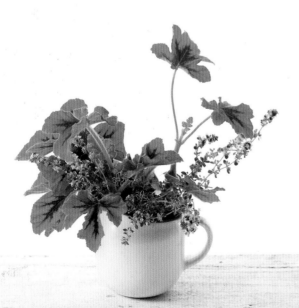

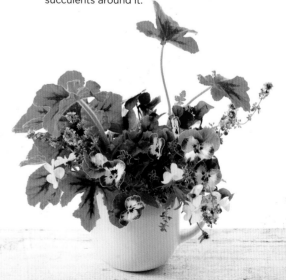

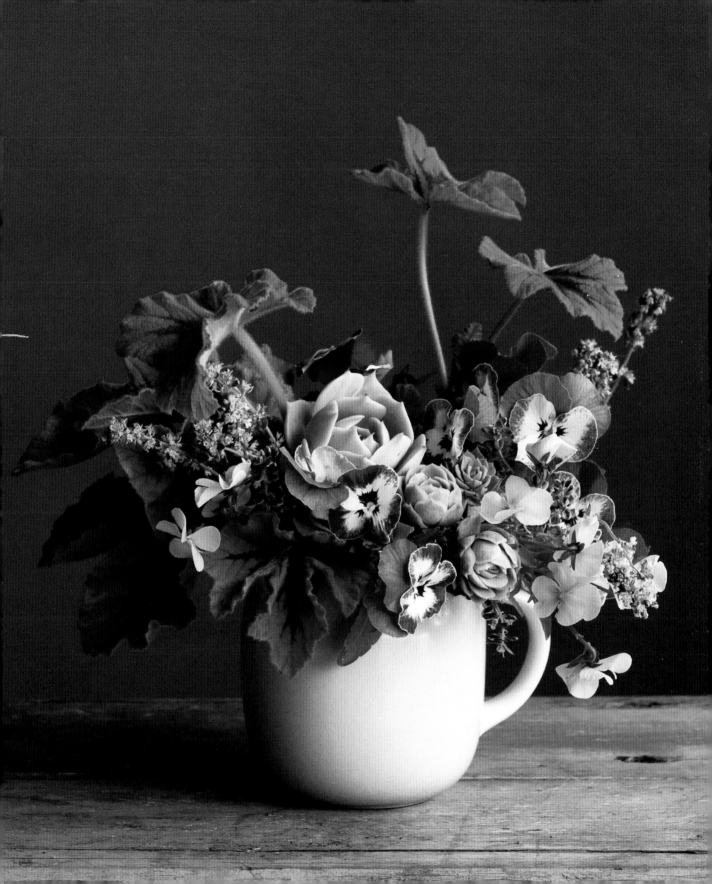

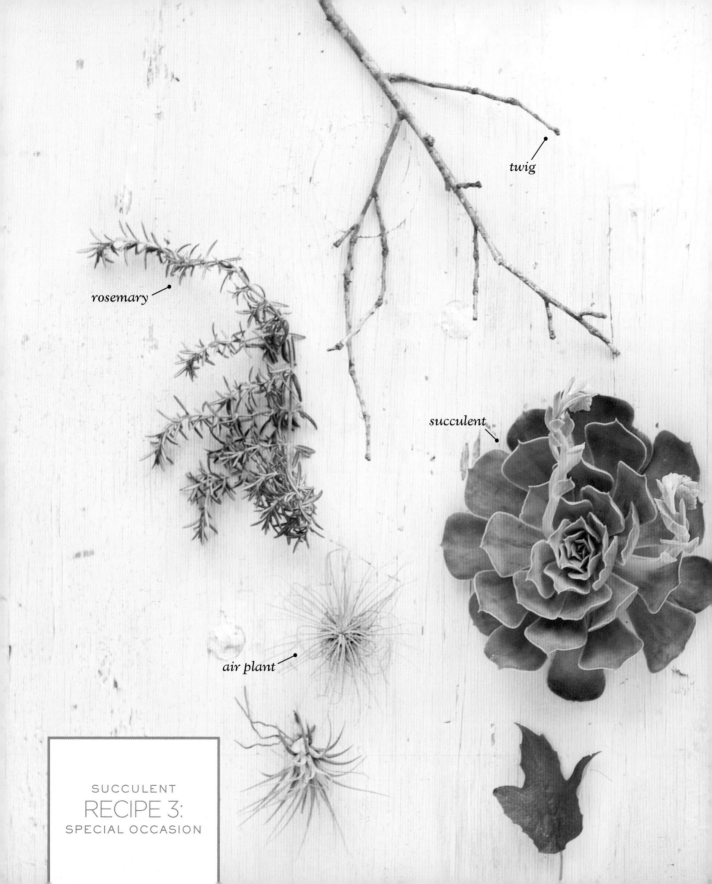

twig

rosemary

succulent

air plant

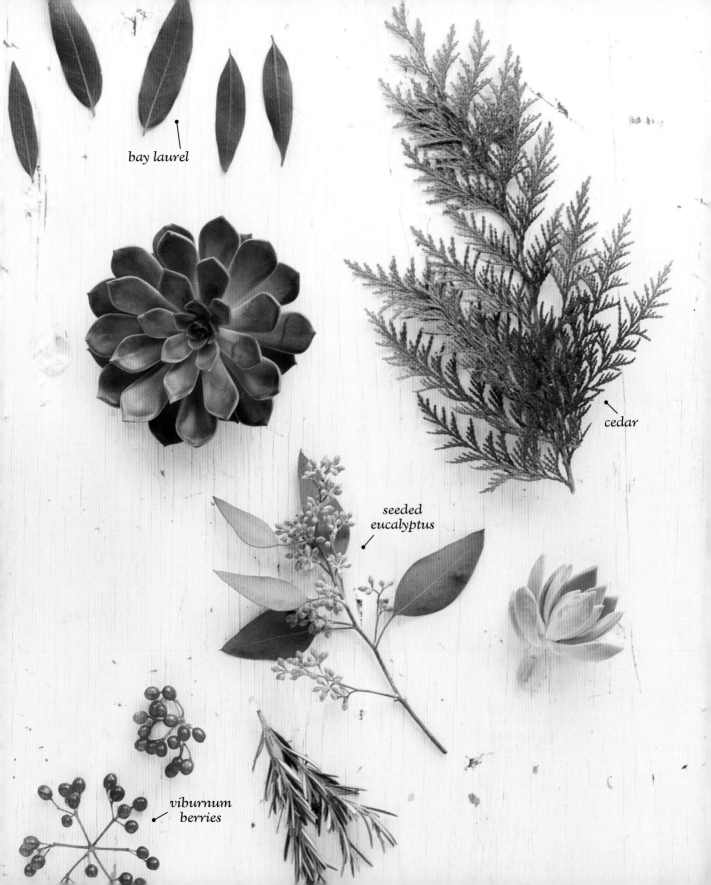

bay laurel

cedar

seeded
eucalyptus

viburnum
berries

FLOWERS

3 branches of bay laurel

3 stems of seeded eucalyptus

3 stems of rosemary

4 succulents (3 large, 1 small)

3 clusters of viburnum berries

2 air plants

5 branches of cedar

5 twigs

MATERIALS

10-inch wreath frame

Two or three 6-inch lengths of medium-gauge wire

1 Using the sectional cutting method (see page 14), cut the bay laurel, eucalyptus, and rosemary into approximately 6-inch-long pieces, leaving some slightly longer.

2 Create a bundle in your hand with three or four assorted pieces of the greenery, and place it on the frame. While pinching the stems together near the bottom, wrap the paddle wire around the bundle and frame several times. Do not cut the wire from the paddle until the wreath is completed.

3 Make a second small bundle and lay it on top of the first, covering the stems of the first bundle with leaves in the second. Hold the bundle in place and wrap the paddle wire around it and the frame several times. Continue making and attaching the small bundles all the way around the frame.

4 Place and attach the last bundle onto the frame, tucking the stems underneath the leaves of the first bundle. No parts of the frame or stems should be visible.

5 Remove a few of the lower leaves from the largest cut succulent to create a small stem. Insert a piece of wire horizontally through the stem just below the leaves, then lay the succulent in the desired spot on the wreath. Wrap the ends of the wire around the back of the wreath and twist them to secure the succulent. Repeat with the remaining succulents, creating a cluster on one side that visually balances the largest succulent.

6 Tuck two clusters of viburnum berries into the top of the wreath, and one at the bottom. Use another piece of wire to hold in place if necessary.

7 Gently wrap a piece of wire around the base of each air plant and secure them at the top and bottom of the wreath.

8 To finish, tuck in twigs randomly on all sides, with the direction of the tips following the swirl of the wreath.

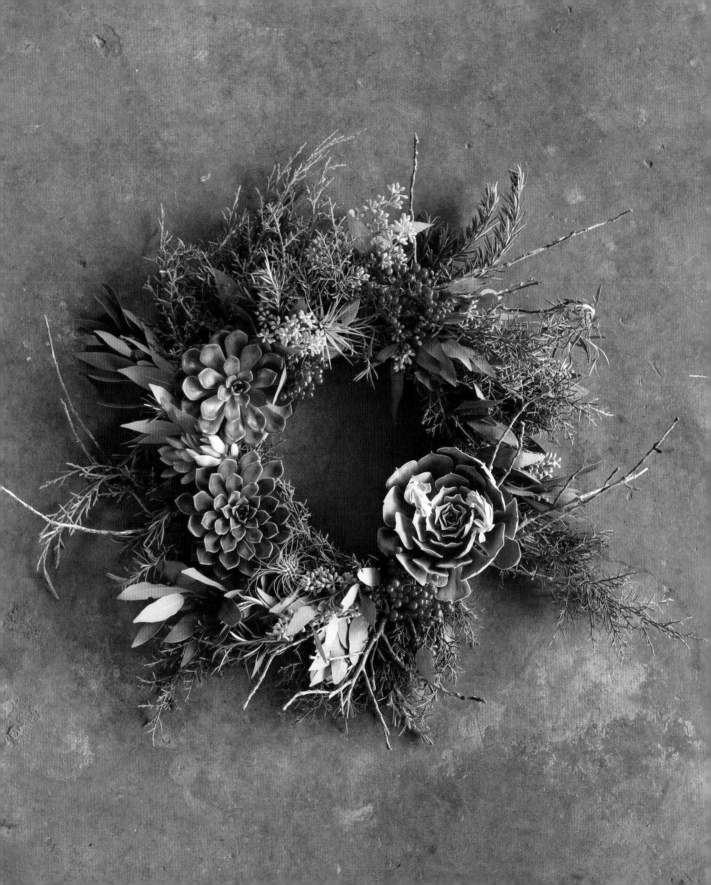

SUNFLOWER
(SUHN-flou-er)

AVAILABLE COLORS: black, orange, red, white, yellow

A sunflower's new buds will move their heads throughout the day in order to follow the sun, making this member of the daisy family a true sun worshipper. With its hefty stem and a head typically 6 inches wide, the sunflower is definitely a scene-stealer in any arrangement. The petals usually fade first, so when they've lost their luster, pluck them out and use the seed head to add texture to arrangements.

SUNFLOWER
RECIPE 1:
ON ITS OWN

———

FLOWERS
13 sunflowers

VESSEL
Milk glass
pedestal vase

1. Secure a flower frog in the bottom of the vase with floral putty.

2. Trim and add the first two stems to the vase so that the blooms hang over the rim.

3. Add the next five blooms, starting from the left side, trimming so that the heads are lined up at the same height.

4. Finish by trimming and adding the remaining stems so that the blooms rest above the layer below.

1 | Choose a low vase
in a color that
complements the
flowers' autumnal
palette.

2 | Trim four stems of acacia to twice
the height of the vase and add to
the vase. Trim the remaining stems
several inches longer and add on the
left side.

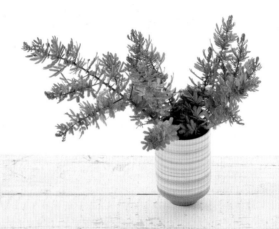

3 | Trim and add the stems of celosia to
the left side of the vase.

4 | Trim and add one sunflower so that
it rests at the rim of the vase and
another slightly above it; both should
face out at the front. Trim and add
the remaining sunflower so that it
faces to the left side several inches
above the others. Finish by trimming
and adding the stems of cyclamen so
that they arc up dramatically on the
right side and balance the acacia on
the left.

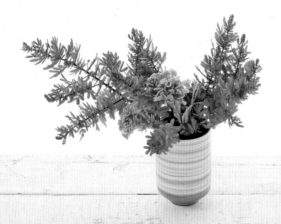

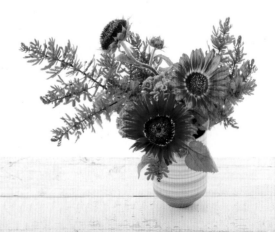

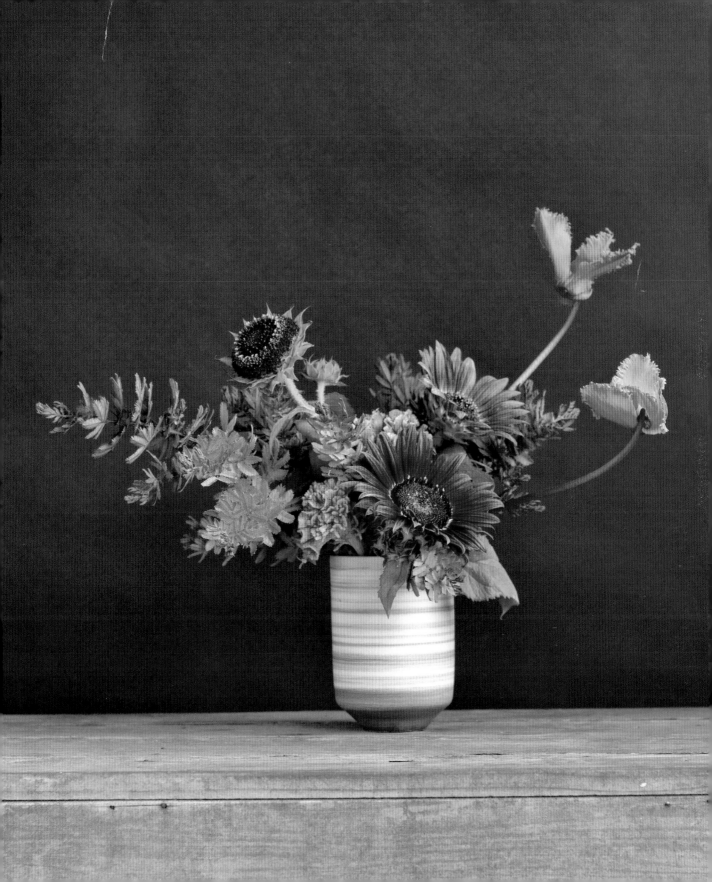

SWEET PEA (SWEET-*pee*)

AVAILABLE COLORS: pink, purple, red, white

These sweetly scented old-fashioned favorites are perfect for adding a delicate accent to large focal blooms. The foliage and tendrils also work well to form the viney base of an arrangement. When grouped together in a soft rainbow of colors, sweet pea blooms are incomparable harbingers of spring.

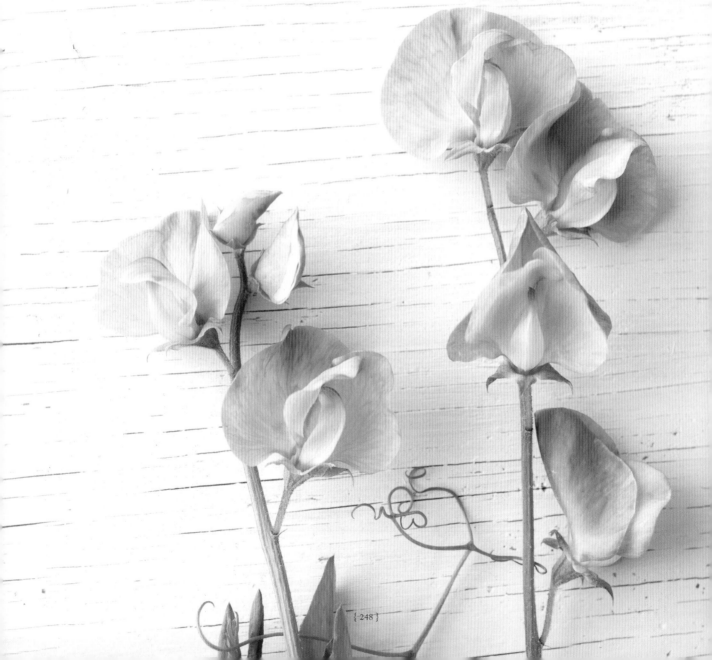

SWEET PEA
RECIPE 1:
WITH COMPANY

FLOWERS
15 stems of
sweet pea

4 stems of
Christmas bush

2 sprays of mums

VESSEL
Rustic pitcher

1. Gather all the sweet pea stems into a loose bunch, lining up the bottom blooms. The stems will be different lengths.

2. Trim the stems and place them in the pitcher so that the bottoms of the blooms start at rim level.

3. Trim and place three Christmas bush stems in a cluster on one side of the arrangement, then trim and place the fourth stem on the opposite side, allowing it to arc out a few inches.

4. Trim and place the sprays of mums in the center of the Christmas bush cluster.

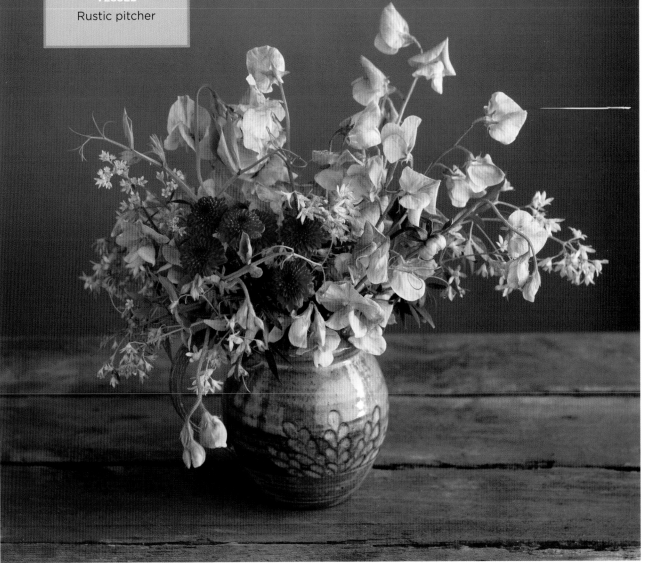

1 Choose a grouping of
simple canning jars to
let the ombré design
shine. Arrange the jars
into a grid.

2 Divide the darkest bunch of sweet
pea into three small bunches. Trim
the stems and place one bunch in
each jar of the first column, from
front to back.

3 Divide the next lighter color bunch of
sweet pea into three bunches. Add
most of each bunch to each jar in the
second column, but hold back a few
stems. Add these to the jars in the first
column, creating a soft blend along
the line where the two colors meet.

4 Repeat the process for the next lighter
color, holding back some stems.
Finish by dividing the lightest bunch
of sweet pea into three bunches and
placing one in each jar of the third
column on the right side of the jar.

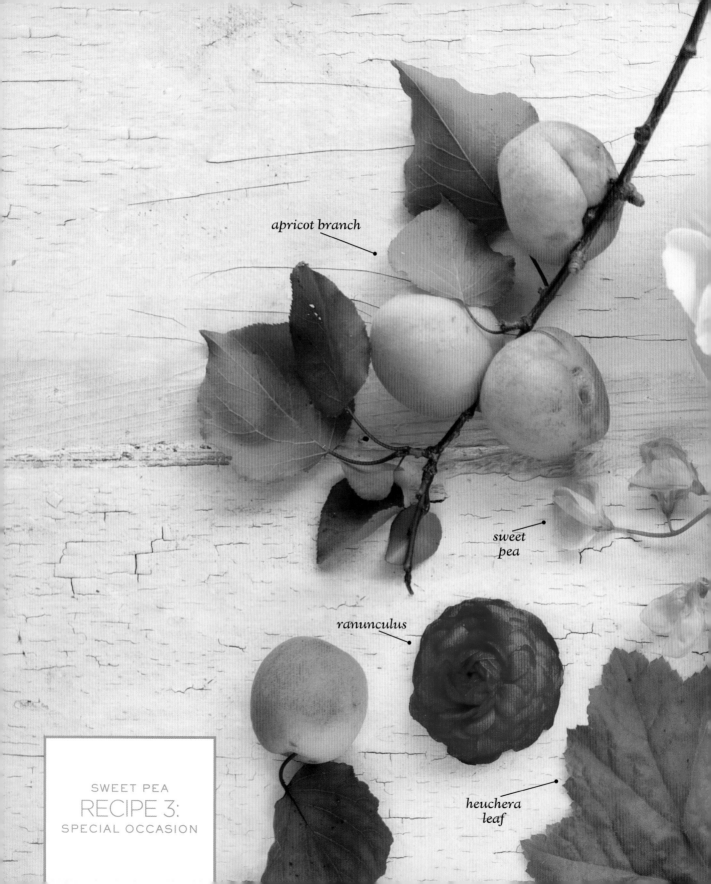

apricot branch

sweet
pea

ranunculus

heuchera
leaf

SWEET PEA
RECIPE 3:
SPECIAL OCCASION

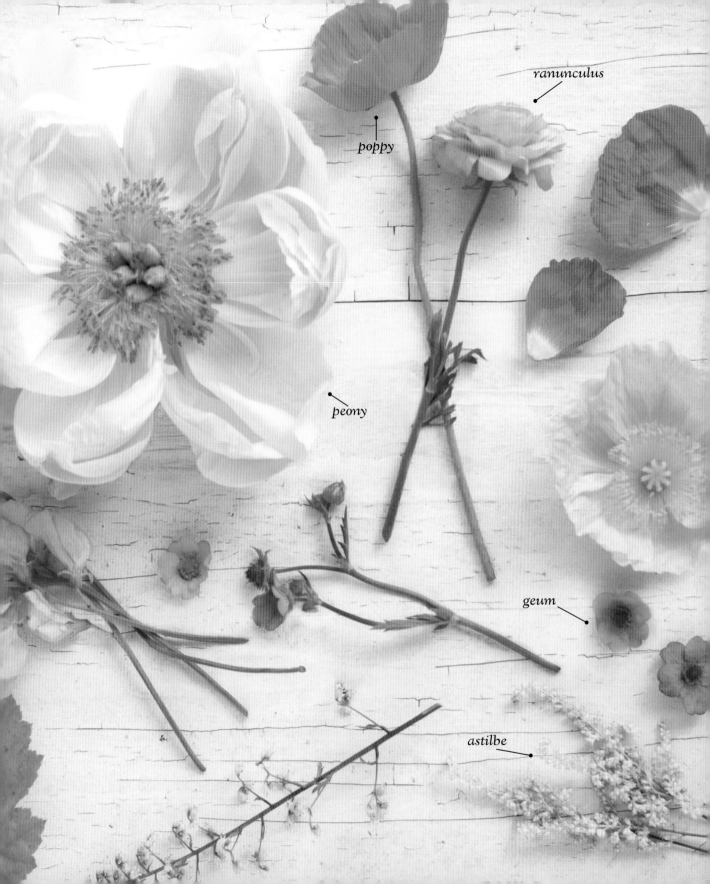

ranunculus

poppy

peony

geum

astilbe

SWEET PEA

RECIPE 3:
SPECIAL OCCASION

FLOWERS
2 apricot branches

2 heuchera leaves

1 peony

6 stems of sweet pea

2 stems of ranunculus

2 stems of astilbe

4 stems of geum

6 poppies

VESSEL
Handmade ceramic vase

1 Begin by trimming and adding the apricot branches to one side of the vase, letting the leaves and fruit cascade over the rim.

2 Trim and rest the heuchera leaves at the rim of the vase on the side opposite the apricots.

3 Trim and place the peony above the heuchera leaves so that the bottom of the blossom sits about 2 inches above the rim.

4 Trim and nestle the stems of sweet pea all around under the peony.

5 Trim the stems of ranunculus, astilbe, and geum and add to fill in around the peony.

6 Trim and burn the poppy stems before adding them to the arrangement: Place them around the peony at different heights, turning the blooms in the vase so that they face in different directions.

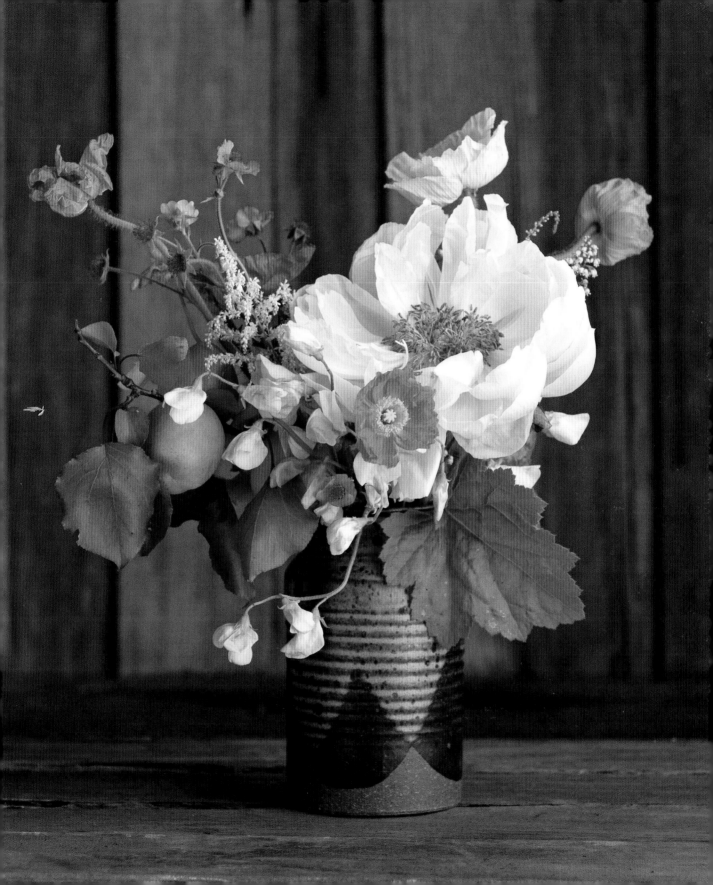

THISTLE *(THIS-uhl)*

AVAILABLE COLORS: blue, green, purple

The term "thistle" is used to describe any number of prickly-headed, sharp-leaved flowering plants. Originally developed as a defense mechanism against hungry herbivores, the thistle's prickles can make it a bit touchy to work with, but it's worth the risk. Often coming in multibloom and multibranched sprays, one stem of thistle can usually be cut apart to make multiple pieces in an arrangement. Thistlelike plants, such as the blue thistle, and actual thistles, such as the globe thistle, add rugged texture to arrangements.

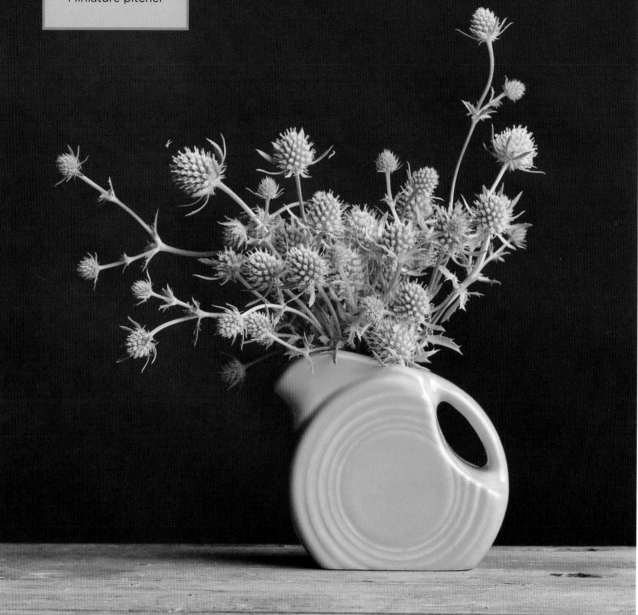

THISTLE

RECIPE 1:
ON ITS OWN

———

FLOWER
1 spray of thistle

VESSEL
Miniature pitcher

1. Cut apart the spray of thistle into smaller sections (see page 14).

2. Remove any leaves and blooms from the bottom of the stems that will fall below the rim of the pitcher. Gather the stems into a bunch, loosely lining up the bottom blooms. The stems will be at slightly different heights.

3. Trim the ends and place them in the pitcher together.

1 Choose a sturdy jug with a wide bottom that will support this substantial arrangement; the weathered patina of this jug complements the rustic floral palette.

2 Gather the branches of acorn into a bunch, aligning the lowest forks; they will be at all different heights. Trim and place them in the jug together.

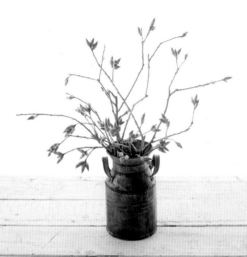

3 Trim two sprays of globe thistle and cluster them at the front of the jug close to the rim. Add the remaining three sprays of thistle at the back, trimming so that the blooms sit several inches above the other thistle.

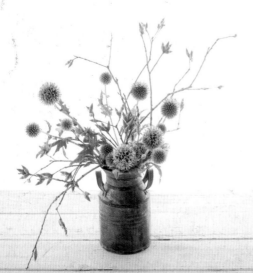

4 Trim and add three dahlias clustered toward the middle of the arrangement so that they sit a few inches above the rim of the jug. Add the last dahlia, trimming so that the bloom stands at the same height as the tallest thistle. Finish by trimming and adding the stems of euphorbia, filling in at different heights around the dahlias.

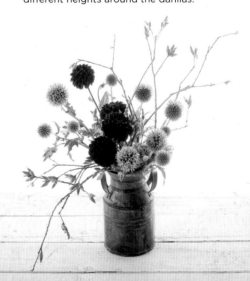

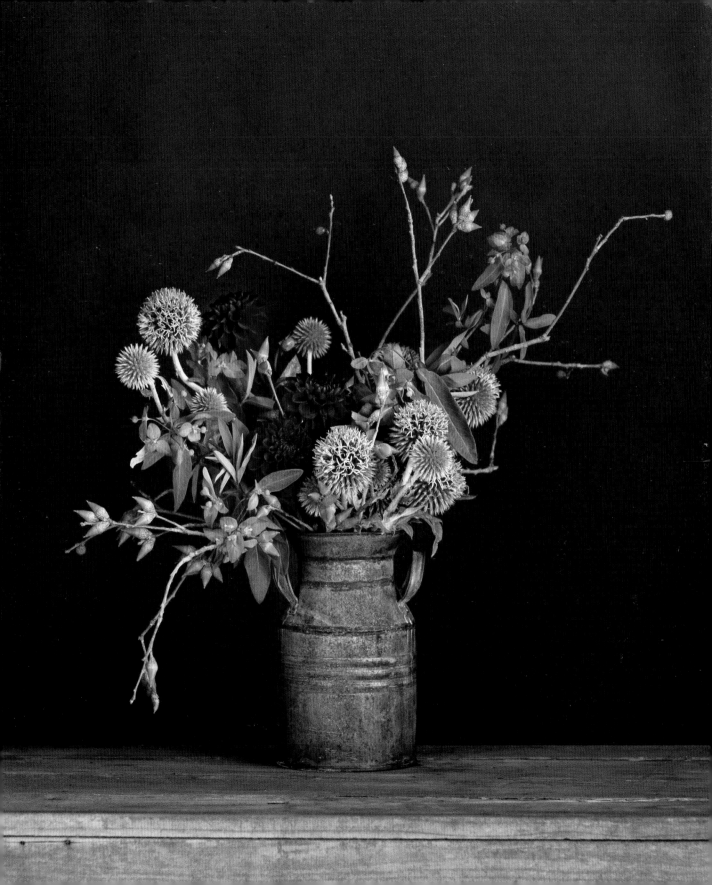

TULIP *(TEW-lihp)*

AVAILABLE COLORS: most, except for blue

These spring beauties can sometimes be difficult to work with because of their bendy stems and ever-changing shape. They continue to grow after they are cut, so trim them a bit shorter than you normally would when you first use them in an arrangement. If you leave enough space in your arrangements to account for movement and growth, their opening process is a pleasure to watch.

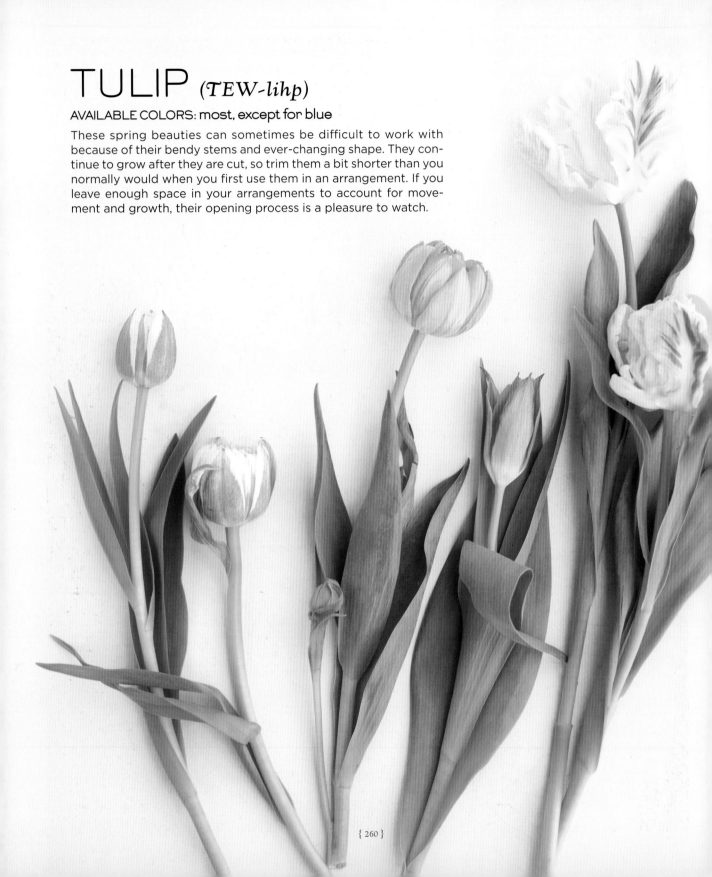

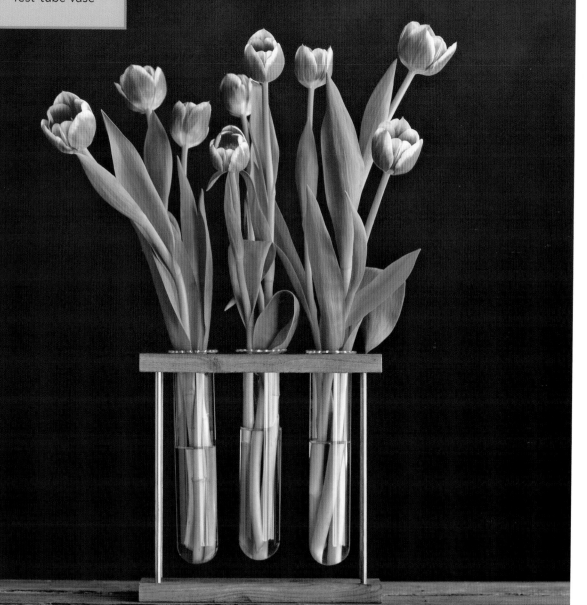

TULIP
RECIPE 1:
ON ITS OWN

FLOWERS
9 tulips

VESSEL
Test-tube vase

1. Remove the lower leaves, along with any bruised or damaged ones.

2. Trim the stems so that the bottoms of the lowest leaves will sit at the rim of the tubes.

3. Place a few stems in each tube and turn the tulips so that they arc out in different directions.

FLOWERS

3 stems of snowball viburnum

4 nasturtium vines, with flowers

5 stems of 'Double' tulips

5 stems of 'Ballerina' tulips

VESSEL

Flared glass pedestal vase

1 Select a vase with a narrow bottom and a flared opening to allow the tulips to grow and spread.

2 Give the viburnum a woody stem cut (see page 14) and place the stems so that the bottom set of leaves sits at the rim of the vase.

3 Trim the nasturtium vines and add them to the vase, placing a tall vine arcing up on the left side, balanced by a long draping piece on the right. Fill in the empty spaces among the stems of viburnum with the remaining vines, trimming them to roughly follow the established diagonal.

4 Trim the 'Double' tulips and place them in a horizontal line toward the top of the composition. Finally, trim and add the 'Ballerina' tulips so that the blooms sit at the highest level of the arrangement. Turn all the tulip stems so that they face outward.

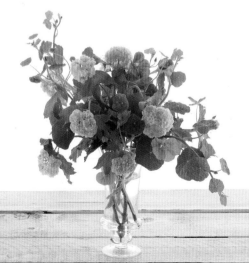

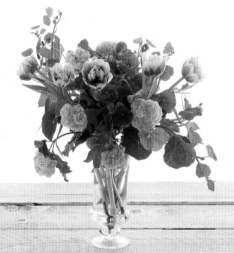

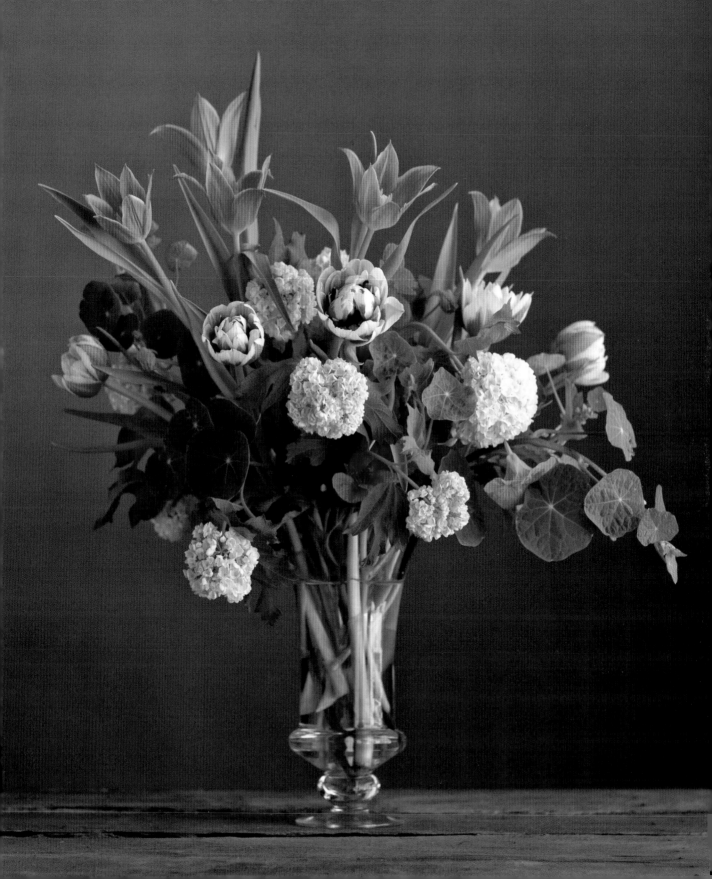

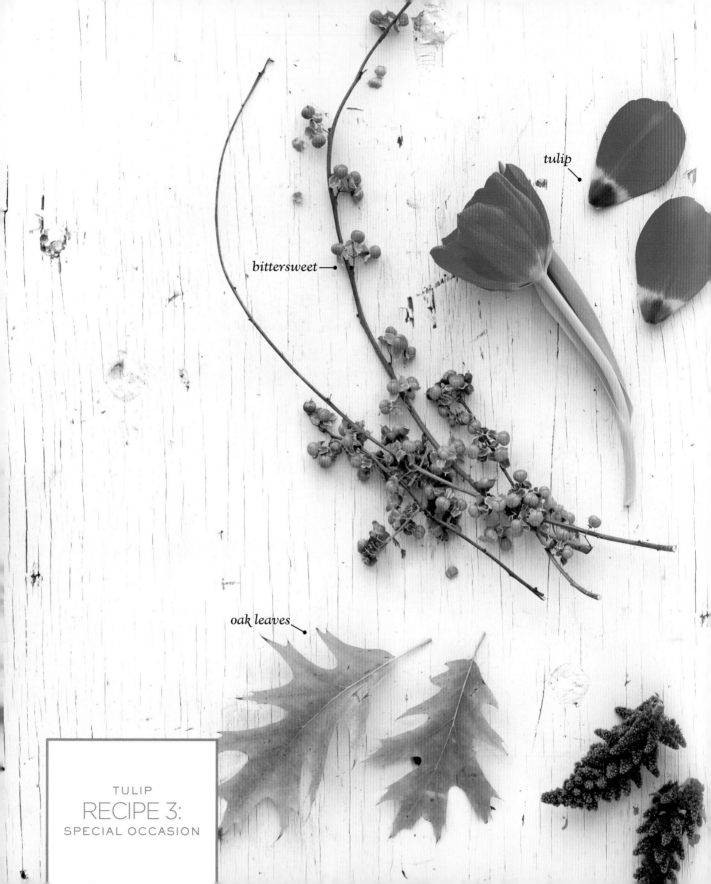

tulip

bittersweet

oak leaves

TULIP
RECIPE 3:
SPECIAL OCCASION

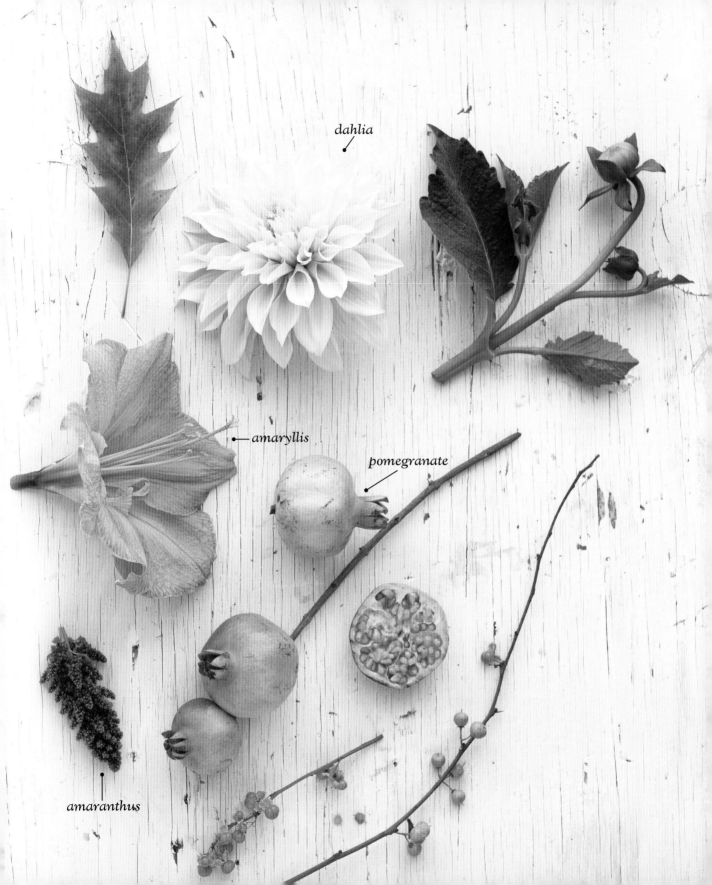

dahlia

amaryllis

pomegranate

amaranthus

TULIP
RECIPE 3:
SPECIAL OCCASION

FLOWERS
2 branches of oak leaves

2 stems of amaryllis

3 dahlias

6 tulips

2 stems of amaranthus

4 skewered pomegranates

2 branches of bittersweet* or ilex berry

VESSEL
Wooden box with liner

1 Place a flower frog in the liner and secure with floral putty.

2 Trim and add the branches of oak leaves to the left corner of the box, letting them drape out so that they almost touch the tabletop.

3 Trim and add one stem of amaryllis so that it rests on the front edge of the box, then add the remaining trimmed stem directly above the other so that they create a large mass of blooms.

4 Next, add the trimmed dahlias in a cluster on the left side, nestling the first bloom right next to the amaryllis.

5 Create a tulip bunch in your hand, lining up the blooms and turning them to fan out in different directions. Trim and add them to the right side of the box together.

6 Trim and add the stems of amaranthus to the left side, with one stem in front of the dahlias and the other toward the back, with the tips pointing out a few inches above the other elements.

7 Gather the skewered pomegranates into a cluster and place them on the left so that they spill forward over the front edge of the box, above the oak leaves.

8 Carefully add the bittersweet branches to the left so that they curve around the side of the box and cascade over the tabletop at the front. The branches don't need to be in water, as they will dry and the shells will crack off, revealing the bright berries inside.

*AN IMPORTANT NOTE ABOUT BITTERSWEET: Some varieties are extremely invasive and illegal to sell and transport in some states, especially in New England. Substitute ilex berry or another vine if bittersweet is not available.

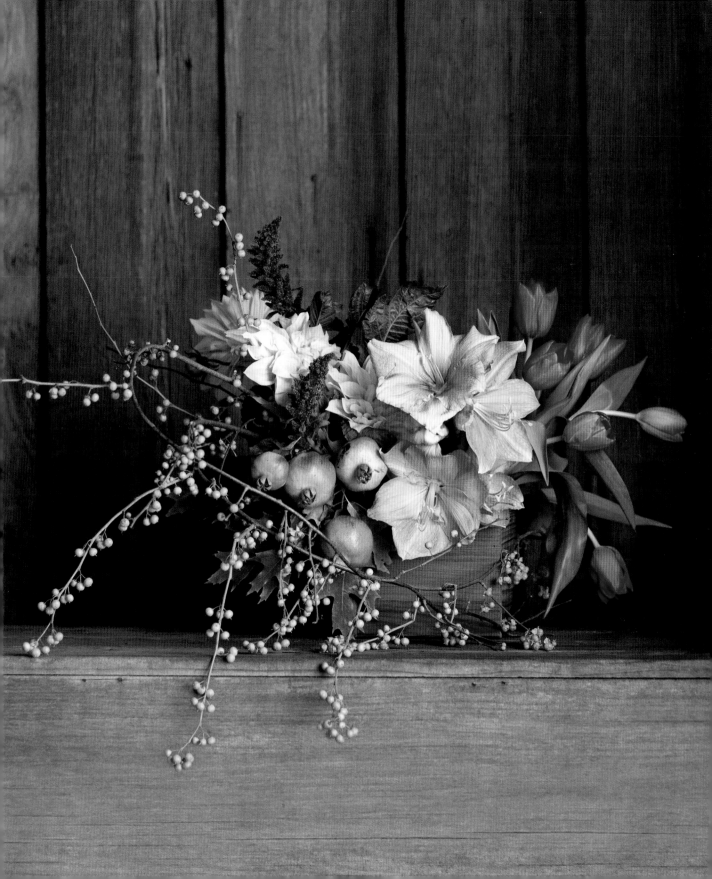

ZINNIA *(ZIN-ee-uh)*

AVAILABLE COLORS: most, except for blue

In the garden, zinnias are a favorite of butterflies and humming-birds, but indoors they find just as many admirers. A member of the ever-popular *asteraceae* family, zinnias closely resemble their daisy and sunflower relatives. These summery flowers usually come in intense pinks and reds, but some varieties have unusual muted palettes and interesting variegated color combinations.

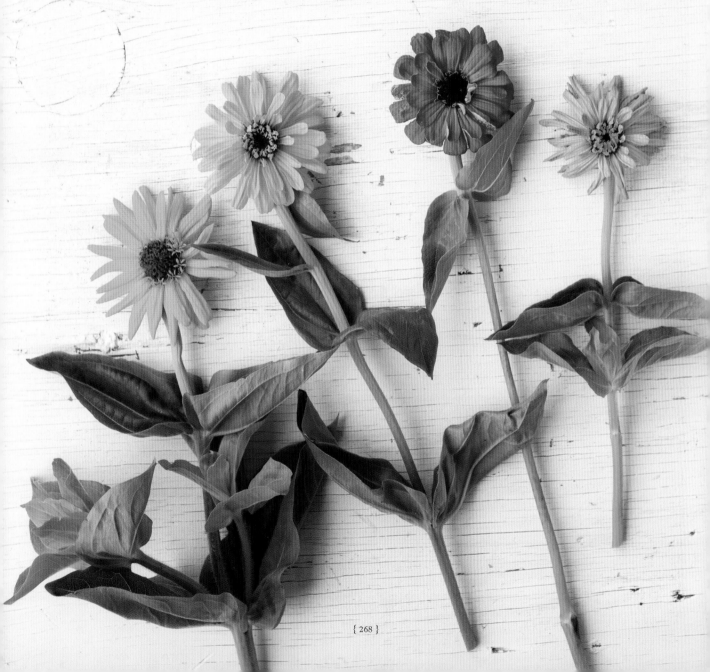

ZINNIA
RECIPE 1:
ON ITS OWN

FLOWERS
13 zinnias

VESSEL
Handmade
ceramic vase

1. Gather the stems into a bunch in your hand, clustering the blooms to create a rounded dome shape.

2. Trim the stems and place them in the vase together, resting the lowest leaves at rim level.

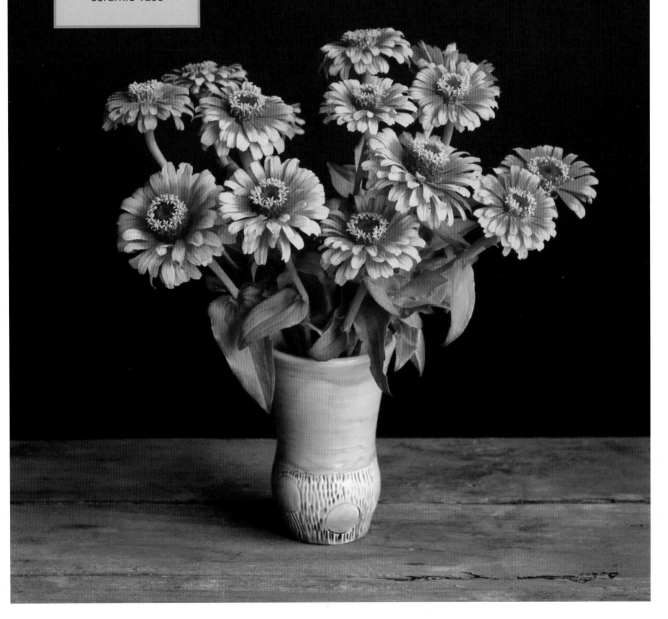

ZINNIA
RECIPE 2:
WITH COMPANY

FLOWERS

20 zinnias

4 stems of
amaranthus

2 stems of lupine

4 stems of veronica

VESSEL

Hanging basket

Using a hanging
basket provides the
opportunity to bring
an arrangement into an
area that may not be
suited for a traditional
tabletop piece.

2 Trim all the zinnias and fill the
basket so that the lower leaves
rest at the rim.

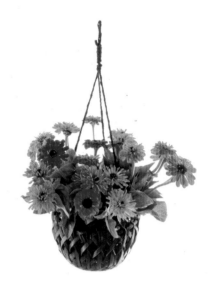

3 Trim and add the amaranthus to the
front and left side of the basket,
allowing the blooms to hang over
the rim.

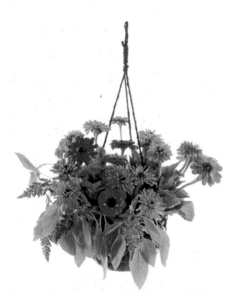

4 Trim and add the stems of lupine to
the back right side of the basket so
that the spires sit several inches above
the zinnias. Finish by trimming the
stems of veronica to a similar height
and adding two stems to the center
and two stems to the back left side.

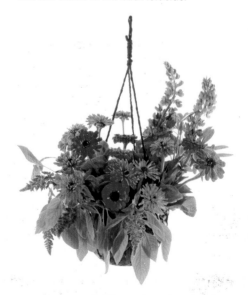

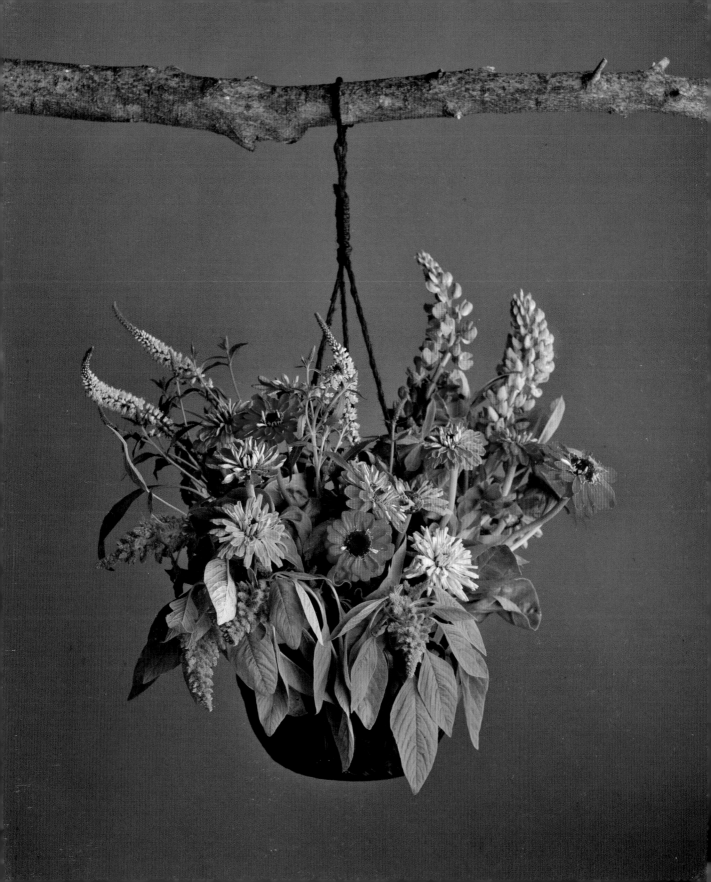

THANK YOU

To Kay and Jon for coming out of retirement for a new career in child care, Ever for being so darn sweet, Babe for building us things and cooking dinner, Papa Ron for his green thumb, Kathi for always being there, Auntie for her creativity and flower skills, the Pilottes for being the cutest family ever, Paige for her amazing leveling skills and surface sensibilities, Lia Thomas for saving the day, AB and Wu for holding down the fort, Cate for teaching us the importance of which bucket to choose, Bill for letting all us gals use his bathroom, our families and friends for putting up with months of neglect, all the lovely folks who let us borrow their beautiful vases, Kitty for finding us, Lia Ronnen for believing in us, Mimi for her hard work and understanding, and the bad-boy crew for loving us no matter what.

The authors and publisher wish to thank the following people and companies for providing their vessels for use in the book: Karin Erikkson and Camilla Engman (pages 74–75), Linda Fahey (pages 134–135), Diana Fayt (page 209), Patty Herzfeld (page 189), Vince Montague (page 173), Lorna Newlin (page 61), Sara Paloma (pages 158–159, 218–219, 229, and 246–247), Sophie Pigeon (page 53), Sadie and Emma Pottery Co. (pages 12 and 73), Sharon Virtue (pages 30–31 and 269), and Yellow Owl Workshop (page 177).

ABOUT THE AUTHORS

ALETHEA HARAMPOLIS and JILL RIZZO are best friends and founders of Studio Choo, a San Francisco–based floral design studio that has been serving up fresh, wild, and sophisticated flowers for weddings, special events, and individuals since 2009. Their artful and accessible work has been featured in publications such as *Sunset*, *Food & Wine*, and *Veranda* and in the blog *Design*Sponge*. The ladies can usually be found making displays in their San Francisco storefront, prepping for a wedding at their studio, or scouring the California coast for the freshest flowers to bring to their clients.